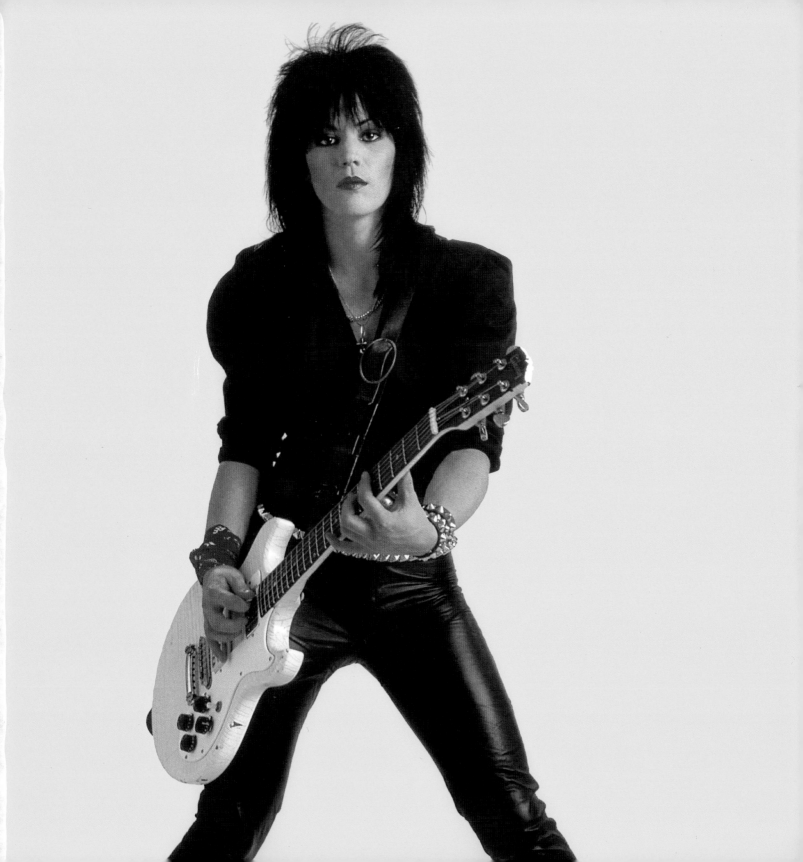

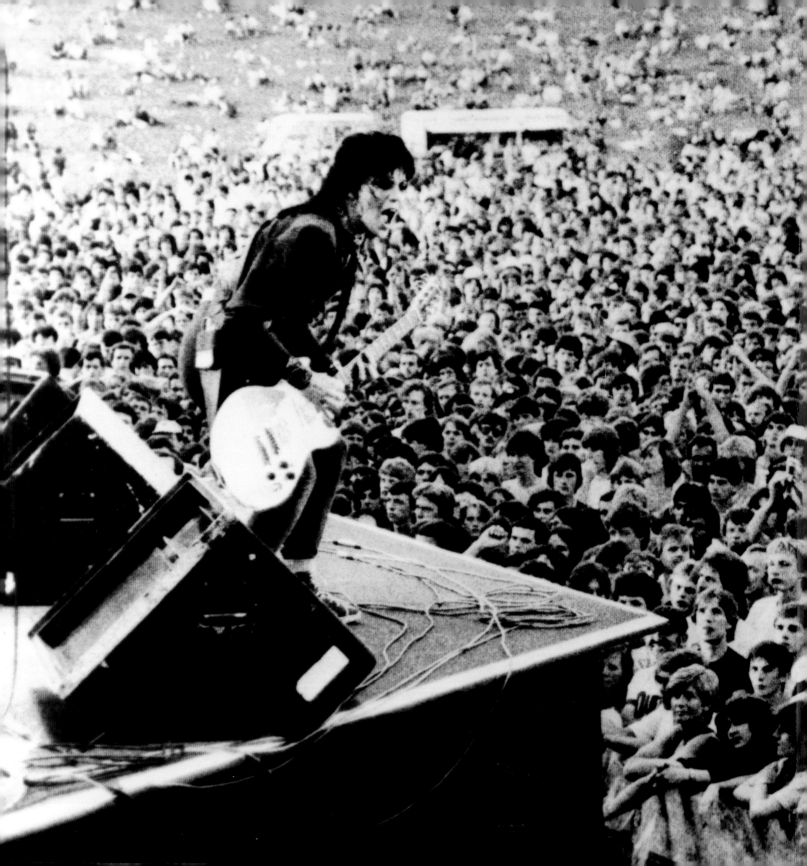

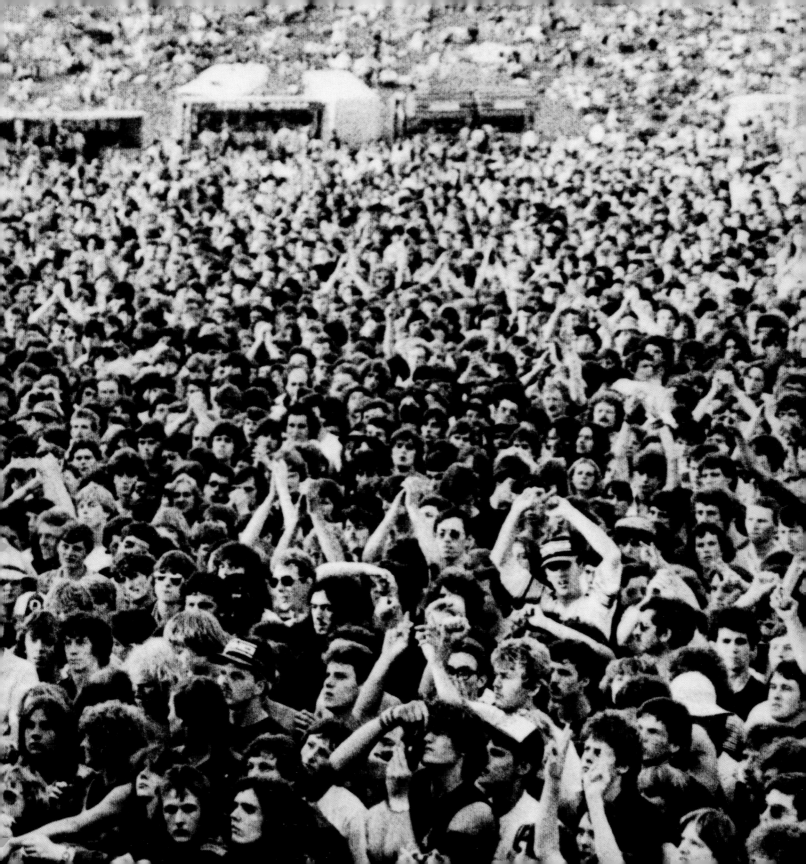

TODD OLDHAM

JOAN
JETT

AMMO

"THERE ARE VERY FEW PEOPLE LIKE ME, WHO LOOK UPON ROCK AND ROLL AS A KIND OF RELIGION."

—JOAN JETT, 1988

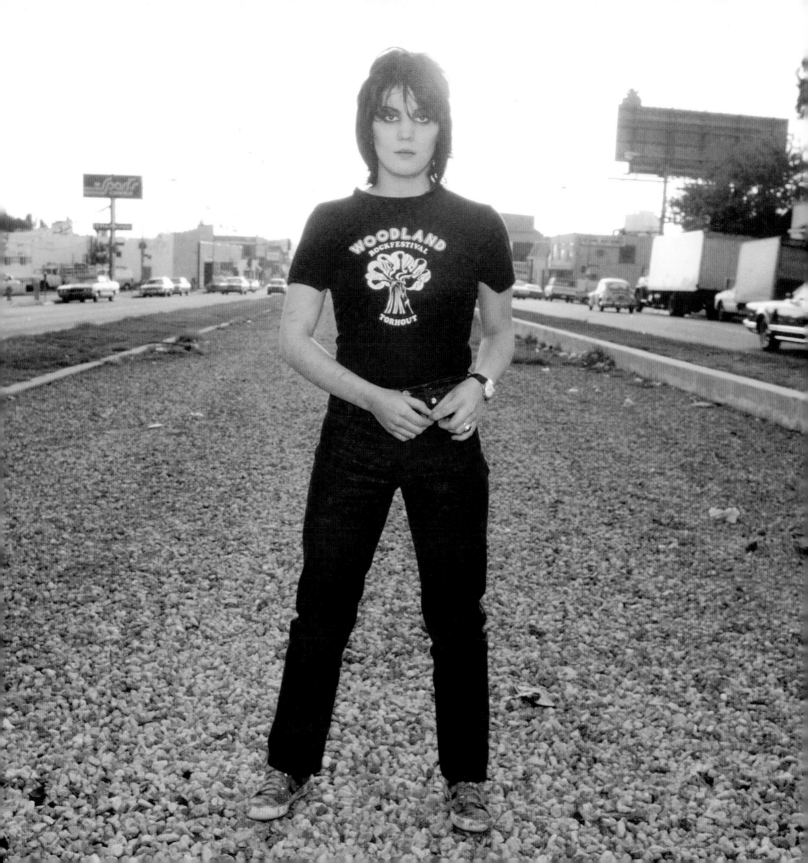

W.W.J.J.D?

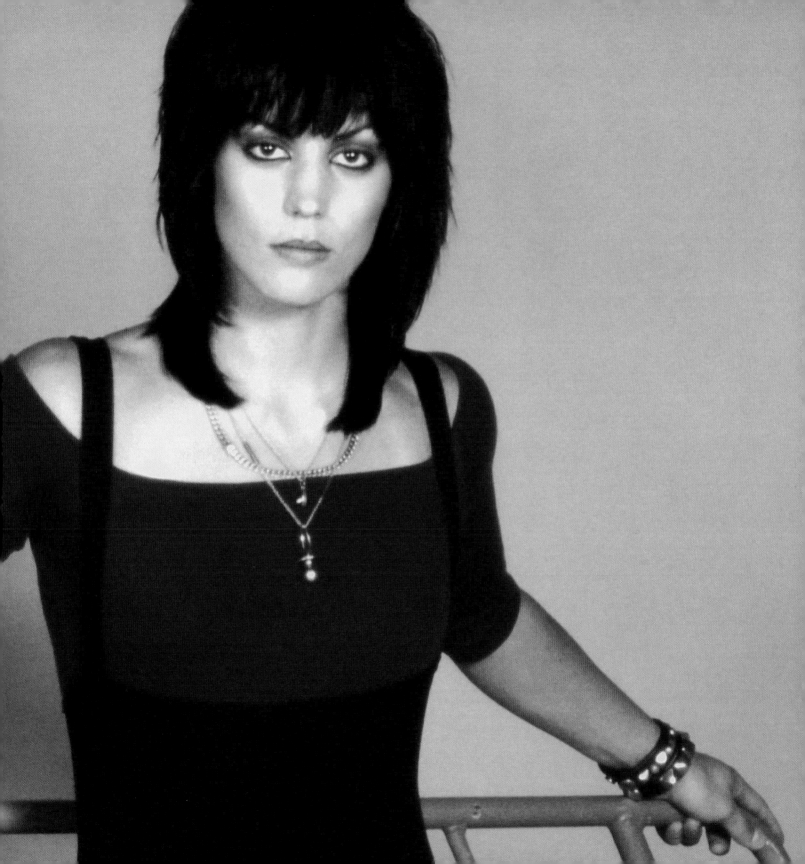

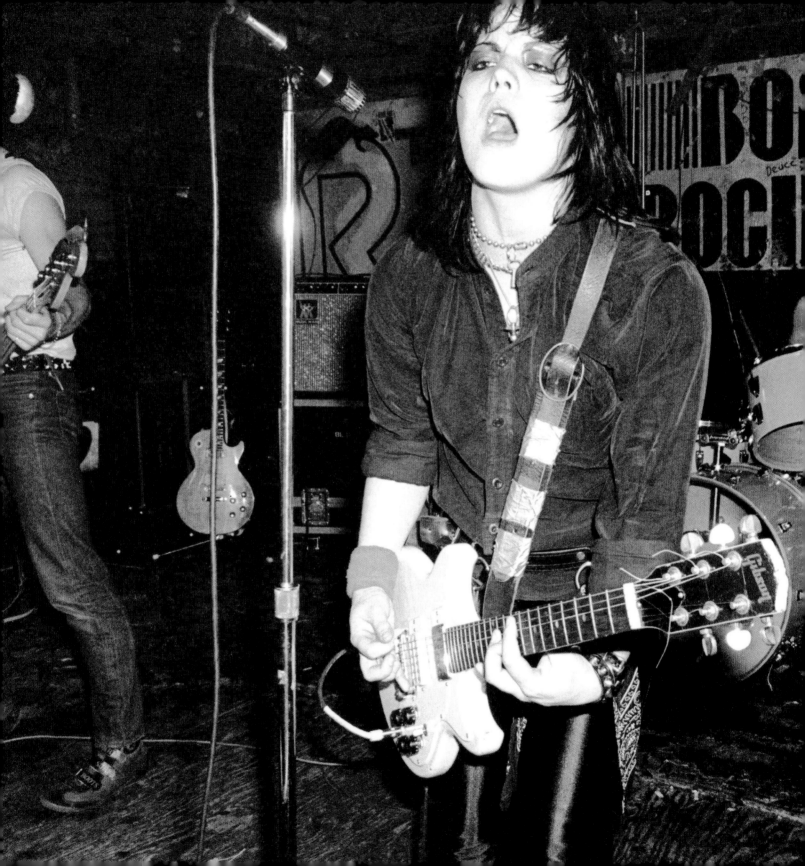

"BEING ON STAGE IS
EVERYTHING THAT'S
GOOD ABOUT LIFE."

—JOAN JETT, 1988

"I WASN'T GOING TO CHANGE JUST TO GET ACCEPTED."

—JOAN JETT, 1992

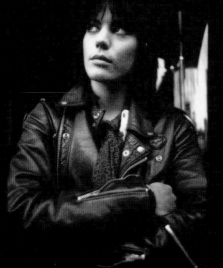
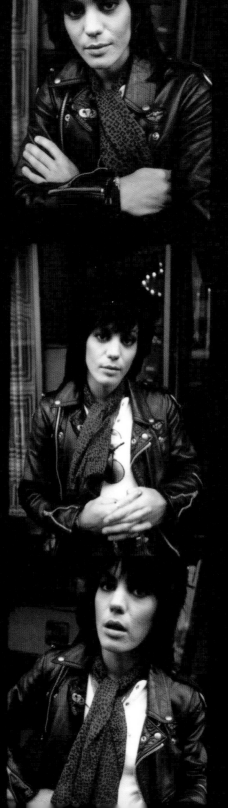
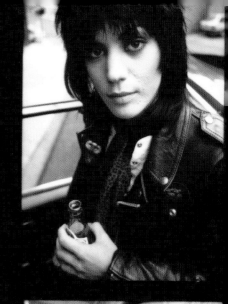

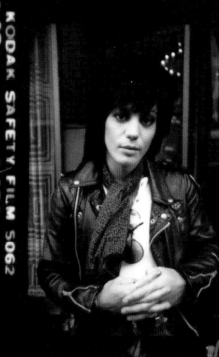
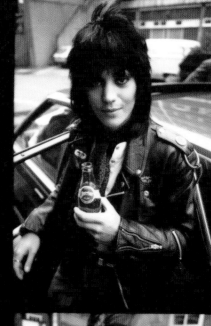
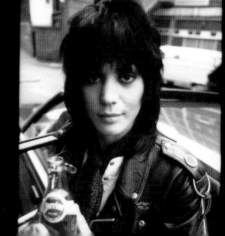

JOAN JETT WAS BORN TO ROCK
by KATHLEEN HANNA

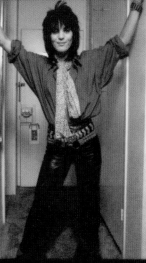
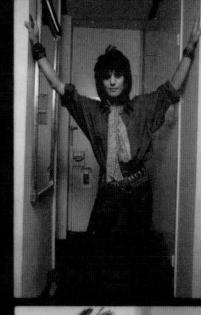
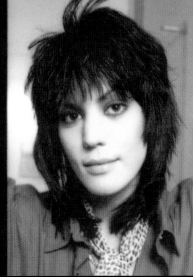

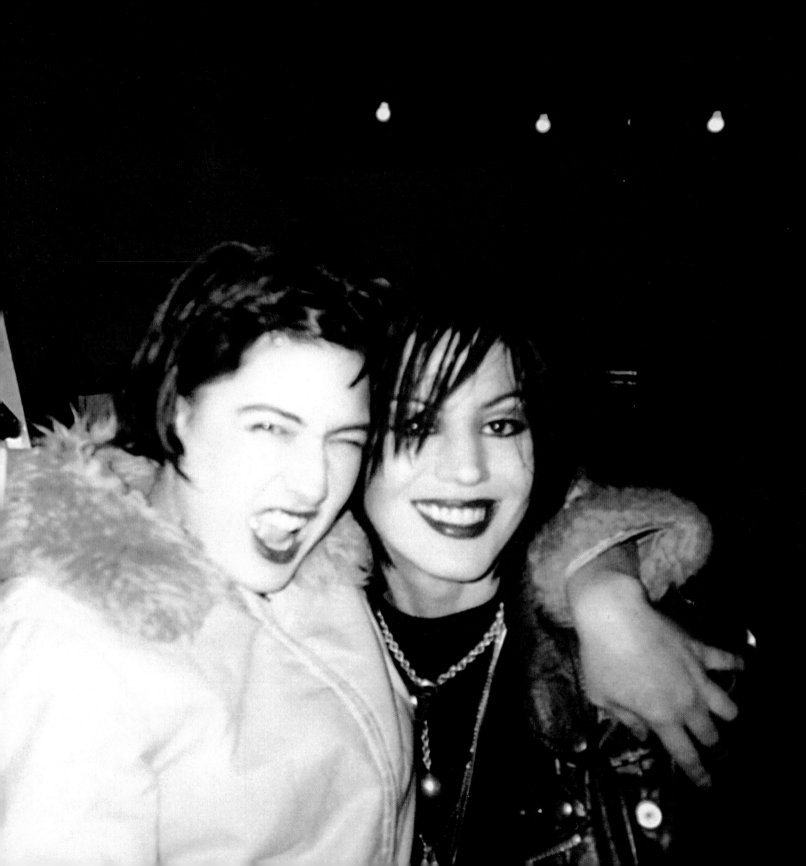

JOAN JETT WAS
BORN TO ROCK

BY
*Kathleen
Hanna*

Joan Jett was Born to Rock. I know that sounds like some fucked-up bumper sticker, but it is absolutely true. Joan is one of those rare people who **need** to play music.

Joan was born into a world that didn't quite know what to do with a girl like her. Luckily, she never let that stop her. In 1975, at the age of 15, she started her first band, The Runaways. While they are heralded today as the band that opened the door for female rockers everywhere, they were much maligned in their own time.

Some feminists didn't like that Cherie, the singer, wore lingerie on stage or that a man had crafted the band's jailbait image. Many male audience members felt threatened when they saw these talented girls crashing their party. At a show in London, a man threw a bottle at Joan's head and knocked her out cold. When she came to, she got up and started the next song.

After The Runaways broke up in 1979, Joan embarked on what would become a highly successful solo career. What most people don't know is that her biggest hit, 'I Love Rock 'n Roll,'

was released on Blackheart Records, the independent label she and her manager, Kenny Laguna, created because no major label would sign her. Joan and Kenny sold records out of the back of his car the year her record came out.

The first time I heard 'Crimson and Clover' was in the front seat of my mom's brown Ford Fairmont. As Joan sang, "I don't hardly know her, but I think I could love her," I felt a pleasant sense of confusion, the same way I did when I saw David Bowie on *Don Kirshner's Rock Concert* and when I saw the cover of Prince's first album. As I listened, a whole new world of possibilities opened up — a world beyond tiny Laurel, Maryland, a world where sex was as gorgeous as Joan's round, smoky, perfectly pitched voice and gender could move and change like the signs along the highway.

I met Joan in 1992, when she came to see my band, Bikini Kill, play. She told me she could hear the record she wanted to make with us inside her head. A few months later, she made good on her promise and produced a three-song single that is, to date, the best record I've ever made. We've been friends

ever since. Through her example, I've not only weathered the successes and pitfalls of my own career, I've had fun doing it.

People always call Joan an "icon," and it kind of pisses me off. Not because she's not an icon but because that word tends to gloss over the fact that she is a total weirdo who continues to make great music.

Who else can wear a spandex pantsuit that fits inside a sandwich bag while talking about politics like a Harvard Law professor?

Who else has an audience that includes suburban moms, soldiers and S&M dykes?

And who, who, who can stand like her onstage? You know that stance. The Joan stance—totally confident, tough and in charge, her guitar hanging down like she's the lost member of the Ramones.

Who but Joan can step to the mike, tough as fuck, with that gorgeous vampire-face-mask of a face and have **that** fucking voice come out? That voice—the one that recalls Lesley Gore and Suzi Quatro at the same time, the one that makes it feel like every door in your head is flying open, the one that is so friendly and welcoming, yet, in its perfection, so hopelessly impenetrable?

Only Joan can do the things she does the way she does them because she was truly and irrevocably born to rock, and she will always, always, always refuse to listen to the voices that say she can't.

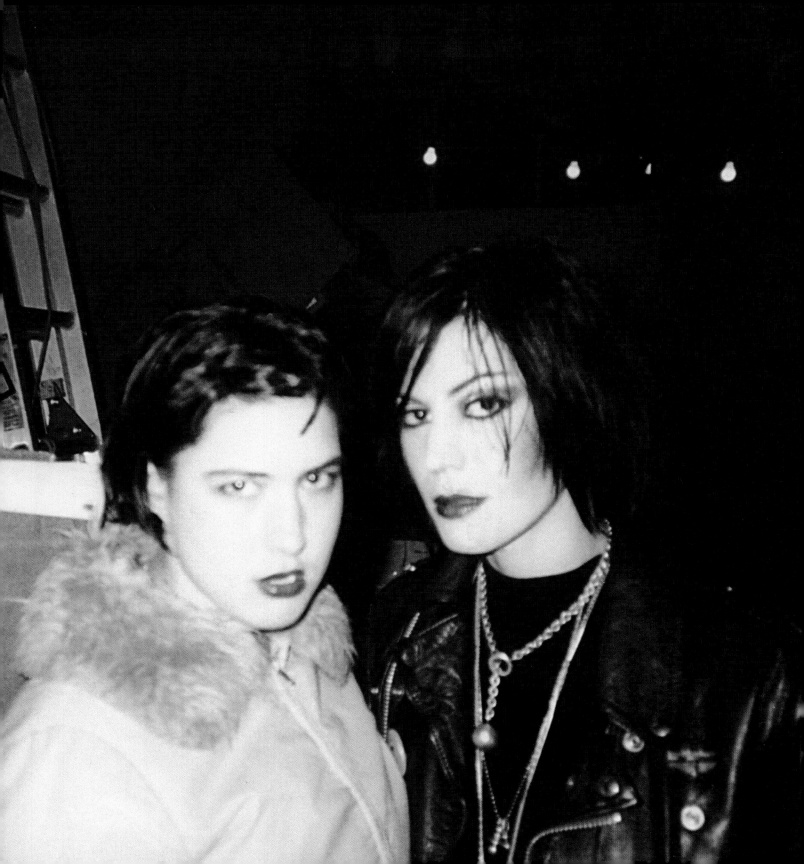

1

YOU CAN BE ANYTHING YOU WANT IN THIS WORLD, JOAN

I was born in Philadelphia, Pennsylvania, in a Lankenau hospital. I don't remember much about Philly 'cause we moved quickly to Pittsburgh. My father was an insurance salesman, so he got transferred a lot, so we moved around a lot. For most of my life my mom was a homemaker. I think we were always very close. They weren't young parents. They were the same age, 27. So in those years, the late '50s, that's old to have a baby. My mother had had three miscarriages before me. I'm the oldest, and I felt like, whoever those kids are, I have all of them in me. I kind of felt like whatever spirit or soul I got, I'm like four people.

It was a very normal, happy childhood. My parents would read to me. I have a brother who's a year-and-a-half younger than me, James Albert Larkin. And we are very close. He was like my best friend. We did everything together—played and roughhoused and, of course, got on each other's nerves and fought viciously as well. I also have a sister who's six years younger named Anne Elizabeth Larkin. When I was a kid, she seemed so much farther away in age; she was the baby of the family and would act like it sometimes. But we're very close, and she's like a best friend now.

It's great that I've always remained close to my family. There were never any kinds of heavy, weird family issues I think.

We were pretty good kids. I mean, it wasn't like now, you didn't fuck around; you just didn't. It wasn't just my father; my mother laid down the rule too. You just didn't talk back. You were polite, you said, "Please" and "Thank you." You didn't hurt people's feelings. I remember when I was very young, maybe four, my mother's best friend gave me something very girly—like a rabbit fur hand muff or something—for a present. I didn't like it. I was a little tomboy. I forget how I reacted, but it wasn't right. And my mother let me know it. "You do not, **do not**, do that. You do not hurt feelings. You say, 'Please' and 'Thank you,' and you just accept it."

My parents divorced eventually, and my mother remarried. My father had girlfriends here and there, but he has since passed away. We were very close. After my parents divorced, I didn't speak to my dad for a year. He didn't really know what was goin' on with The Runaways; he left. And I was probably pissed about that. I didn't know what he was up to, whether he cared. I miss him a lot. I'm pissed because he would have been so amazed at all this shit. You know, seein' a black guy get elected president.

My mother is very liberal. My father, I don't think was. Now my mom is pretty much retired and relaxing and loving her animals. We always grew up with animals; we had everything—dogs, cats, turtles, birds, rabbits, hamsters, rats, mice, frogs.

I think I always liked music. I always liked listening to the radio. My father listened to a lot of classical music. My parents would also play a lot of Sinatra, Johnny Mathis, Nat King Cole, a lot of different things like that. So I'd hear things around the house when I was really young, and probably somewhere around, say, five, six, my parents told me, "You can be anything you want in this world, Joan." And I took it to heart. You know, you remember things your parents say like that when you're that young. I remember wanting nothing really to do with music at first, I was interested in a lot of things. I loved animals and nature, and space was fascinating to me. I wanted to be an astronaut and an archeologist. All sorts of things.

When I was ten or 11, I was urged by my parents—let's put it that way—to take up an instrument. But I didn't really gravitate towards it; there was nothing I was really interested in playing.

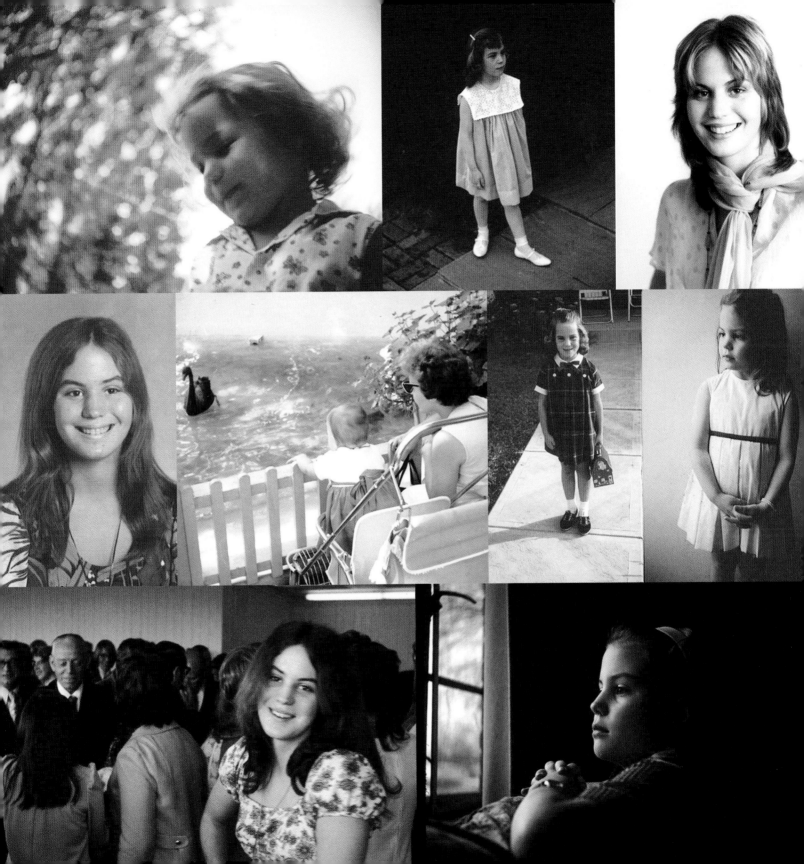

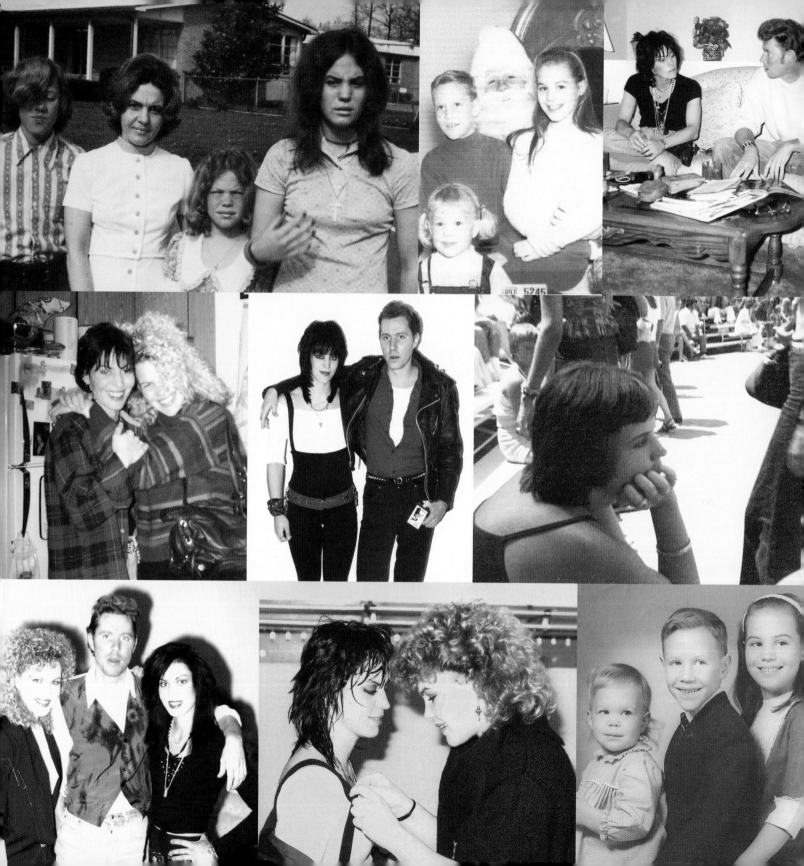

But I played the clarinet. It wasn't even band class, it was just orchestra I guess, but it's not like it was in a marching band. It was just a class where you're taught to play, so I did that for a couple years. But I didn't really grasp it well, and I wish I had now when I think back. I wish I had been more interested. I felt that I could sing on key, and I felt that I had pretty good rhythm. But the whole reading music thing didn't really resonate with me. I didn't take to it. It was not fun. And all of sudden, I'm noticing the radio. I was 12 by then. I started to listen more to the rock-and-roll songs instead of things like Donny Osmond or something like that. I was noticing Alice Cooper, 'School's Out,' 'I'm Eighteen,' and 'All Right Now' by Free. I think the first single I ever bought was 'All Right Now.'

There was all that great stuff that was on the radio then—Hendrix, Zeppelin, T. Rex. I had a big crush on Marc Bolan for a while. I can remember getting into an argument with my mother about a Zeppelin song. I think it was 'Whole Lotta Love.' There's this part with all these weird noises, and we were arguing about whether it was music or not, and then my brother agreed with her. The two of them made me so mad.

I hadn't started thinking about playing music, but I was loving rock and roll and loving the guitar. Probably playing air guitar.

At one of the first concerts I ever saw, Black Sabbath, Blue Oyster Cult and Black Oak Arkansas, I was about 12, watching the kids jump up and down—and me, too, jumping up and down (I'm a good fan)—and I started thinking, wow, that's what I want to do. Be on stage and sweat and play my guitar.

I used to go to shows at the Capital Centre, in Maryland, and I was motivated by all the lights and the people having a good time. I thought, wow, it would be great to make all these people happy. I'd like to do that. I was really listening to the radio, really getting into the beat. I loved rock and roll, the stuff you could dance to. I made up my mind that I wanted to play rhythm guitar, not lead, but more like Chuck Berry and Keith Richards. The Stones were naturally a big influence.

But in school, I started getting into acting. It all started when I was 13, and I saw the movie *Cabaret*. It changed my life. I knew I wanted to do something in the arts. Seeing Liza Minnelli made me think, god, I hope I can do something like that

one day! I was at that age when you start to think about sex, and that whole decadence thing in the movie was really attractive to me. Within a year or so I tasted a bit of the real thing—I saw the New York Dolls and stole David Johansen's beer bottle off the stage.

My family is very proud, and it's mind boggling to me. I guess it's not my image, but one of the biggest thrills for me is flying my mom to a concert date and then taking her sightseeing afterwards. I did that when I played in San Francisco, and we had a great time. My mom is one of my biggest fans. She stands and cheers and screams at my concerts.

My parents' only objection to me playing in a rock-and-roll band was the question of me surviving. You know, this business can chew you up and spit you out. It happens every day, especially to girls. But I've always wanted to play the guitar and sing, so they let me. They always stood by me no matter what, and that's what has kept me going during the rough times.

I may look hard and tough, but deep down, I'm not really. If I didn't have the love and support of my parents... well, I don't know if I could handle it.

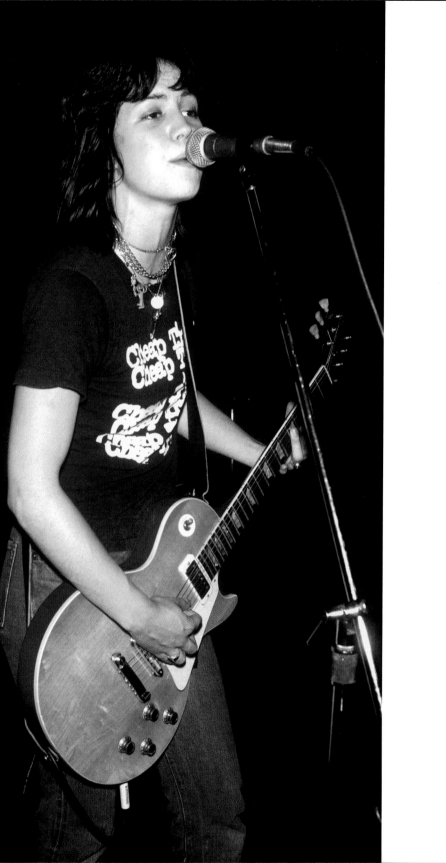

2

I WANNA LEARN HOW TO PLAY ROCK AND ROLL

I'd just turned 13, and Christmas was coming up, so I asked my parents for an electric guitar. I thought, if anything, they'd probably get me an acoustic one, but sure enough I got what I wanted—a Silvertone from Sears. I sat there making horrendous noises all day, 'cause I didn't know what the fuck I was doing. So now I'm thinking, I'm into this. I wanna do this. So go learn how to play. But being a kid, you wanna do it now. You don't want to have to do the work. I didn't want to have to read music again. And of course, I go in to take a guitar lesson and the guy, he's got sheet music there. So I said, "I wanna learn how to play rock and roll," and he taught me how to play 'On Top of Old Smoky.' And that was really the one lesson. That was it. I left, and I bought one of those, "How to Learn Guitar Chords" books—it's not sheet music, it just shows you diagrams of where to put your hands on the guitar and how to play it and what chord it is. I went home, and I learned how to play chords from a book. And I put on my records, and I tried to sit there and learn how to play from my different records. I tried 'All Right Now,' Deep Purple's 'Smoke On The Water,' and Black Sabbath's 'Iron Man,' 'cause it was big, slow chords, so I could try to figure it out.

As I learned to play guitar, I had to figure out how to hold it. I hold my guitar really low. The pickup, which is the part of the guitar that transmits the sound from the strings—it's the little square bit on the front of the guitar—that part sits right on my pubic bone. And there's something about hittin' a chord and that power goes through your pubic bone. And it's definitely very sexual, and it's powerful. It's not just sexual, but it is sexual.

It's that raw power. It makes me think of 'I Wanna Be Your Dog,' that Iggy song. You know, it's just raw emotion, raw hormones, raw potential. Just that raw, pent-up coil. And when you hit those chords, it just goes out. For me, that's what it feels like. And I'm sure for other musicians it may feel like that. I don't want to speak for Sandy West, but I'll just say that when we met to play in The Runaways, I felt that we really locked in because we played our instruments with the same abandon. It was a real absolute release for her. And it was absolute release for me. To see a girl handle a guitar well, that is a great sight. Somewhere along the way I lost or wrecked that first guitar, which pisses me off because it would be a collector's item now.

"IT JUST
WASN'T LIKE
EVERYTHING
ELSE."

—1995

3

THE GLITTER TEENAGE SCENE

I was reading rock-and-roll magazines like *Creem* and *Circus*, and I started reading about a club in Hollywood called Rodney Bingenheimer's English Disco. It was just a column, so there wasn't a lot of information, just enough to titillate. There was just one picture of this wild-looking kid that was hanging out there, this guy named Chuckie Star. He had platforms that were literally like seven inches high, and silver lamé shorts, and fishnet stockings, and a little T-shirt, and his hair like Bowie, lots of makeup. You know, you just didn't see guys like that in America at the time. He was standing there with a girl, all dressed up; she was a groupie. Her name was Sable Starr, and she hung with the Rolling Stones. And I'm thinking, "Wow, that looks really fascinating." They're playing this music, all these songs from Britain that kids never hear here in America — things like David Bowie and T. Rex, Gary Glitter and Suzi Quatro. I had never heard these names. And at the same time, I'm still listening to Led Zeppelin and the Rolling Stones and all my 45s. I'm buying the things I'm hearing on the radio.

My family moved to Los Angeles in the summer of 1974, when I was 14. I was extremely excited about it because I had this urge

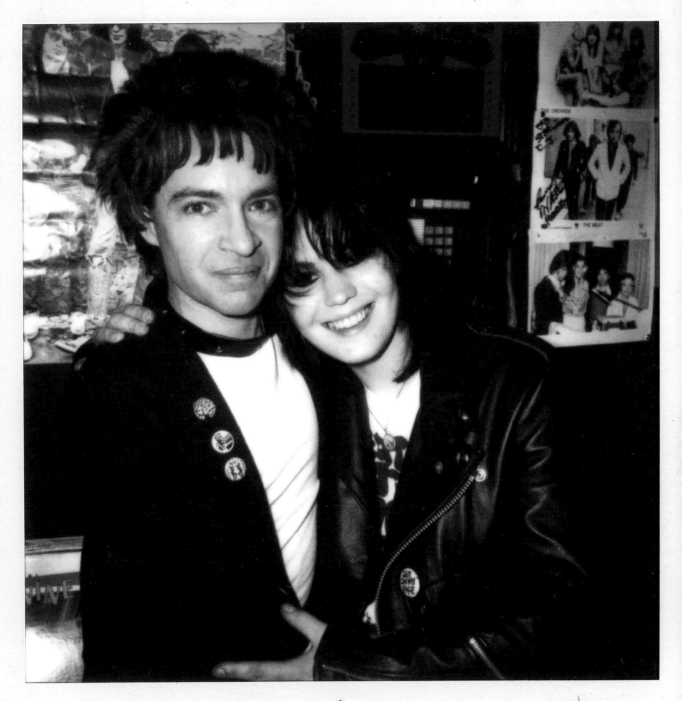

I Love Rodney Joan Jett

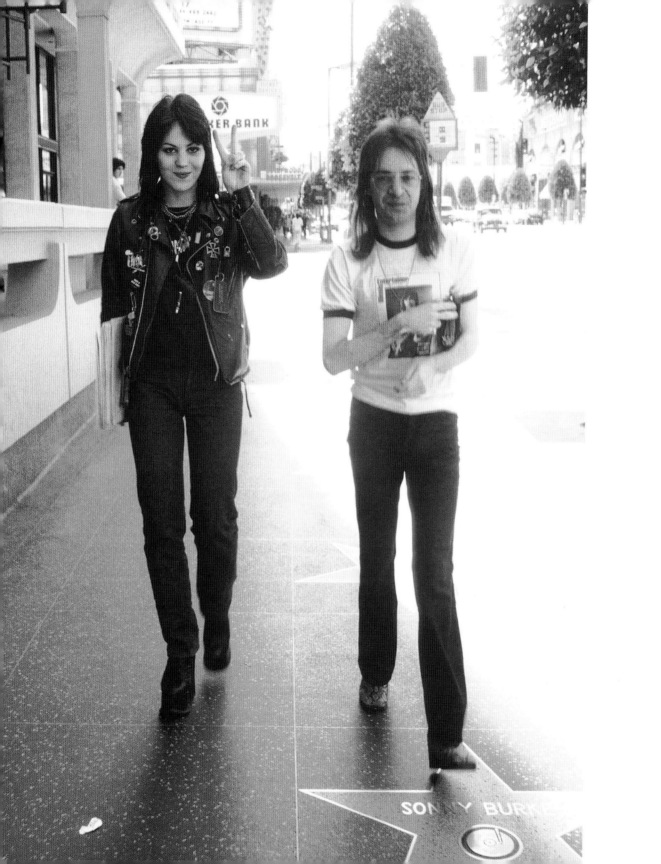

inside me—I was pretty sure it had to do with performing—and here I was in one of the two cities people go to get famous.

So now, all of a sudden, this place I'm reading about, this Rodney's English Disco, I'm gonna be close to. And it's a disco for teenagers; you don't have to be 21 to get in. It's like if you're 21, you're too old already. The club served only soft drinks, but the rock stars and other celebs went there to cruise the underage girls, and many people brought their own non-alcoholic inebriates anyway.

I made the first of what would become weekly trips to Rodney's. It took a couple of city buses for me to get there, and when I arrived I was blown away. There were people from 12 years old up to their twenties—and they played the kind of music I wanted to listen to, the kind you couldn't hear on the radio. It was a whole other side of life. It was…Hollywood!

I was still in high school near Woodland Hills, and I felt that the people around me didn't understand me. I occasionally wore platforms, a tube top, and satin bell-bottoms to school,

and I remember the kids howling, "Aa-oo, diamond dogs!" and throwing rocks at me. Most of my friends were from the club; Rodney's was a place where I felt accepted. My parents actually let me go to this place since it was for teenagers and there was no drinking. Sometimes they actually drove me there, and my mother picked me up.

It was totally glam, a glitter teenage scene, you know. It was not menacing in any sort of dark way. People were thinking about sex probably and, you know, thinking about drugs to a degree. But that wasn't really on my radar. It was about the music, and about meeting other people, and about dancing, and just hearing all this … stuff.

Rodney's is where I started thinking that I could form a band.

4

I WANNA FORM AN ALL-GIRL BAND

So I figured, you know, I'm in Hollywood, and I wanna play rock and roll. And I can't be the only girl thinking like this. And if Suzi Quatro had hits in England, I mean that means that it's possible. She plays the bass. Wow. If she can do it, I can do it. And so I started asking some of my friends that I had met at Rodney's if they wanted to form a band. One girl named Kari Krome, this girl was like 13 at the time, she said, "I write lyrics. I don't play an instrument. But maybe you should talk to the guy that publishes my songs, Kim Fowley." And I was, like I said, very shy and very naïve. So god, the thought of talking to somebody in the business was petrifying; I'm talking about petrifying. So I got Kim's number and I called him, or he called me, I don't remember how it went. But he asked me a bunch of questions about how long I'd been playing. I told him I wanted to form an all-girl band, and he asked me if I'd ever played with other people and did I have a demo? I'm like, "What's a demo?" So I felt like, "OK, that's the end of the conversation now. Man, I really blew that." I was scared to death and was really pretty devastated.

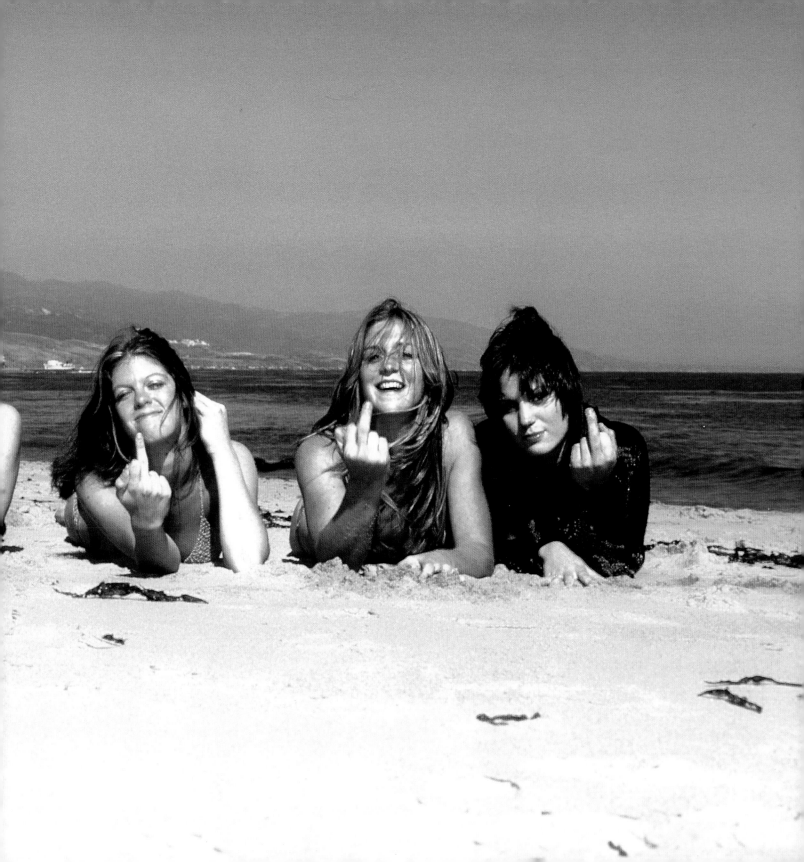

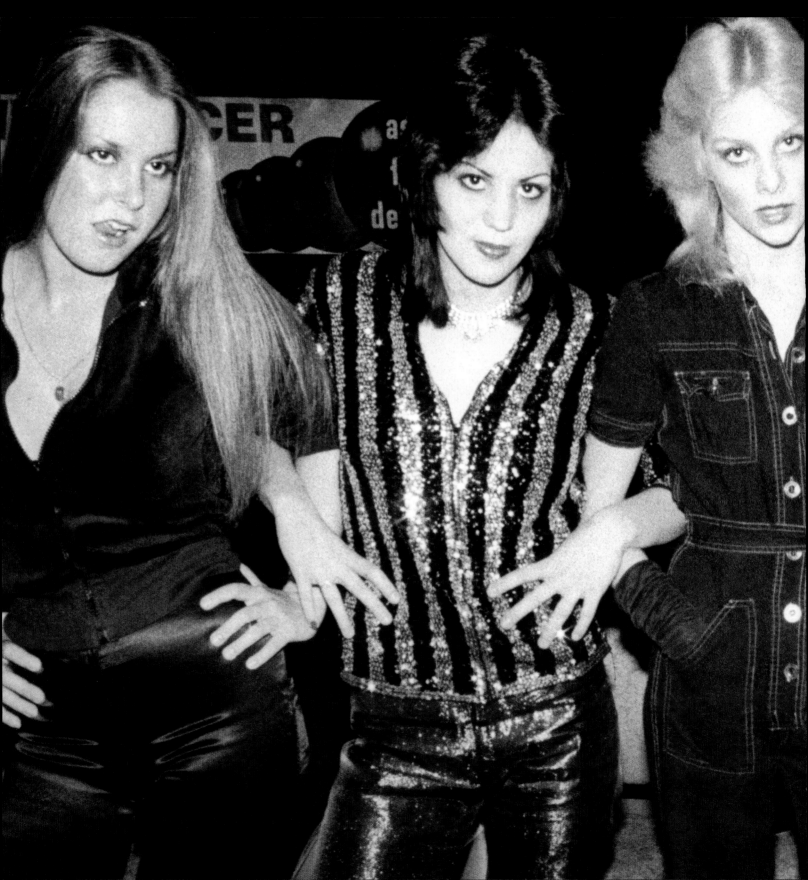

A couple nights later Kim met Sandy West. There's a restaurant called The Rainbow, and it's actually still there on Sunset. And it used to be where everybody would go, all the musicians, and have pizza. They'd go and be seen, and at 2 a.m., when it closed, everybody would stand in the parking lot and talk. It was a scene. And Sandy somehow knew this, and she went to look for people in the business 'cause she played drums and she wanted to form a band. She had been in bands down in Huntington Beach, but with guys. And she wanted to form an all-girl band. Now this is completely separate from me—just the same idea at the same time.

She recognized Kim Fowley, went up to him, and said, "I play drums. I wanna form an all-girl band." He said, "I met a girl the other night who plays guitar. You guys should talk and get together. And if anything happens, give me a call." So Sandy got in touch with me, and she told me to come on down to her house in Huntington Beach. I took like four buses down to Huntington Beach with my guitar and my leather jacket. She had a big rec room, and her drums were set up. Sandy and I hit it off right away.

She was great. I mean she could play. Oh my god, she was powerful. What a drummer! She had experience 'cause she'd played in bands, just teenage stuff, but she'd played with other people. I'd played in my room. She was very outgoing and very warm and, you know, just a really good person. And so we hit it off really well. We sat down, and we just played just straight up rock and roll. She was more well versed in playing those kinds of songs than I was. After a couple hours we called Kim up and said, "Check it out," put the phone down, played a little bit. He said, you know, "It sounds great. Let's go on the search for other girls." So that's what we did. There were a couple of ways we did that. One was we went out and just looked in clubs, which is how Kim and I found Cherie Currie. We put the word out down in the South Bay. There were some rock fanzines that were out there.

Our first bass player was Michael Steele. It didn't work out, and she left the band after a month or so. She later surfaced as a successful member of The Bangles, and she's still playing today. The Runaways never did get a stable member at bass, but we moved on. We went and looked for other bass players.

I think Lita Ford ... I don't remember exactly how she came to us. I think Lita initially came in to play bass but then went to lead guitar. Lita was such an amazing lead guitarist; she could play Ritchie Blackmore's solo from the Deep Purple song 'Highway Star' note for note. If you know that solo, it is very impressive and would blow guys away. We would jam at sound checks on 'Highway Star' just to see people's reactions.

Sandy West was the beach surfer girl—long blonde hair and cut-off T-shirt. Jackie Fox was the intellectual. She's a lawyer now—she went to Harvard! Cherie and Lita were the sex-bombs—both in their own way. Cherie was definitely more androgynous than Lita. I was the tough girl, and it came out more and more—especially after *Queens of Noise*.

I was 15 when The Runaways formed.

Believe me, I'm not taking anything away from Kim or from what he did for us. Without him—and also him without us—we couldn't have achieved what we did. But by no means was it him saying, "I'm going to go out and create this band." If he had a master plan from the beginning, he didn't let any of us know about it. A lot of times, Kim would let The Runaways do a song while he sat in the control room. When we did basic tracks, he didn't stay with us very much. He wasn't there all the time. At the final mixes, yes, but when we were recording the overdubs and stuff, we did what we wanted.

Maybe he manipulated the press, I have no idea. He never tried to manipulate us. He didn't tell us how to talk, he didn't tell us how to dress. Kim and I wrote a lot of songs together, and I got along with him real well, although I used to fight with him all the time. When disco started to get big and everybody wore big painter's pants with baseball caps, he wanted us to dress like that. I told him to fuck off. He did not push us around—we weren't puppets—contrary to what everybody believes. He liked the way The Runaways acted. He thought The Runaways could be the next big thing.

But as I reflect on it, obviously, he was trying to use the fact that we were girls. And we were too, to a certain extent. We wanted to shock people because we knew it was gonna blow

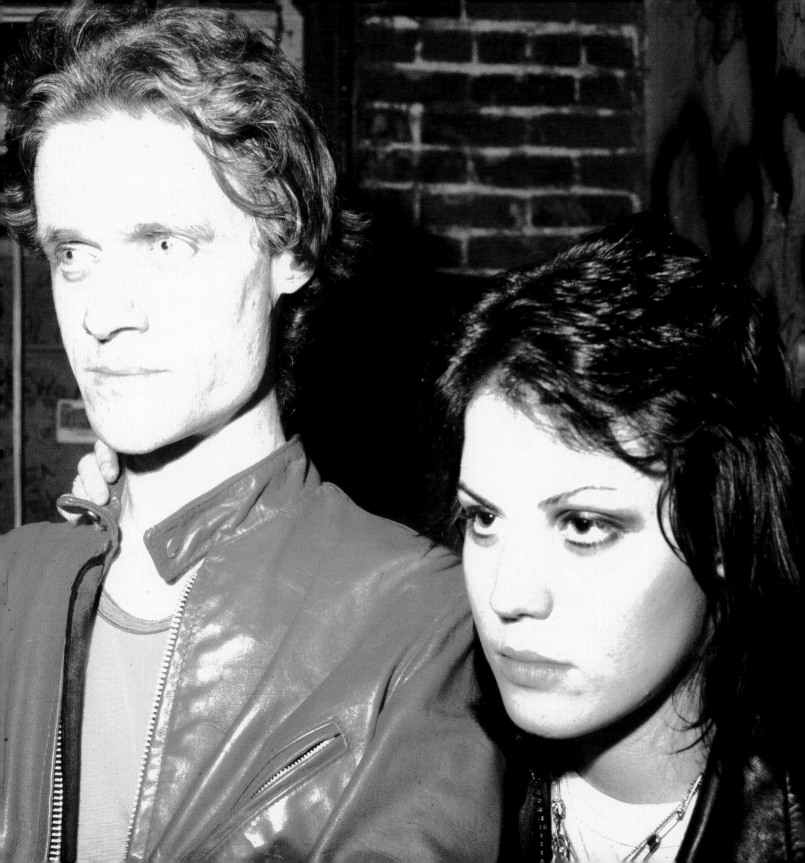

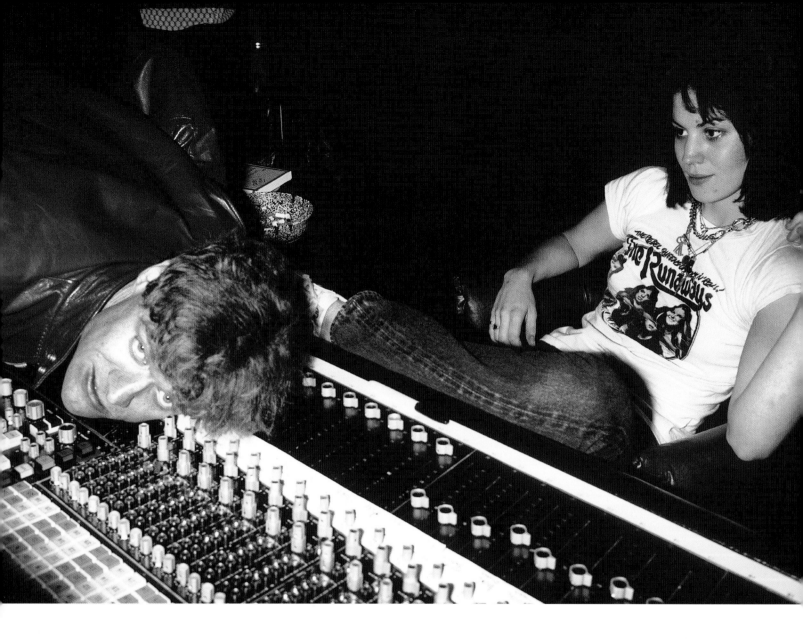

people's minds to see teenage girls play sweaty, hard, serious rock and roll. And it did.

When I see pictures of me and Kim, it just reminds me that Kim and I were friends. He taught me how to write songs. I think he saw something in me. And it was easy for us to just sit there together. It was very, sort of, stream of consciousness with him. I'd just grab my guitar and play stuff, and things would come up. I lived out in the Valley, so it was quite a hike to Kim's in West Hollywood. And The Runaways were pretty much, I'd say, a Hollywood band. So I used to stay at Kim's apartment. He had a two-room apartment, and I would stay in his extra bedroom. Eventually, Lita started stayin' there too because she lived in Long Beach I think.

My father never met Kim, 'cause my parents were separated by then, and he was sort of out of the picture and never really experienced that whole Runaways thing. I think he would have been horrified. So in ways it's probably better for his own self that he didn't. But my mother was very amused by Kim. I mean she thought he was hysterical; he didn't scare her. He

was very strange. My mother was the mother that would drive the other girls to Hollywood, or she would talk to the other mothers and try to convince 'em it was OK or whatever. Maybe she was kind of, I don't know, maybe living vicariously through me to an extent. But she was really into it. Granted, she didn't know a lot of the details that were going on, you know, what teenagers do and stuff. When I was still living at home, Kim would call her, and they'd be on the phone for hours. I mean if you ever have the chance to speak to Kim Fowley, you better make sure you've got a couple hours because you won't be able to get away. It's not like you can go, "OK." It's like one of those things where that's it. You're gonna hear it, and it's amusing. It's like watchin' a movie, kind of. I don't think Kim was a mean man. He could be mean, but all of us can be mean. He certainly was intense, and he had his own language. Things were on "levels." "You wanna do it on the rock-and-roll level." And everything had to do with "dog." He used to use the word "dog puck." Not that it meant anything, "Hey dogs." That stuff was real. I was totally amused by it. It wasn't insulting, and I didn't feel spoken down to. Because you can bet, if I felt spoken down to, I would let Kim know it.

So as we got started, we stayed outta Hollywood for a while 'til we were more rehearsed. We did a lot of shows out in Riverside County or down in Orange County.

And by this time, Cherie was in the band. Cherie joined the band in December of 1975. And by then, we were a five piece. We brought Kenny Ortega on board early '76, like January, and he came in to help us work out a little bit of a stage show. At certain points in certain songs, we'd come together and do movements together. At one point maybe Lita and Cherie might do something together. When I would sing lead, that would give Cherie time to go do a costume change. Pretty incredible to think that Kenny Ortega was working with us and all that he came to do.

Kim did funny things, like he had people throwing stuff at us. We did what he called a heckler's drill, and this was real. We had to be ready so we would not be surprised and taken aback if somebody threw somethin' at us. Now when I say, "Throw somethin'" I'm talking about McDonald's cups, stuff like that. Just to get used to what it's like in a rowdy bar and not to be taken aback. And to, you know, attack. That's not attack in a bad way but to attack the crowd, to keep control.

So we talked a lot about strategies and stuff like that, but it was really about the music. It wasn't about this sexual element. Most of the time people focused so much on Cherie's corset, I mean that was for one song, 'Cherry Bomb.' And for the rest of the show, she was in either a jumpsuit or jeans and a T-shirt. It wasn't about showing skin a lot, it was about the music.

But girls have to be allowed to be sexual, too, because they are. And it's wrong to say they can't be and that they can't own it. It's something people don't accept. I thought, certainly, in the liberal rock-and-roll world, it's not gonna be a problem. But it was a big problem. And I always ran into it. It was constant and still is. Now, even to this day, all these years later, a girl with a guitar, a girl owning it, is very threatening. They always want you to tone it down. In the early days of The Runaways, our audience was 99 percent male. I think they were all standing there wondering when we'd take our clothes off. They'd never seen anything like girls playing rock and roll. We put it right in their face, man.

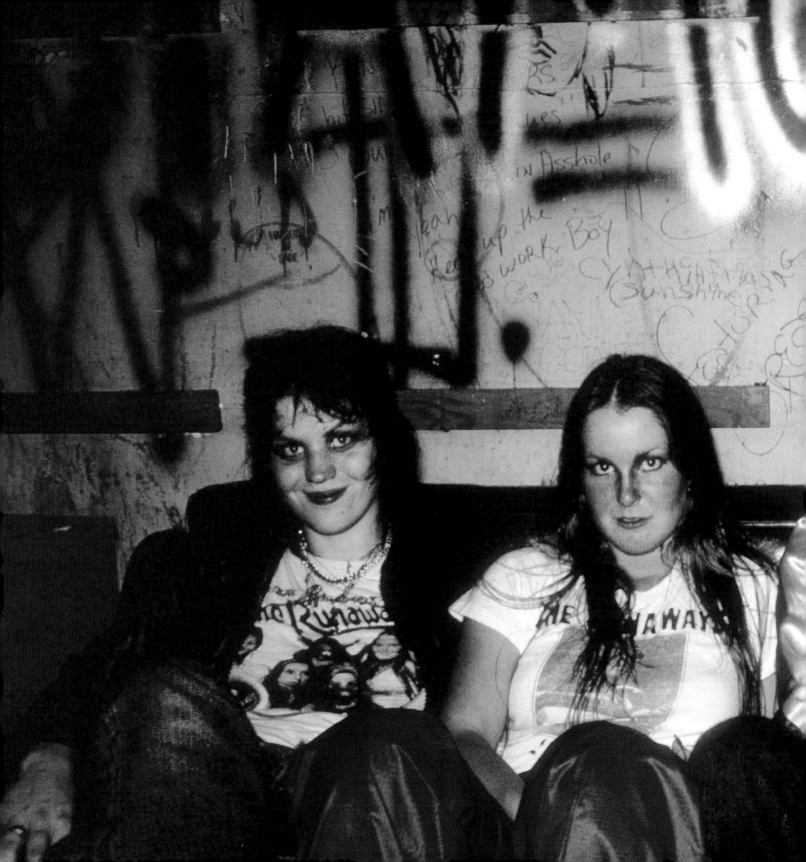

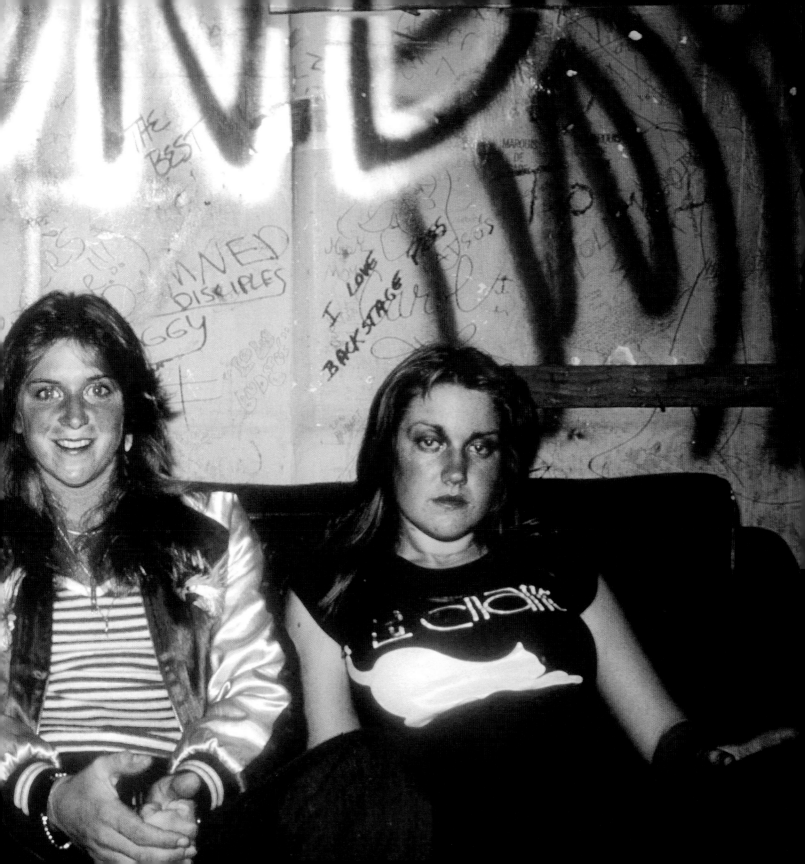

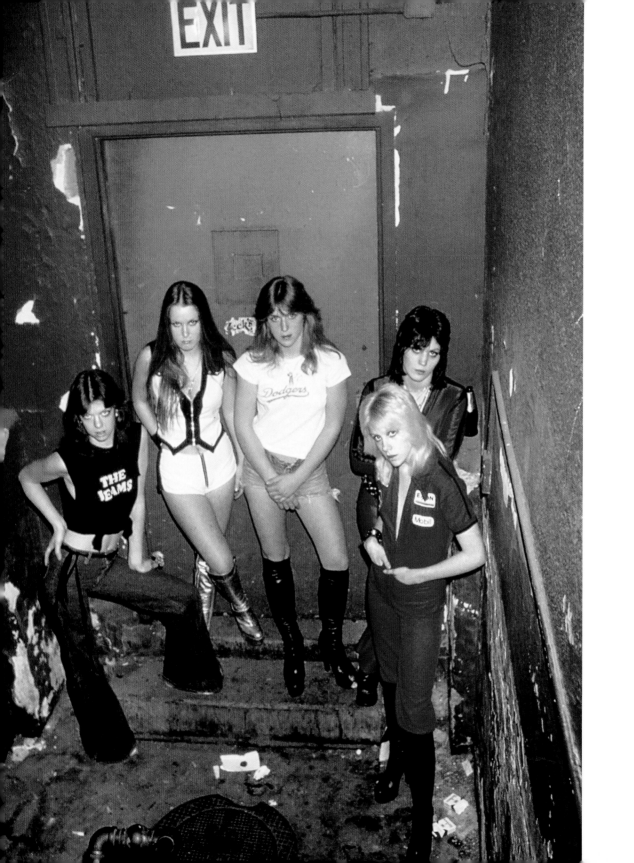

"WE DIDN'T HAVE TO DO ANYTHING TO FREAK PEOPLE OUT.

WE JUST HAD TO SHOW UP."

— 2010

The Runaways became a staple on the Sunset Strip, and as my apartment was right across the street from the Whiskey a Go Go, all my friends would hang out before heading out for the night. My apartment was party central. We'd go see Blondie, Devo, The Cramps, X and others that were playing the local clubs. I can remember Billy Idol of Generation X coming over to my apartment before a Whiskey show.

I got into punk right away. The Runaways were lucky enough to go to England in 1976, so we saw all these people when they were hanging out at the clubs. I got to see The Clash; I saw people pogoing when the United States was just reading about it.

One day, Lita and I were down in Kensington High Street. Some kid came up to me and he said, "You in the Runaways?" and I said, "Yeah." And then he started talking about, "How come you don't dress like we do over here? How come you're playing the Hammersmith Odeon? Why aren't you playing any clubs instead?" I said, "Look, we've been playing clubs for two years." And he said, "But there's no atmosphere at the

Our jumpsuits were made for us. We did design some stuff. I mean kinda, I talked it out. I don't know if I sketched it out or anything. But I knew what I wanted. I couldn't have black because I think that would look too much like Suzi Quatro because she wore black jumpsuits. And I didn't want anything light because that just wasn't my thing. And Cherie was gonna do silver. So I did red. —2010

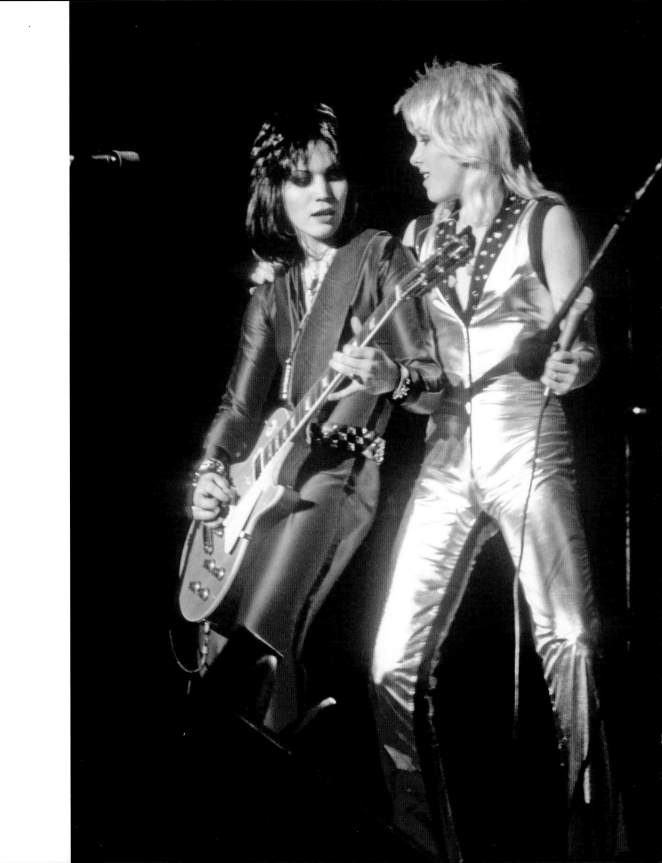

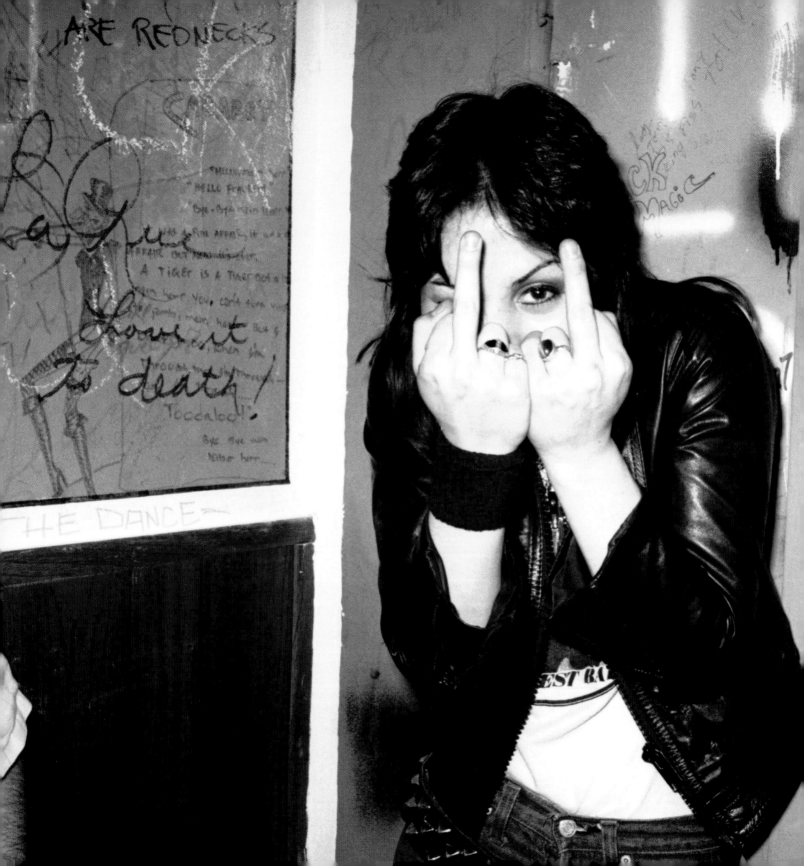

"WE'RE GONNA GO BACK UP TO NEW YORK AND KICK SOME ASS AND SHOW THEM ALL WHAT ASSHOLES THEY ARE."

—1981

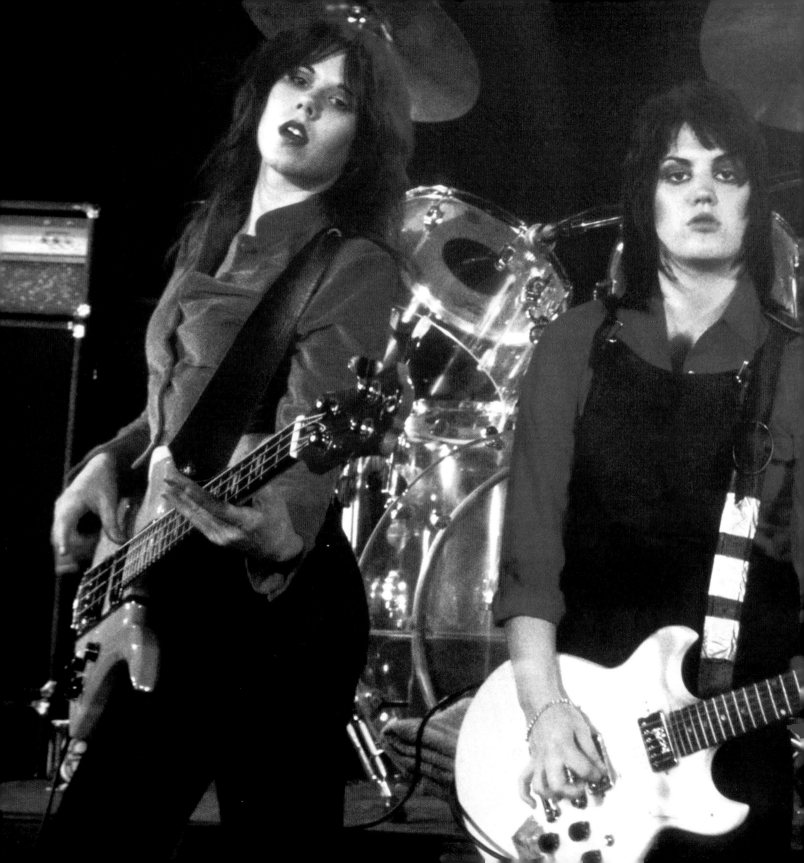

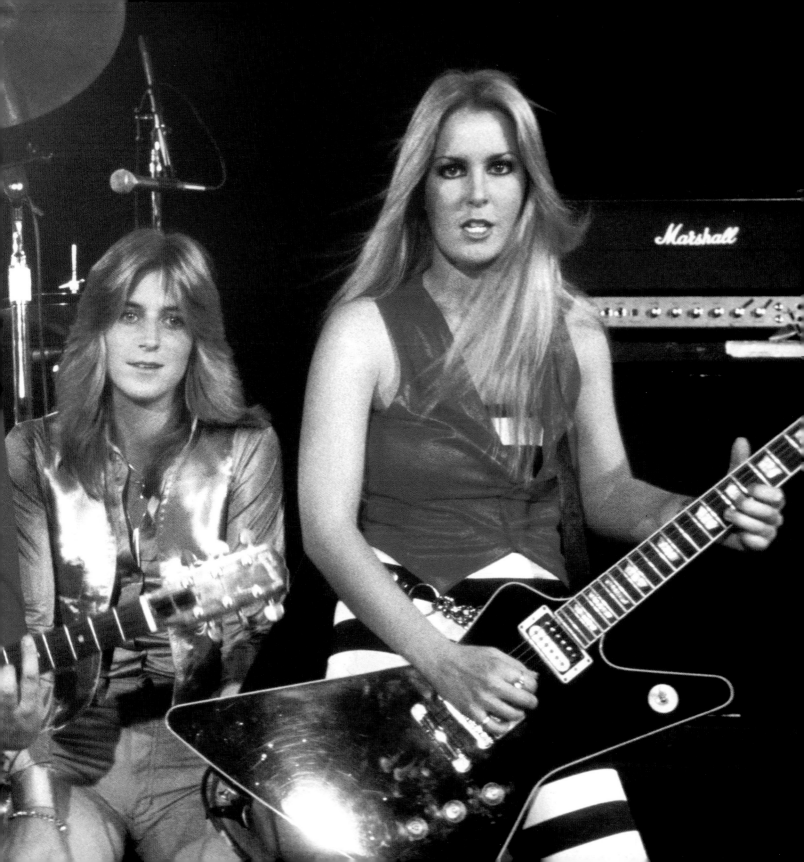

Hammersmith Odeon." The way I feel is, in anyplace, it's the band that makes the atmosphere. If the band can generate the excitement and get the audience off and the audience gets the band off, you're gonna have a great time at the Hammersmith Odeon, I don't give a shit if it's big.

When we were in London or something, we would throw this big record company Runaways party, and everybody showed up, you know. It was one of those things. So I met the Sex Pistols there. After The Runaways broke up, I wanted to do some recording, and the Sex Pistols were like my favorite band. I mean the drums and guitar were incredible, so I just said, "You wanna play on this, you wanna make a couple bucks and stuff? I'll let you produce it." And they said, "Yeah," and we had a fuckin' great time. It was really good. They were very professional. A lot different than people think. They think, "Oh, Sex Pistols! Fuckin' Sex Pistols, they go in and fuck around." But they're real professional. I mean, Steve Jones was like adding tambourine and saxophone, and I'm going, "What are you doing?"

Two of the songs wound up on *Bad Reputation*: 'Don't Abuse Me,' and 'You Don't Own Me.' Innocent, that's the word for

Sid Vicious; he was like an innocent little boy. The Runaways lived on a houseboat on the Thames for a while, and Sid and Nancy came over one night, and they seemed very high. He was yelling: "I'm violent! I love violence!" I'm not usually the one to complain about noise, but I finally said: "**Shut up**! You damn junkie!" He stopped shouting and started crying about a friend of his who had just died. He said he was on a methadone program and kept telling me that "The Sex Pistols love Joan Jett." He went out the door, and that was the last I ever saw of him. It's so sad. I guess it's a case of, "The strong ones make it."

In Japan, I really understood the girls. I was shocked at first because we didn't expect the response we got. It was literally like The Beatles—thousands and thousands of girls in the street and at the hotels and at the concerts, and screaming! It was crazy, but they were very polite. They'd give us combs to comb our hair, so they wouldn't rip our hair out. We were heroes to them because we were speaking up for 'em.

In Scandinavia, we had the same response. In Sweden we got off the plane and there were thousands of Swedish girls with

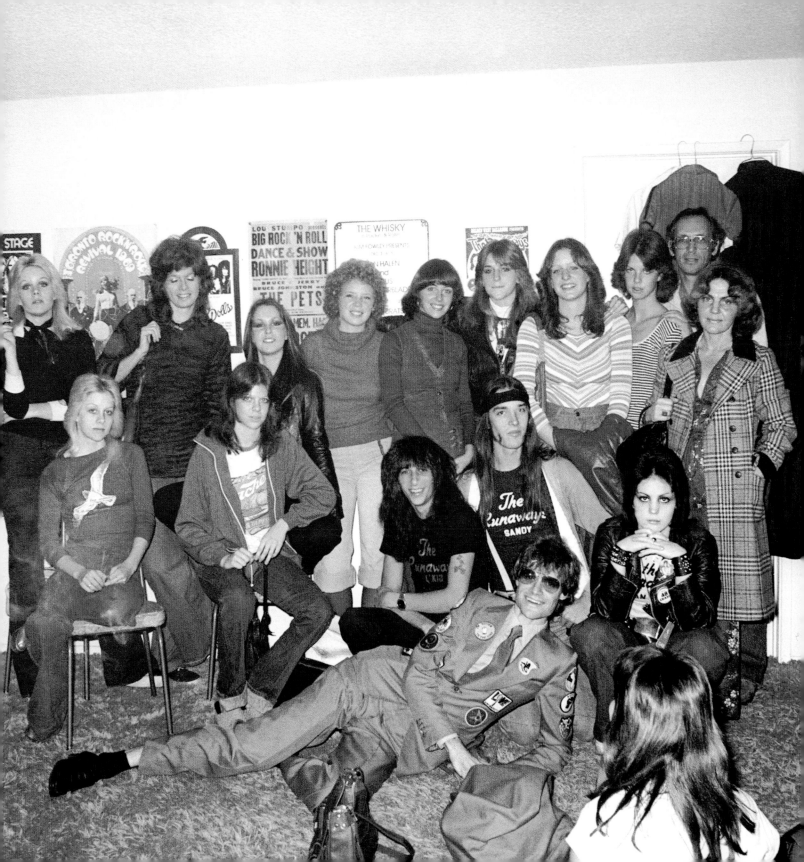

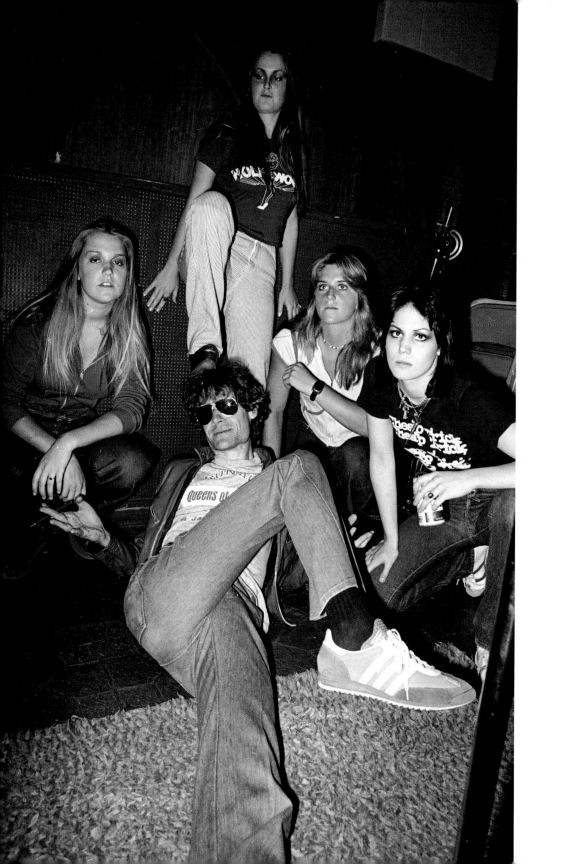

pacifiers in their mouths, real pacifiers. Must have been a fad or somethin', I never found out what that was. But, I'll tell you, that fucks your head up. You get off a plane, see a lot of gorgeous Swedish teenage girls sucking pacifiers. That makes some weird rock-and-roll thing go on in your head at that point, you know? The silver pacifier that I have on in some pictures I wore for years. I found it in some shop in Europe somewhere. I had to get it—sort of a memento from that time.

Because I thought, "People are gonna freak out, man! People are gonna die! They're gonna love it!" I was really confused when they didn't. All I can say is that somehow it's threatening, but I don't know what that threat is. We're just trying to play music. Of course, there are always messages behind music, you're always saying something, but on its face, girls playing instruments was a problem. I would hear, "Girls can't play rock and roll." What do you mean girls can't play rock and roll? Do you mean, they can't master the instruments? Girls are playing cellos and violins, playing Bach and Beethoven. What do you mean they can't? Rock and roll is very sexual to me. It might not feel that way to a lot of people, but to me it's sort of an aggressive, sexual thing. I think of the album covers like *Sticky Fingers*. You got Jagger's crotch with a zipper that opens. And it's kinda hard; you can see the shape of the penis. Or Robert Plant and all those pictures of him standing with his shirt open and the mike right there. I mean it's just a sexual thing, that's how I took it. It's about saying, "I own it, and this is what I'm gonna do to you." Girls aren't allowed to do that. But you see, I'm the other way around. I'm not asking permission.

Where are all the girls with guitars playing rock and roll? They're out there. They're in every city; they exist. With technology now, a struggling band can build a Web site, get a MySpace page or whatever, and get a lot more people to hear their music than what The Runaways were able to do initially. I think today you do have a way to get your music to a lot more people. But what is the goal? To have a hit record on the radio used to be the thing. There was a finite goal you were shooting for; you knew what it was. But for now, I mean where are you shooting? Are you aiming for the radio? Are you aiming to get your song on a TV commercial because that seems to be the new radio? Before, you could have regional hits. The radio stations

"I FIGURE I JUST
COULDN'T HAVE A
NICE QUIET JOB BECAUSE
I'D PROBABLY FREAK OUT.

WHAT ELSE COULD I
POSSIBLY DO WITHOUT WINDING
UP ABSOLUTELY INSANE?

THAT'S THE WAY I FELT
WHEN I WAS YOUNGER,
THAT'S THE WAY
I FEEL NOW."

—1981

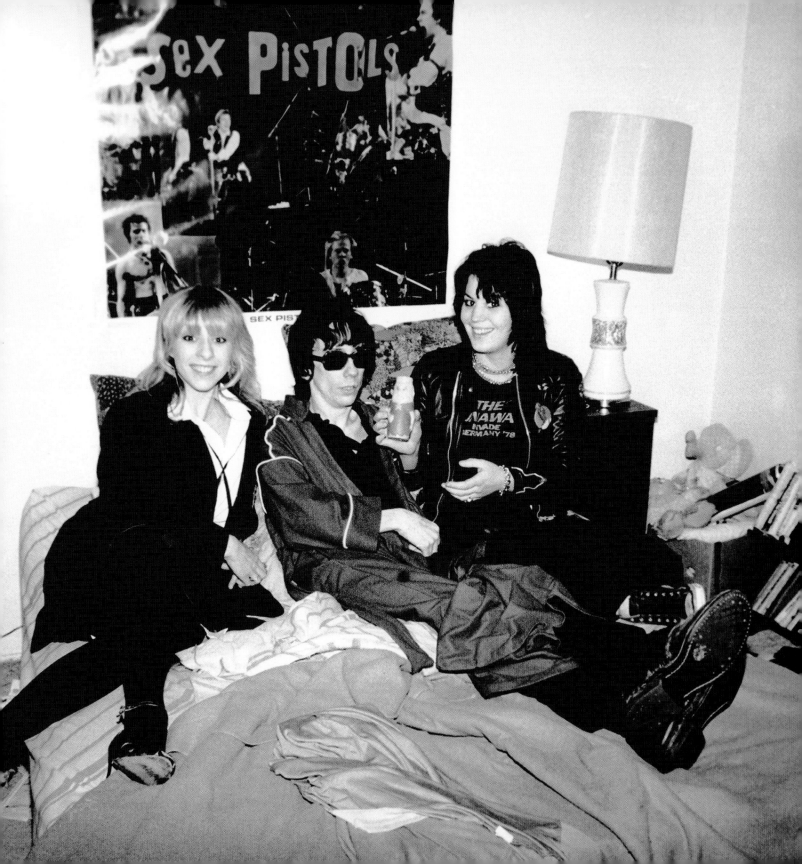

listened to what the fans requested. You actually could get your record played if people wanted to hear it. And that was the way 'I Love Rock 'n Roll' was really broken in the northeast. A lot of people called up and requested it, and the radio stations listened. As it heats up in one area, it spills over to the next area because they're close to each other. And it snowballs. And all of a sudden, you've got this regional northeast hit. Now, you don't really have that because fans don't have a place to call up and say, "Hey, I wanna hear this band!"

It's just a whole different context of the way an artist is brought up. I mean, a lot of kids now think the way you do it is with *American Idol*, that sort of instant success. And people become famous, and they go on, and they have a career. But they don't have the background because they haven't done the years of struggle on the road, which is so important. What I would say is, don't go that route. You know, you need to do the struggle. If you're not willing to do that struggle, then this is definitely not the gig for you.

For me, The Runaways really was my dream. I think for Sandy it really was her dream. For the other girls, I don't think it was

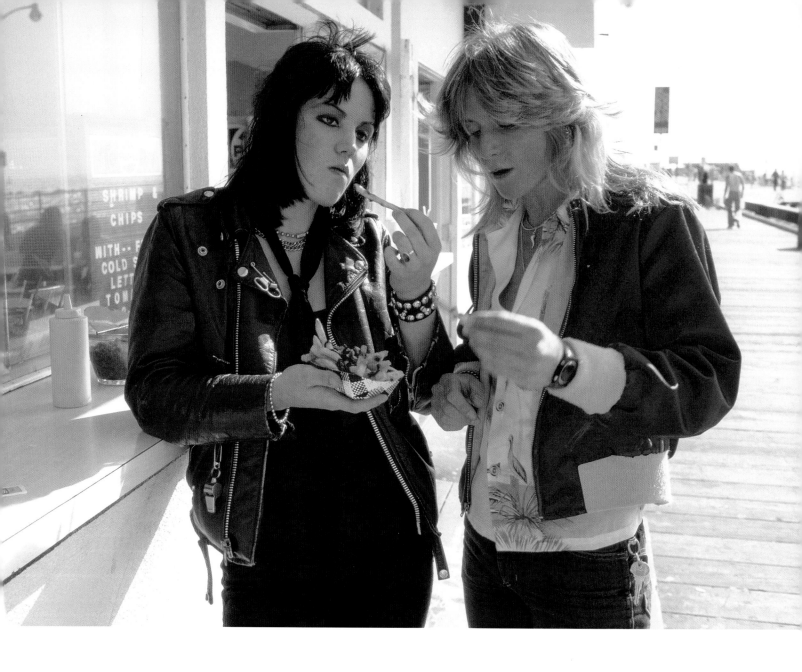

their ultimate dream for life. I think it was fun to a degree, for them. The way I look at it is everybody bailed on it. Jackie Fox quit, then Cherie left. Because she was very popular in Japan, I think that she had visions of leaving and doing her own thing. And then we were a four piece and went on like that for a while. I was always tryin' to make peace between the girls. It was like our high school; everybody was always fighting, always about stupid stuff, me included.

At the end we did an album with a producer named John Alcock who did sort of hard, heavy metal stuff. I was kinda more into the punk rock vibe. But to me, my punk rock, I was playing rock and roll. We were playing the same kinda music, it's just mentally I was in punk rock. Sandy and Lita were much more into sort of heavy metal stuff.

While we were hanging out doing this last album, I think the producer gave the girls the idea that they might be better off—I mean this is just me guessing—without me. They could be the singers then; they could write more of the songs. And he could produce, and they could do like a heavy record. And I could really sense this and was feeling really on the outs. I

thought, "I am not gonna get fired from a band that I started. So let's just end this fuckin' thing." I think our last show was New Year's Eve 1978 into '79 in San Francisco. And that was it. It was not fun anymore. It was not at all what it started out to be. We just weren't all on the same page.

I had so much fun in The Runaways. I really loved it. I mean, there were definitely a lot of tough times, but we had a real, sort of, family feel. We were all in it together, and we knew we were doing something that was shaking people up because people were really hostile. A lot of the press was really hostile, and I couldn't understand it, why they would be so… mean. It wasn't like we were killing people; we were just playing rock and roll. They said, "You shouldn't be doing this," and "That's not ladylike." You know, "You're supposed to grow up and have kids," and that totally set me off. We got a lot of slut questions. We got tired of being asked about sex. A writer asked me once, "Are you guys ever really cherry bombs?" I just said, "When we're not too tired." We didn't have time for that shit. "Do you feel like a man or a woman when you're on stage?" Those were the kind of questions I'd get. "Do you think, when men play guitar with male skin, and females play guitar with

female skin, do you think it sounds different?" It would make my head spin, I swear to god. They were all serious journalists from serious publications. It was ridiculous.

At interviews I waited so long for the questions to come about the music. They'd look me in the eye and say, "What the fuck are you doing, don't you know girls can't play guitar?"—so condescending, so matter-of-factly. I'd get really angry; we'd throw people out of our hotels. I was lucky I didn't have any heavy artillery on me. The Runaways were really degraded by the press. If we were a guy band, nobody would even turn their heads. It was just the fact that we were girls. We took a lot more shit than people will ever know. The meanness started coming out in people when they realized we weren't gonna go away. The press tried to humiliate us, to make us say stuff to look really bad. I remember once in Chicago some writer came into our hotel room and already had the article written. I don't know how it came about, but he was asking us what we used to do before we did this, and we were joking around and said something like "babysitting" and things like that. The guy started saying, "Well, what did you do when the kids would start crying?" and we said, "Slap their hands." The next day,

the headlines were "Baby beaters." It was incredible. If you're 16 years old, and someone says your band sucks, it's, "Where the fuck are they? I'm gonna beat the shit out of 'em!" And that was my attitude, and that's how I got my "bad reputation." I didn't take any shit. It was frustrating more than anything, but all the experiences were great. We got to see the world. I learned a lot through those experiences, and I would do it all again. I'd go through all the bad stuff too.

The Runaways were five suburban girls who represented basically what teenage girls were like in America, and people didn't want to know. Mothers and fathers did not want to hear that their daughters smoked and drank and entertained thoughts of sex. We were just telling the truth, and we got nailed for it.

When The Runaways first got together, we were pioneers—there weren't any other women playing hard rock. A lot of people want to put us down and make fun of what we tried to do, but I'm still proud of that band. There aren't too many groups that can say they really started something—The Runaways did.

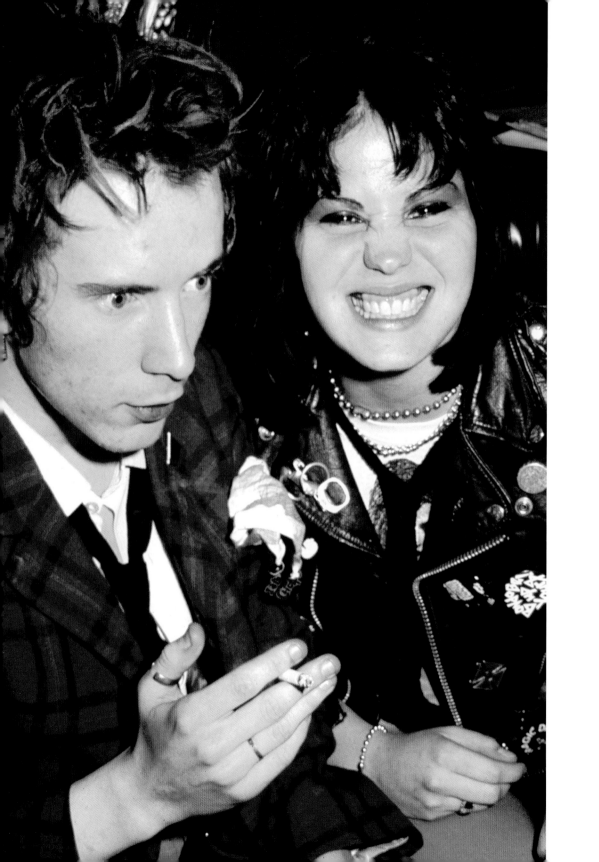

I'm extremely humble because a lot of people I respect in music like The Runaways and what we did. They're not necessarily specifying if it was the music that turned them on, but it is the fact that we did what we did. Look, you don't have to love the kind of stuff we did, you don't have to sit and say how good our music was—I understand. The point was that something was done, something that made people freak out.

The Runaways were very serious, believe me. We weren't out there to mess around. More than anything else, we wanted to be the next big long-lasting band. We weren't amazing musicians, but we played definitely equal to a lot of bands. The Runaways was a learning experience. I think most of all, we just gave women or girls the idea that, "Hey, if she can do it, I can do it." Sometimes people overlook how important it is to have a goal. The Runaways gave a lot of girls goals. I think that's probably the main way The Runaways inspire people.

Sandy West has since passed away. She passed away in 2006 of lung cancer. I'd seen her pretty much yearly for the past several years, and I saw her weeks before she passed away. What a tough life. She was in and out of prison a lot of her life, which is for me just unbelievable to think. She was livin' a lot of the stuff we sang about. But you don't really wanna have to live it. It was more fun to sing about it. I believe Lita got married and was living in Florida for years. I think she's startin' to do some live gigs again. Cherie's done so many things after The Runaways. She did some acting. She was in some big movies like *Foxes* with Jodie Foster and other things. She was married to Bob Hayes, the actor. She has a son named Jake, a great kid who's now in a band. She did a lot of things. I think she became a drug counselor for kids for a while. But what I know she does now is she's a chainsaw artist, which sounds weird, but she makes statues out of wood with a chainsaw. And they're beautiful. I had no idea that she had this sort of talent to do something like this. I mean singing and then making three-dimensional art are two different things. And she's doin' it with a chainsaw! She carved a tribute to Sandy West that they mounted at a music store in California. She's writing a book about her life. It touches a lot on The Runaways and is what the movie *The Runaways*

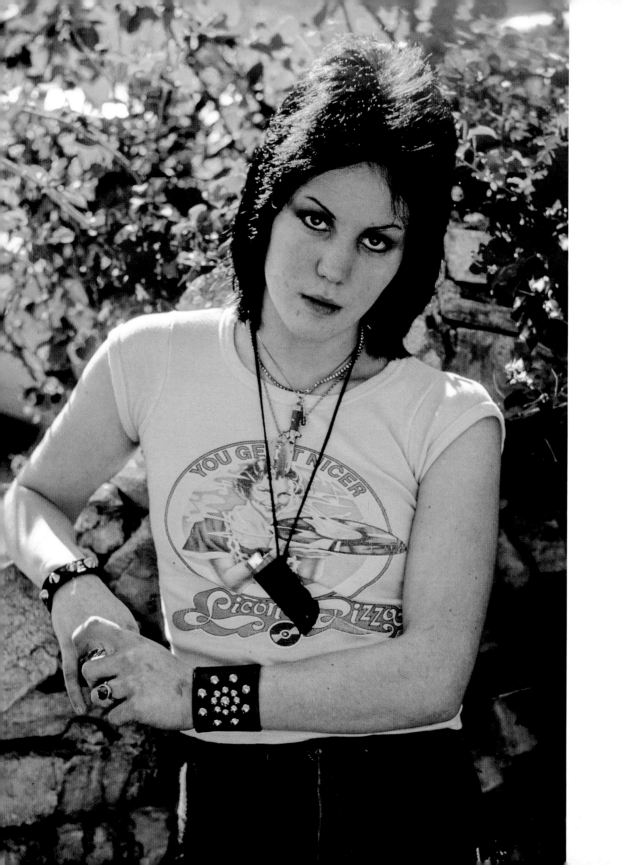

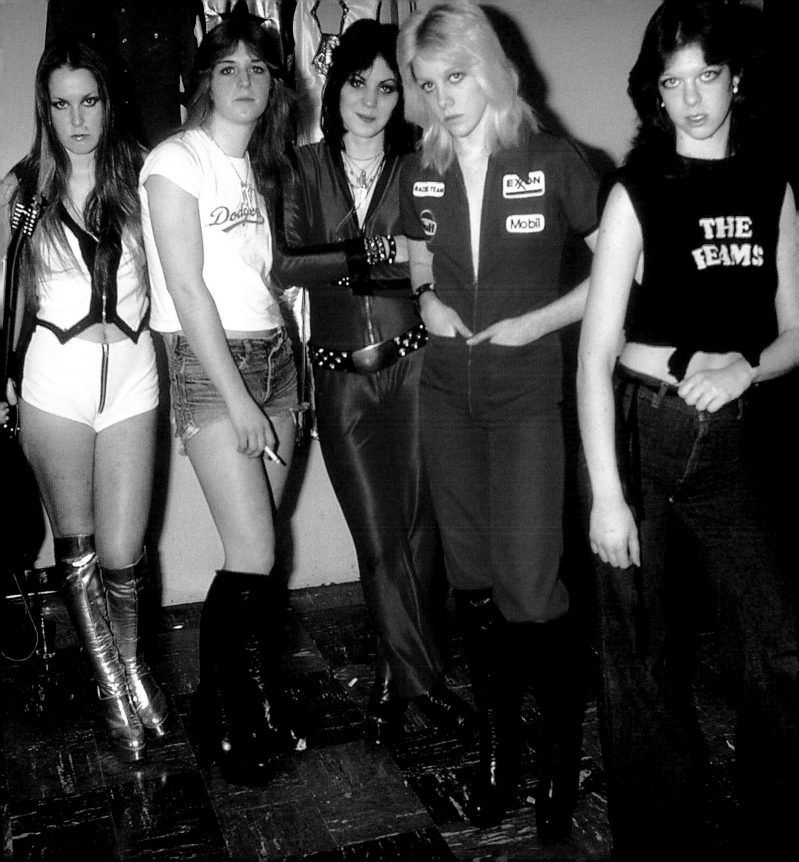

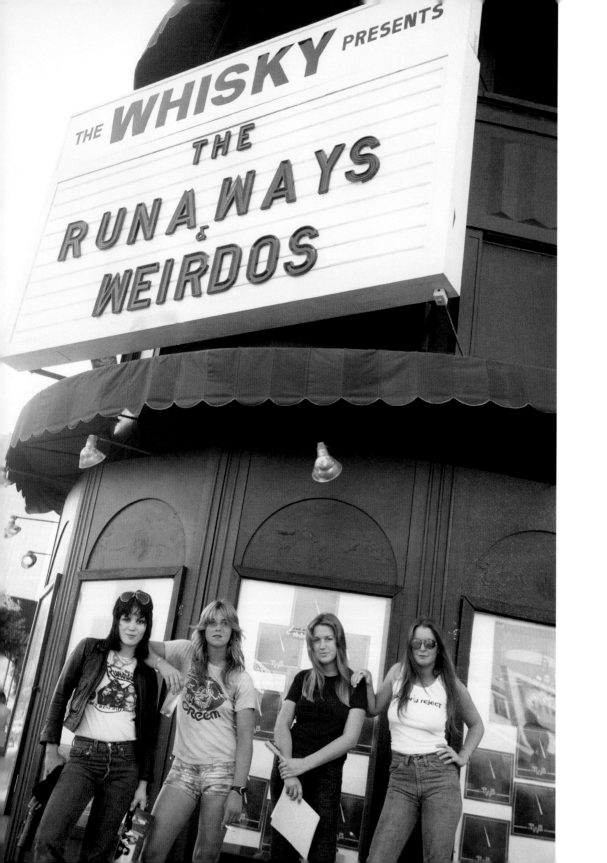

was based on. I can't imagine Kim ever really retreating from the business. He has continued writing songs and producing people and making his own records. He moved out to the California desert for a while. He looks pretty much the same. It's the same guy. It's amazing to be with him because, for me, it's like no time has passed. When I sit down with Kim, it's like I have nothing but really warm feelings.

I guess it had to be like it was, and it had to end how it did. And it had to go through its growing pains and be just what it was because anything else, it just wouldn't have been The Runaways. We couldn't have really gone into our twenties being The Runaways because it doesn't work energetically. How can you be in your twenties and be a runaway? It doesn't make sense anymore because then you're legal and you don't have to run away anymore. It had its time and its purpose, and I think even its destruction and disillusion kind of happened in a perfect way.

It wasn't too much too soon for me, I think it was too much too soon for the music industry. We were living out our fantasies, and I had a good time.

I've heard from the women in the band L7 that The Runaways had an effect on them. They thought we were a cool band. I'd say that Kathleen and the others in Bikini Kill feel that same way. If we inspired anyone to form a band, that's really nice. I really feel that I'm here to just tell people to follow their dreams; you gotta go for it. You can't let other people dictate your life.

5

KENNY
HAS BALLS
JOAN ON KENNY

After the band broke up, I wasn't doing too good. I wasn't playing. I had no band. I was just hanging out, you know. I did have a project to do. The Runaways agreed to do a movie and to write the soundtrack. And then we broke up. So I was afraid that if I didn't fulfill this contract, I'd be the one to get sued because I was really the main songwriter. I just didn't know what would happen if I didn't do this. I'm thinking, oh man, I can't really get sued. I got nothin' to get sued over. I don't wanna be on the street, so let me just do this.

The Runaways made no money. Nothing. Nada. For a whole year afterwards, I was really poor. I mean penny roll and you-ate-yesterday-so-you-don't-need-to-eat-today poor. But I couldn't ever bring myself to go into a Jack in the Box or McDonald's and get a job. I was very depressed. I wanted to be in a band on the road; just sitting there in Hollywood doing nothing was driving me crazy. Compound that with heavy drinking, and it wasn't a very thrilling picture. Luckily, I met Kenny Laguna.

My manager at the time, Toby Mamis, knew Kenny Laguna.

(Actually, Kenny was almost gonna produce the previous Runaways album but didn't.) He was already considered a veteran in the business. Kenny had worked or played with lots of bands like Tommy James & The Shondells, Edwin Starr, Tony Orlando, The Ohio Players, and more. He knew that Kenny was a songwriter and he could come out and write with me, and that he was also a producer. I trusted Kenny pretty much right off. I don't know if I was just dumb because I was destitute and so scared of everything, or if it was real. A lot of people compare Kenny with Kim Fowley, and they talk about Svengali. Kenny's my friend. Kenny's my manager now. He was never intended to be a manager. It's just that nobody wanted to deal with the manager and all that shit, so I asked him to manage us, too. I felt comfortable with him; he'd been a musician, he knew the deal, and we just connected. We had to write like eight songs in a few days. I really thought he was funny, and his New York attitude cracked me up. He intrigued me, and I guess he saw something in me, too, 'cause he gave me some money, dragged me to the store and told me to buy another pair of jeans and a shirt. I can't imagine why.

And so we wrote these songs, and I fulfilled my obligation to the movie. We actually did film the thing, but it never came out as it was supposed to.

Kenny and I immediately hit it off and found we both had a love for the British "glitter" sound, which hadn't really caught on in the United States. Kenny took me to England, where we recorded my first solo LP, originally called *Joan Jett*. He was able to place the record with a European company, Ariola, and with my old Scandinavian company, PolyGram. In the meantime, he bought back the original Sex Pistols version of 'I Love Rock 'n Roll' from the Dutch Mercury Records execs for $2,300.

We couldn't place the record in the U.S., but soon it was the number one selling import in America. Kenny, being the resourceful genius that he is, decided we should print the records ourselves and mark them **IMPORT**. Kenny and Meryl had to use their baby daughter Carianne's college fund and money borrowed from this guy Marty, Kenny's old comrade from Jay and the Americans.

"KENNY."

"WHAT, JOAN?"

"SHUT UP!"

—1983

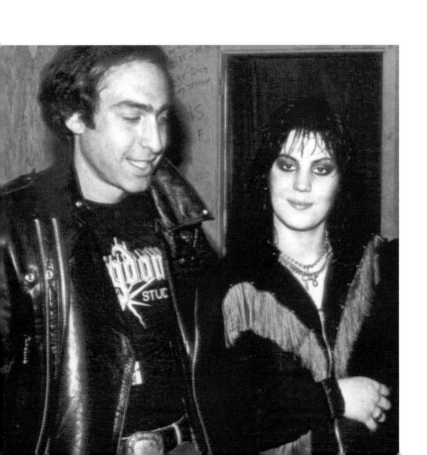

Soon, we were selling more records than we could afford to manufacture. We would keep them in the trunk of Kenny's big Caddie, stopping at stores as we went around doing our bar gigs. We were becoming so popular in the Northeast that the police were closing highways when we played! Still, we couldn't get a record deal; yet, Kenny and Meryl had this unshakeable faith that we would have hits together, and the more the industry rejected me, the angrier and tougher they got.

We started doing small gigs in New York. *Bad Reputation* kept selling out of the trunk of our car. And the next thing you know, it was way sold out, like the concerts were. But we still hadn't been signed by a major label. Twenty-three labels said, "No." They were completely opposed to signing me.

Finally, a guy named Neil Bogart, who was known more for disco, decided to sign us—for a challenge, I guess.

I should mention that Neil changed the name of the album to

Bad Reputation without telling us, which flipped us out, even though history has shown that that was a pretty cool move.

I'm not a real business-type person. I go completely on my instincts, my gut-level feeling. Stuff that feels bad to me, I don't do it. No matter how much people say, "Are you crazy, you could get so much exposure," if it doesn't feel right to, I won't do it, and it usually works. The same is true with Kenny. It's a very instinctive, gut-level, combat-unit family.

Kenny has balls. So many people don't have balls anymore. Everybody else said, "Forget it, Joan Jett can't do it—no way." We fought; we said, "Fuck it, if people won't take us this way, we'll do it that way." We fought because I wanted to play, I wanted to be on the road and Kenny wanted it to work. For some reason he believed in me, he saw something in me. Kenny and I are so much alike and we fought, we fucking fought. And we did something that no one in the industry is going to forget for a long time. A good right to the ribs!

WHOA.
WHAT IS THIS?
KENNY ON JOAN

Joan had a manager who was publicist for one of The Who's
bands, and he was nagging me to meet The Runaways. As The
Runaways were startin' to pull apart, I was gonna go up to visit
them in Amsterdam. I went down to the lobby where we were
meeting, and I saw this guy, Matthew Kaufman, who was a presi-
dent of Beserkley Records. When I said, "I'm goin' up to an
interview to produce The Runaways," he said, "Oh, they lost
their best person, Cherie Currie. They're finished." So I went
back to England. A short time after that, the manager of The
Runaways called me and said all hell was breaking loose. The
producer and two of the members were gettin' high, and it was
fallin' apart and could I come and finish the album? But by then,
I didn't want that job. You know?

In England I worked in The Who's studio; I used to fill all their
dead time in the studio and produce records and then share the
income, which was usually nothing. I'd make anything I could
think of—just singles and make up names of bands. And I get this
call again; he says Joan's in California and that The Runaways
completely have broken up. And there are six songs owed to
a movie company in eight days, finished, or they're gonna sue

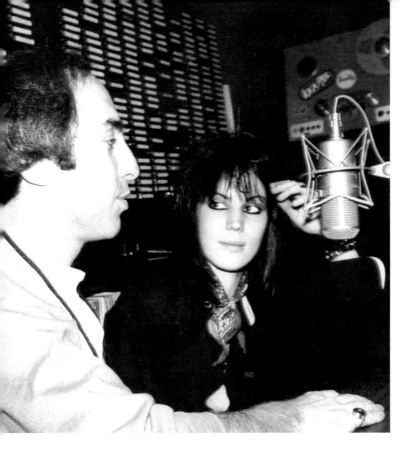

The Runaways, which is basically Joan. The rest of the girls, as teenagers, they ran away.

Meryl, my wife, was the one that said it to me, "I've been reading about Joan Jett. I think she's a significant individual. You should go and meet her." So, I flew all the way from England to California. And she walked in the room; it was a great look. She was beautiful. I was just, "Whoa. What is this? You know, so different." And so, we started writing. And I dug her a lot. And then we went in the studio. At first I said, "We'll just cut these tracks. And you can put your guitar on later." And she goes, "Oh, no. There ain't gonna be a record if I'm not playin' on a basic track." And I'm going, "Listen, I'm here to save your ass. How can you be talkin' to me like this?" You know? But she was Joan. And she was like, "I don't care. I'm not makin' a record that I'm not playin' the main guitar." So, I thought it was impressive that she stood up to me.

We wrote the song, 'You Don't Know What You've Got,' and when she goes, "Oh, baby," she did it with such reckless abandon that for some reason it connected me with Darlene Love,

who I worked with for 15 years. Darlene is considered one of the best singers in the world; she's just got this ability to let it all hang out. Darlene, to me, wasn't white, wasn't black; she could have been 16, she could have been 40. It was like she was O-Negative. Like Joan, just this pure thing. Which is why I think even R&B people like Joan. She's had two R&B hits. I love her. She's one of those. And she had that New York thing or whatever it is, even though she wasn't a New Yorker. She just had that thing. That thing makes rock-and-roll people. And rock-and-roll chicks, which is even more real, you know? And that day I knew we were goin' over the hill.

So I thought, "We're gonna start a company and make Joan a partner." I told this to a friend of mine in the industry, and he said, "What's wrong with you? You're gonna make an artist your partner? You're gonna pay an artist? Are you crazy?" That's what was goin' on in the industry. So, in the end, he died a bitter guy because he got left out. So, Joan became a partner. Jett Lag, that was our company. Then I said, "Look, let me help you get a record deal. I'll help you finance your first album, if I can do the next album." That's really all I wanted because what's lousy

"MY DAUGHTER, CARIANNE, WROTE FOR HER COLLEGE APPLICATION ESSAY:

MOST KIDS GET A DOG.
I GOT A ROCK STAR."

—KENNY LAGUNA, 2010

about being an independent producer is you got a hit record and then, you know, you don't get the next one. It was nothing personal, that's what happens, they just cut the guy out. So we went to England to record at The Who's studio. The studio wasn't a problem. They didn't care if I paid the bill or not, pretty much because I had this arrangement with them.

Joan had this manager that was a little league guy. He called me. He had invested like $4,000 and it was freaking him out that she might kill herself with drugs before the $4,000 was up. And this got back to Joan, and she got really upset. So now there's this rift with the manager. And I didn't ever manage anything, except myself, and now this mess is happening. I said, "Joan, you're gonna move to New York," and she came and slept on our couch. And we just kept going around and around playing. We were on these tours in the Northeast, where we could drive there and get back home in the same day to save dollars. Eventually Iggy Pop took us out. And we'd go further. And all of a sudden, wherever Joan plays, they're closing highways miles away. It was like Woodstock wherever we were playing, and we still couldn't get a record deal.

So we put out the *Bad Reputation* record on our own. And it just kept gettin' bigger and bigger. So finally, one of my buddies, Neil Bogart, said, "You go with me. I like this. Joan could be a star." He started a new company called Boardwalk Records. And we did this joint venture. His wife, Joyce Bogart, is a brilliant lady. She managed Kiss and Donna Summer. That's how they met; they were a real love affair. Joyce helped us too.

The reason we are still around now is that I think that we were lucky that the songs that we did have an incredible staying power. There are actually 17 songs that charted one way or another. Seventeen. But I look at four of them as being so iconic that it helps keep us in the game. The other thing is Joan's integrity—her natural persona and her natural ability to know who she is. She sure made me look smart.

September 5, 1980

Ken Laguna
750 Shore Road
Long Beach, New York 11561

Re: <u>JOAN JETT</u>

Dear Ken:

Thanks for the chance to hear Joan's lp. I am quite
familiar with her and although I like the tunes and
production, I didn't feel strongly enough about her
vocals to make a commitment at this time.

Thanks again for the opportunity to listen and best
of luck with her.

Regards,

David Kershenbaum
Vice President, A&R

DMK/dmw
Enclosure

THE NATIONAL ACADEMY
OF
RECORDING ARTS AND SCIENCES, INC.

presents this certificate to

JOAN JETT & THE BLACKHEARTS

in recognition of

NOMINATION

for the

BEST ROCK PERFORMANCE BY A DUO OR GROUP
WITH VOCAL

"I HATE MYSELF FOR LOVING YOU"
(Single)

© NARAS

for the awards period
1988

ALFRED W. SCHLESINGER
Chairman of the Board

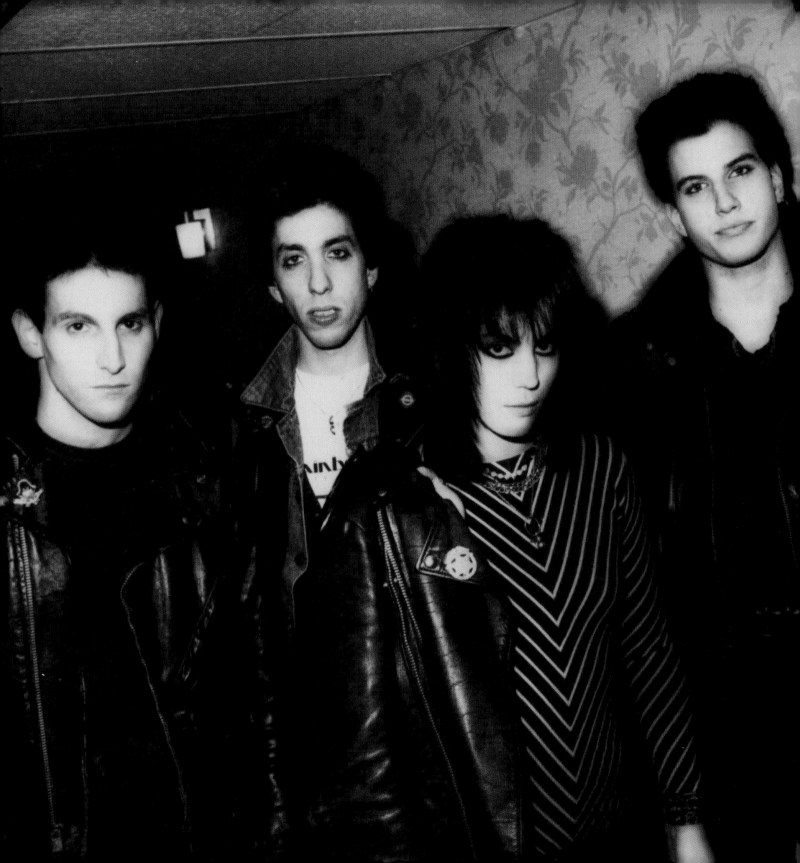

WE PUT OUT AN
AD THAT SAID:

"*JOAN JETT IS
LOOKING FOR
THREE GOOD MEN.*"

7

THREE GOOD MEN

We put an ad in the paper that just said, "Joan Jett is looking for three good men." I specifically wanted men because I didn't want my first band after The Runaways to be compared to them. I took so much shit—and I felt the Runaways were so important—that I didn't want the critics to say, "Oh, she's in another all-girl band." I didn't want to take away from the importance of it.

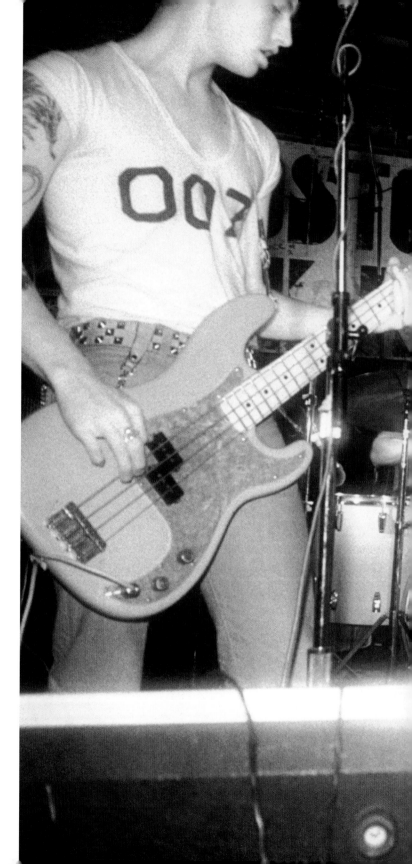

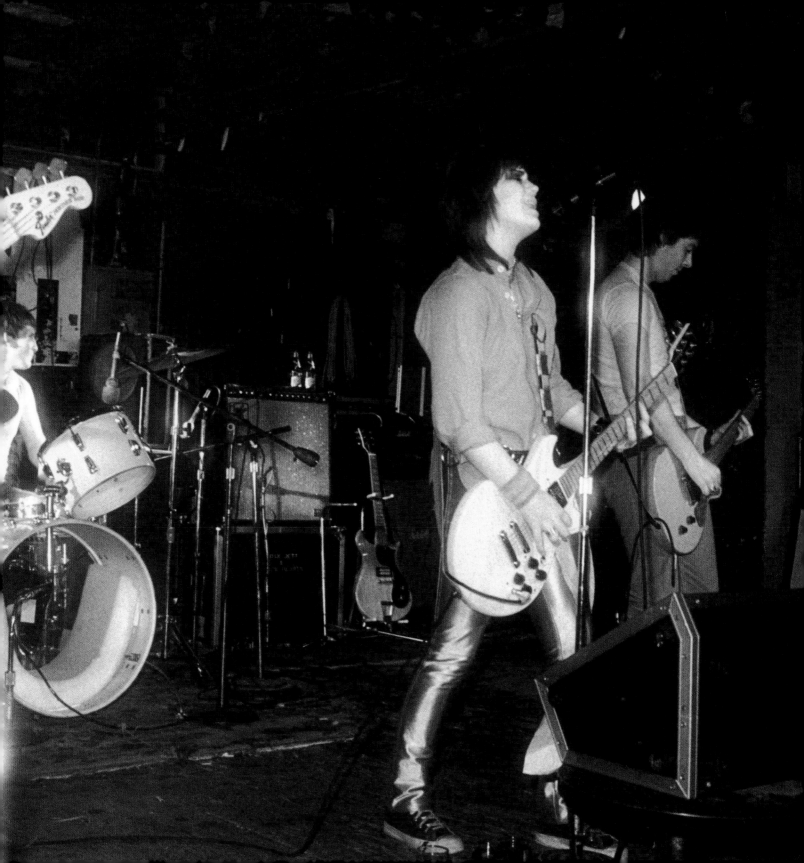

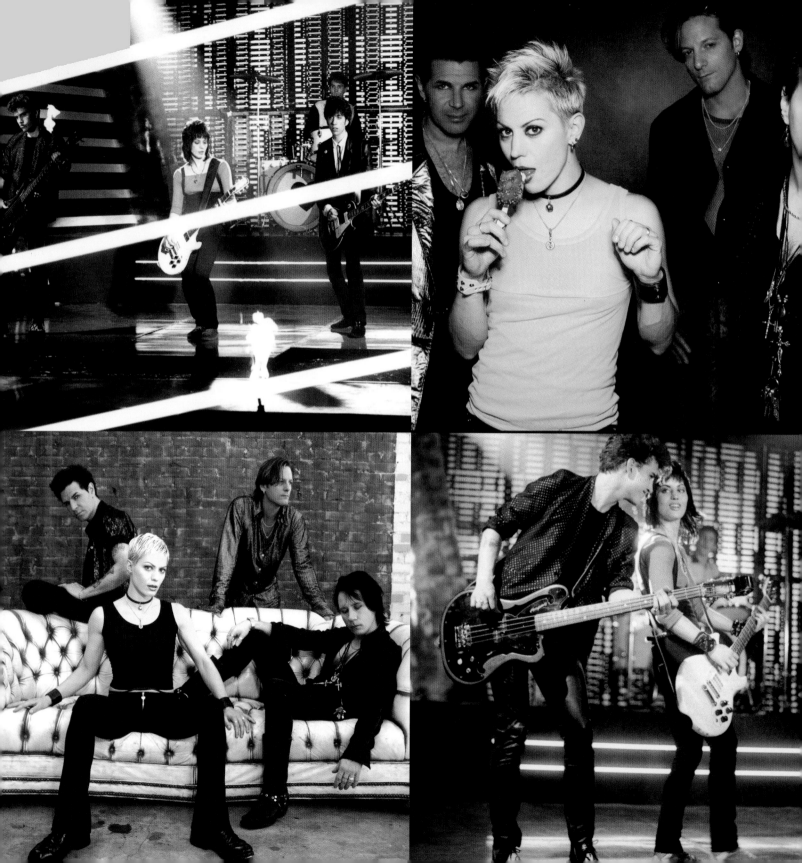

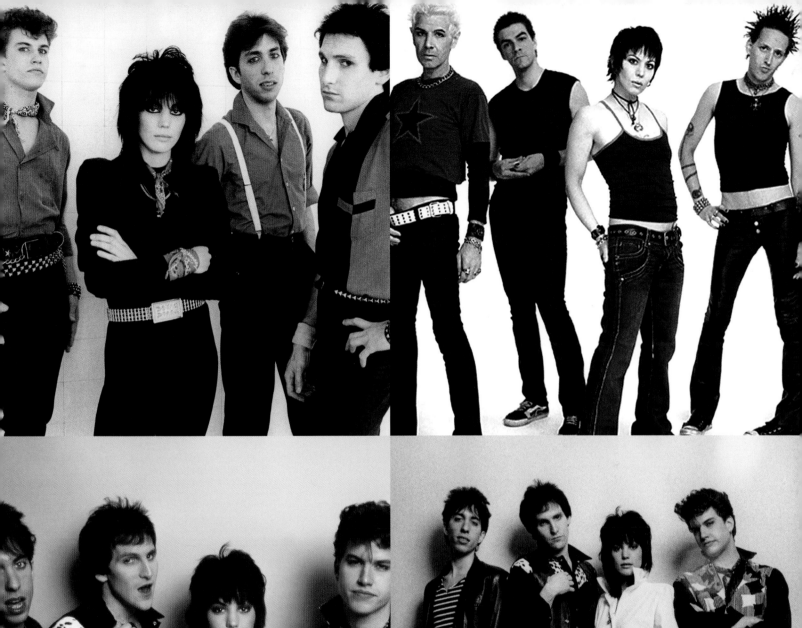
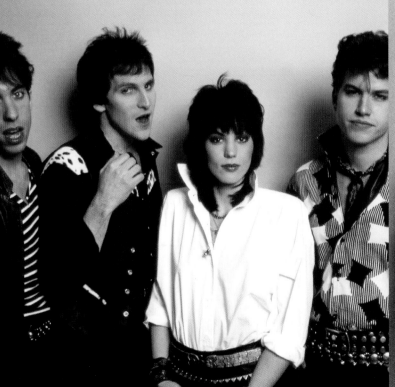
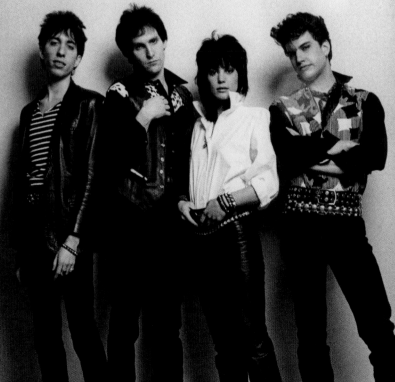

TOO HARD
FOR RADIO

We had gradually written and learned a bunch of new songs while traveling the road in support of our first album and had played them live hundreds of times. Due to the restrictions of our finances, we went into a Long Island, New York, studio during 1981, and in six days recorded the entire *I Love Rock 'n Roll* album.

When The Runaways went to England to tour, I was just watching TV, sort of getting used to the country and noticing the differences. There are a lot more music shows on TV over there, and I saw a band that looked a lot like Aerosmith. They were called the Arrows, and they did this song called 'I Love Rock 'n Roll.' I thought it was a really good song, and it turned out to be the B side of their single that was out. I went out and bought the single. I personally thought it was a hit right there, but The Runaways never recorded it. It just sat there for several years until I recorded it in 1979 with Steve Jones and Paul Cook from the Sex Pistols.

When it finally came out, we couldn't agree with the Bogarts about anything, and although we constantly fought with

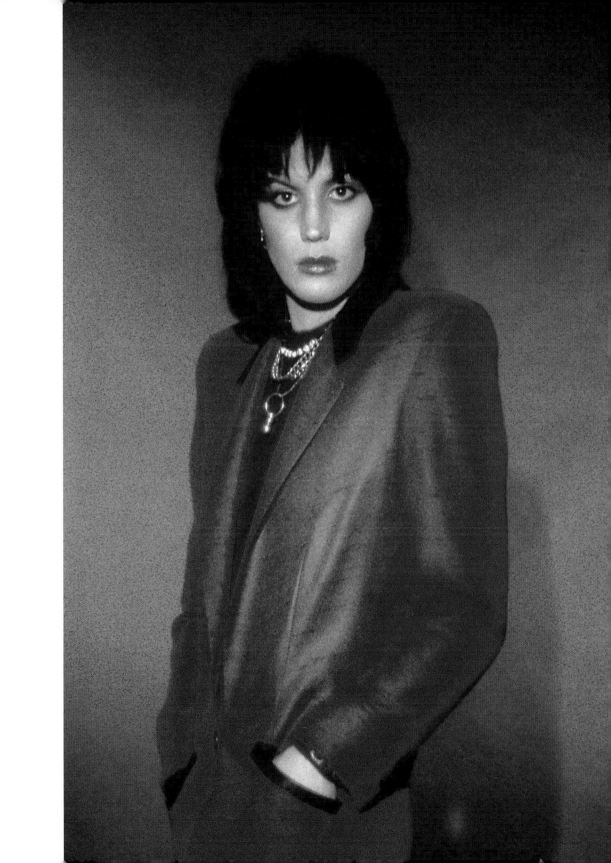

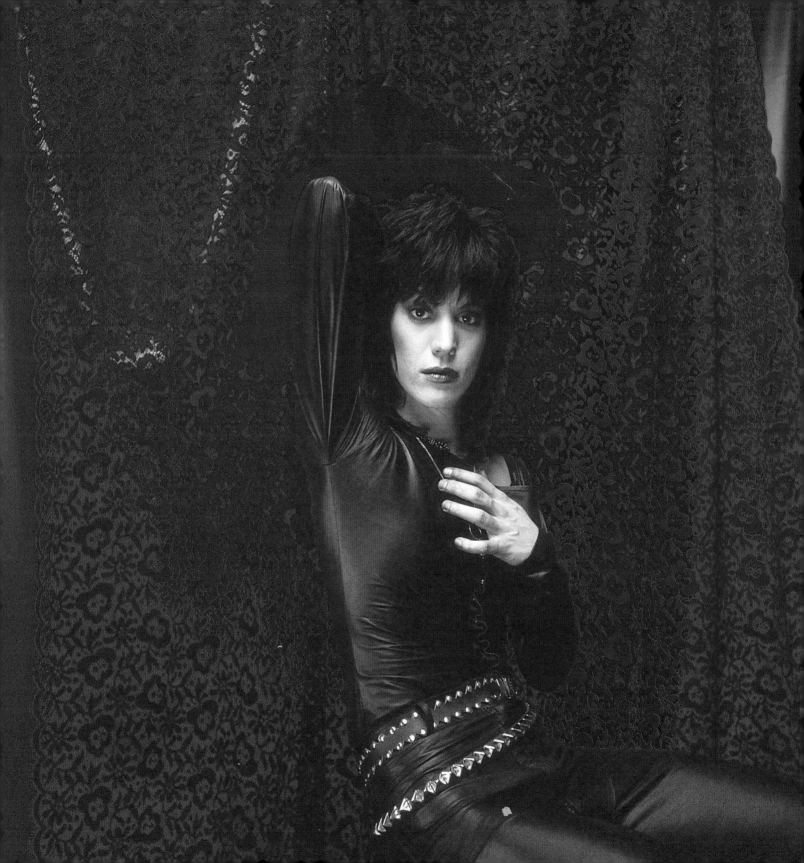

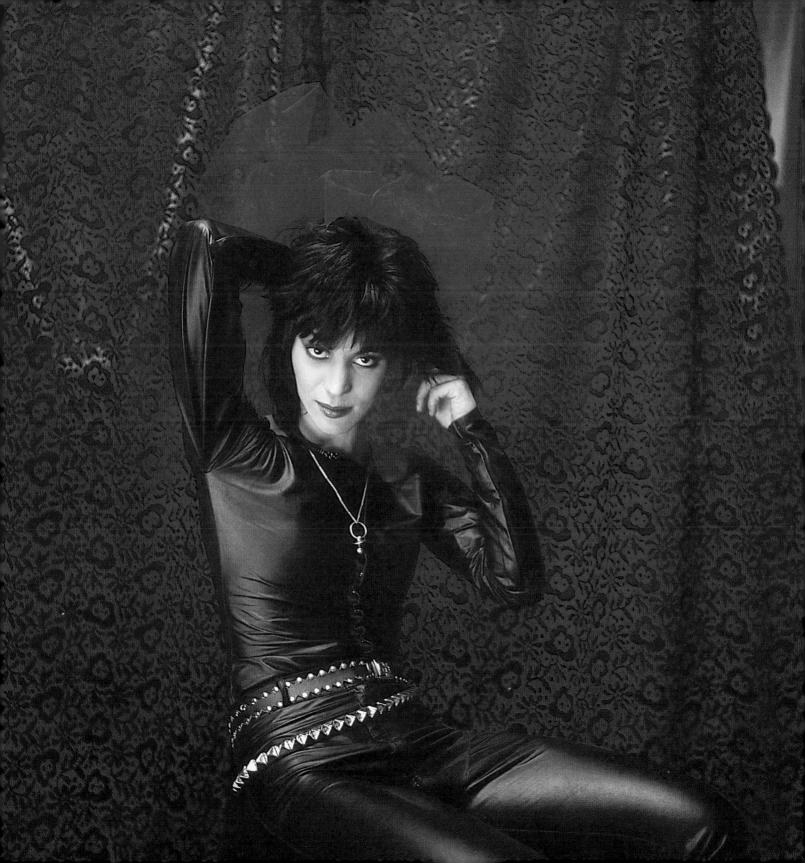

them, we loved them and they loved us. Joyce hooked me up with Norma Kamali, the famous designer. I thought that was ridiculous at first, but in the end, Norma designed all my clothes for the next ten years. Joyce bought me my first expensive piece of clothing in L.A.: a $300 blazer I wore on the cover of the new LP.

When the album came out in late November, we thought we were DOA. Conventional wisdom dictated you cannot release a record in the middle of the Christmas season successfully. Neil wanted to release 'Little Drummer Boy,' and we wanted 'Crimson and Clover' for the first single. We had a top ten "rock track" with 'Victim of Circumstance,' but by January only ten stations were still playing our album. Concert dates were booked constantly, and our radio promo friends Steve Leeds and Lenny Bronstein kept setting up radio visits as we traveled. Suddenly, some "rock radio" stations were playing the 'I Love Rock 'n Roll' cut, the song that the head of promotion said was "too hard for radio."

Whenever it was played, there were a zillion calls to the stations.

Soon it was a top requested record, but since it was only on rock stations, we were thinking that we could never have a Top 40 hit. Besides, The Blackhearts, Kenny, Meryl, and I were traveling and working so much that no one in the band had a real idea of what was going on with our record. All through the miserable winter months of 1982, we worked our way through upstate New York and then all the way down to Florida. One day we left our sound check at Miami's Agora Club and headed to visit Kenny's godchildren in Delray. Suddenly we heard our song on the big Miami Top 40 station. We couldn't believe it. When the song ended, the DJ said, "You're listening to I-95 and that's our number one record!" We turned the dial, and we heard it again. It was on three stations at the same time! Kenny, who never lets you see that side of him, had tears rolling down his face. Sometimes I just couldn't believe some of the stations we were played on. I mean 'I Love Rock 'n Roll' going straight into 'Ben,' by Michael Jackson, is quite a shock to the system.

Within six weeks, 'I Love Rock 'n Roll' was number one in the whole USA, and it stayed there for the next two months. By that

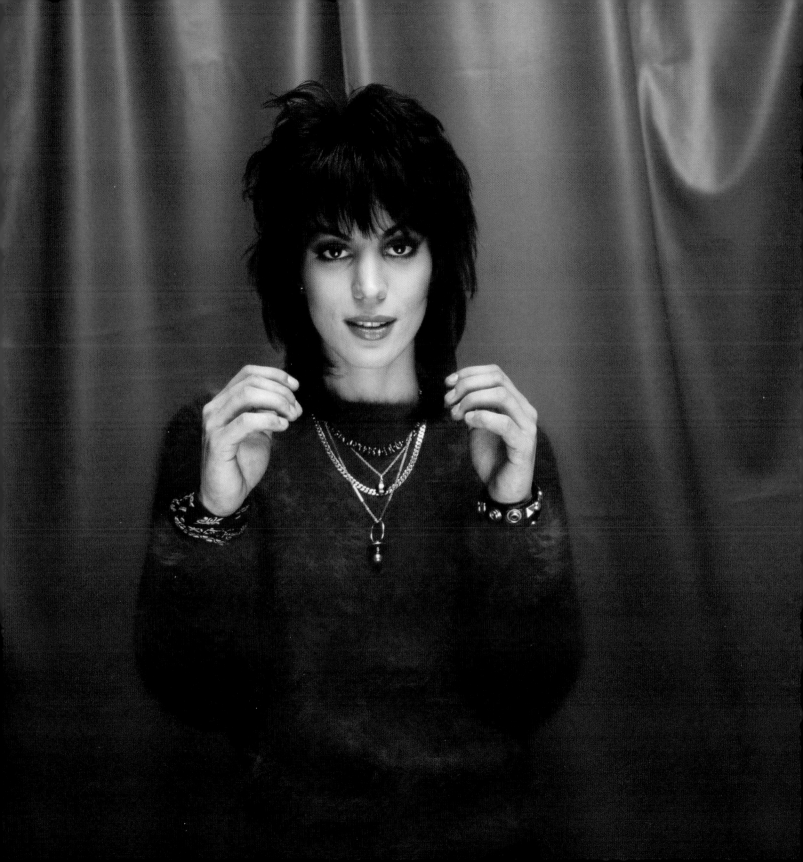

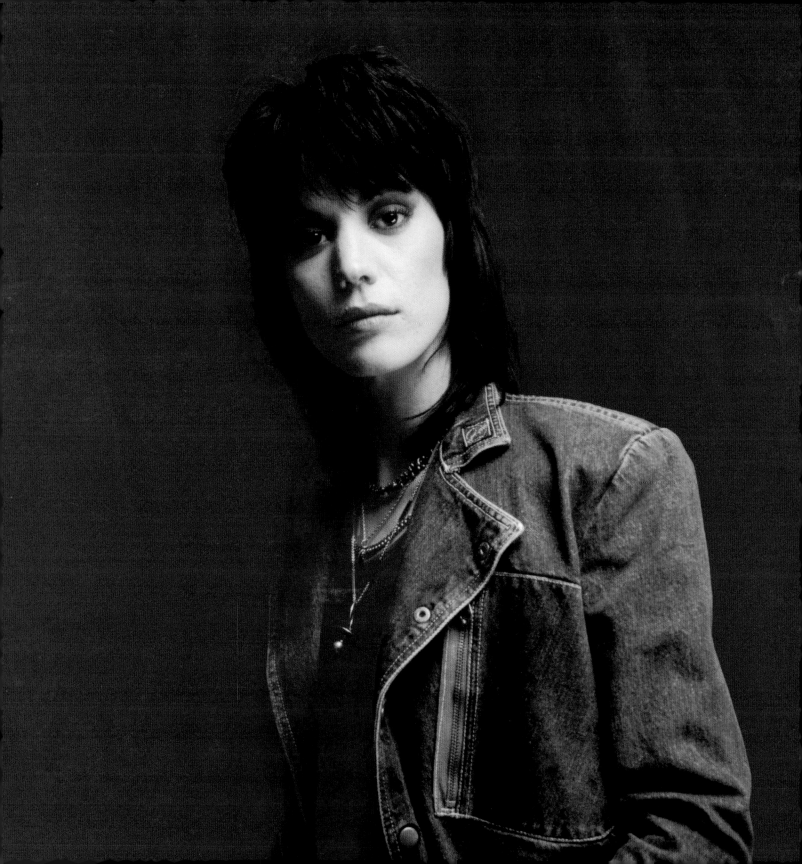

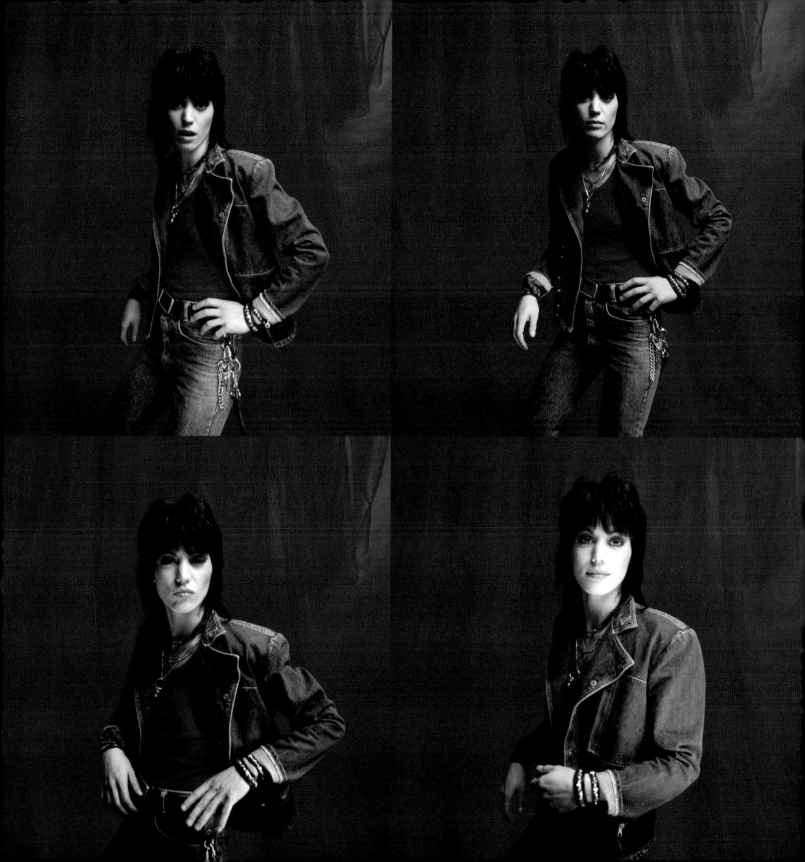

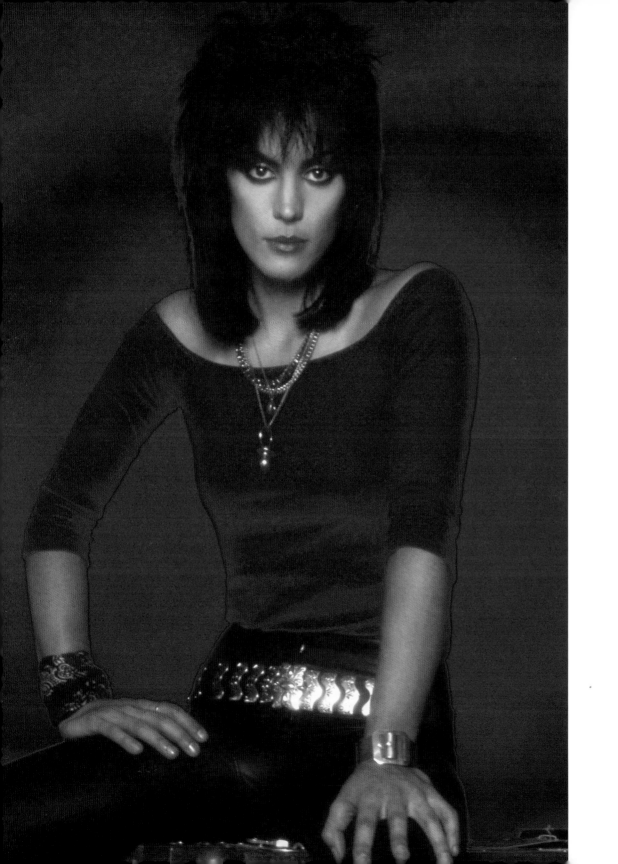

time, it was the number one record in the world. According to Billboard's objective computer, of all the recordings ever charted, it remains the number 28 record of all time, right there with 'White Christmas' and 'Rudolph the Red-Nosed Reindeer.' In songs with "love" in the title, it is number seven, and in songs with "Rock 'n Roll," it is number one. Not bad for a girl who no one wanted to sign.

By the way, since no one really wanted our records, we own them. Blackheart Records is celebrating 22 years—and we're still not in style.

"Cherrybomb"

Words & Music by Kim Fowley &
Joan Jett © 1975

the RUNAWAYS

— HEAVY METAL SCHOOL GIRLS —

(Verse 1)

Can't stay at home, can't stay in school
Old folks say ~~you~~ poor little fool
Down the street I'm ~~the~~ girl next door
I'm ~~the~~ ~~FOX~~ you've been waiting for.

(Chorus)

Hello Daddy, hello mom
I'm your ch, ch, ch, cherrybomb
~~You're the fever that you've always been looking for~~ HELLO WORLD
 I'M YOUR WILD GIRL
 I'M YOUR ch-ch, Cherry Bomb

(Verse 2)

Stone age love, strange sounds too.
Come on baby ~~let~~ me get to you
Bad nites ~~are~~ causin' the teenage blues.
Get down ladies you got nothin' to lose

(Chorus)

(Bridge) (SOLO)
~~Gonna give you the mighty rock-n-roll~~
~~get you~~
~~Cherry punch~~
~~Scream & shout if you want some more~~

(Verse 3)

Hey! Street boy What some style?
Your dead end streams won't make you smile
I'll give you something to live for
Have ya, grab ya, till you're sore

(Chorus)

(END)

BLACKHEART RECORDS

155 EAST 55 STREET · SUITE 6H · NEW YORK CITY · 10022 · PHONE · 212 644 8900 · TELEX · 428 161 · LKI UI · FAX · 212 688 1883

Right Till The End

V1 Out on a dirt highway the sky was screamin' red
i told you my rules i guess you didn't hear a single word i said
You tried to ~~change~~ me what a surprise ~~bet~~ cuz
now i see the tears are fallin' and they're from your eyes

CH Right Till The End i'll walk my way
Right Till The End don't care what ya say
(you knew the first day)

V2 Ah, i'm in my empty room, i had to turn you loose
Don't be like me i don't want compassion like
i want the truth
Don't wanna hurt you thats not me
The only choice i got is hurt you on to set you free

CHORUS

BRIDGE ITS SO EASY to fall out of love when two don't feel the same
ITS SO EASY TO FALL OUT of love when one will never change an i know

CHORUS

9

I WROTE
THEIR STORY

Believe me, it's not easy. Sometimes, if I'm lucky, I get the chance to sit around my hotel room with a guitar and a tape recorder. Most of the time, I don't even have time for that. In fact, some of the best song ideas I've ever had came at times when I didn't even have a piece of paper near me to jot them down. I had to keep humming the tune over and over until I had time to write it down. Sometimes I'll run over scales, but I don't know if they're proper scales. I'll mess around while I'm listening to the TV at a very low volume. I'll just sit there and play chord progressions, just different things going into different things, until maybe I hear two or three chords in a row that sound good, or until a melody pops into my head. I love to write harmonies and melodies. Then you come up with the chords underneath that. My creativity just flies out when it wants to, if it wants to.

You're always writing from the time you complete one album. Anything you come up with, any riffs or ideas, are really a start to

the next record. It's like putting together a puzzle. I am still naïve enough, or hopeful enough, that I do believe in the things I write. I want to believe people are cool; I want to believe the good things. Sometimes that gets you into trouble.

When I write, it feels like rock and roll in a bar. It's simple. I don't ever want to write from the perspective of, "I'm a rock star." I want to write so that my songs apply to everybody. When I sing, "I da da da," that "I" means each person. So if I sang, "I have lots of money" or "I have a hundred cars," that means the people who are going to sing along to my songs aren't going to be able to relate to that. I don't ever want to sing from the point of view that I have this and you don't. People have to be able to relate to it. Kids tell me I wrote their story, and that's a big part of music's appeal. I just repeat from personal experience what every audience feels. My music belongs to everybody. Everybody is a part of it.

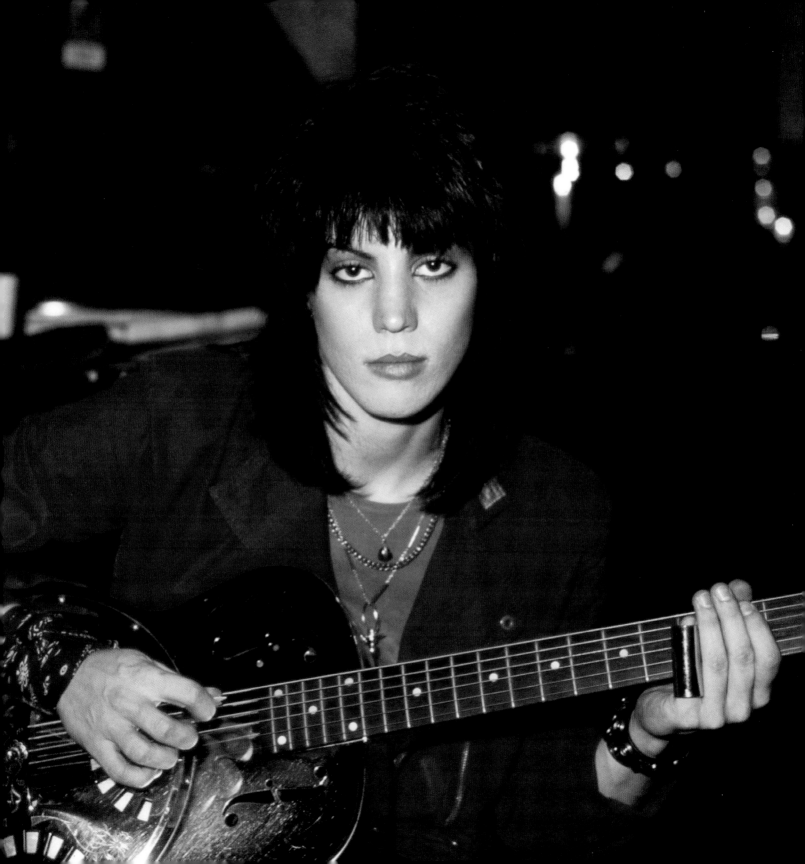

Long Time

Jette Laguna
©84

V1 Nice of you to say
we can still be friends
But what I need the most ~~xxxxxxxxxx~~
is never gonna be again
Sure I always knew we're worlds apart
But that don't help the sadness in my heart

CH Its gonna take a long time
to get this off of my mind though you were
Love like yours is hard to find hard to find
You'll never be mine
Its gonna take a long time

V2 When we were together
Life was so complete
Then you met that girl
I could not compete
You are like a magnet with your ways
That's what I remember everyday

CH SOLO CFC ×4

V3 ~~xxxxxxxxxx~~ My Love is so complex
Thats why I'm upset
I'm not good for you
But still I can't forget
You can always wake the beast in me
Thats the thing that never lets me be

I'm Frustrated

Jett & Laguna
©84

V1
Daddy's got his beer an
Hes glued to the television
Momma's in the kitchen with
the dishes an the pots an pans
An I be in ~~the~~ my bedroom
Contemplatin' all the livin' I'm missin'
Waitin' for the day I won't
have to follow someone else's plans

CHORUS ~~~~

V2 They ~~S~~ee what ~~they~~ wanna ~~see~~ see an'
No one ever knows I'm lonely
I got rockets in my Sockets
But I got no place to go
An in my dreams I find my
one and only
I wake up in the mornin' an
Reality really blows

CHORUS
I'm frustrated - my hands are tied
I'm frustrated - my brain is fried
I'm frustrated - No place I can hide

V3
You can go around in circles
An never find a perfect lover
Steal a glance but never take a chance
so you stay at square one
You make a big mistake when you...

CHORUS

Guitar in G III acents

BRIDGE III Don't do this · III Don't do that DON'T GO OU
 III ~~Can't say this~~ III ~~Take it back~~ COME RIGHT
 NOW
 III ~~~~ III ~~All the time~~ Say bout·
 its such a bore WHATS IN
 SOLO WHATS

10

I TRY SO HARD TO GET IT RIGHT

I spent time in the studio with The Runaways, and I think that if you spend time in the studio when you make an album, you're producing it. You listen to what goes down on tape, you evaluate what the final situation is. To produce a record you don't necessarily have to put in all kinds of effects and stuff.

I enjoy recording and making albums, but it does put you on your toes. You're always thinking in the back of your mind, no matter how well you know the song, "Maybe I should change this at the last second and make it have a different feel." You really try for precision. I try so hard to get it right. Simple music is really the hardest kind of music to play. A three- or four-chord song is very hard to play and be right on top of when you're a guitar, bass and drums sort of band.

We try to keep as much spontaneity in the studio as we can. We try to keep the number of takes to a minimum, and if we're overdubbing guitar solos, we try to do it in one take. I'm a firm believer that rock and roll has to have as much energy as possible, and the only way to keep that energy in a studio is by playing and recording "live" as much as possible. I think we

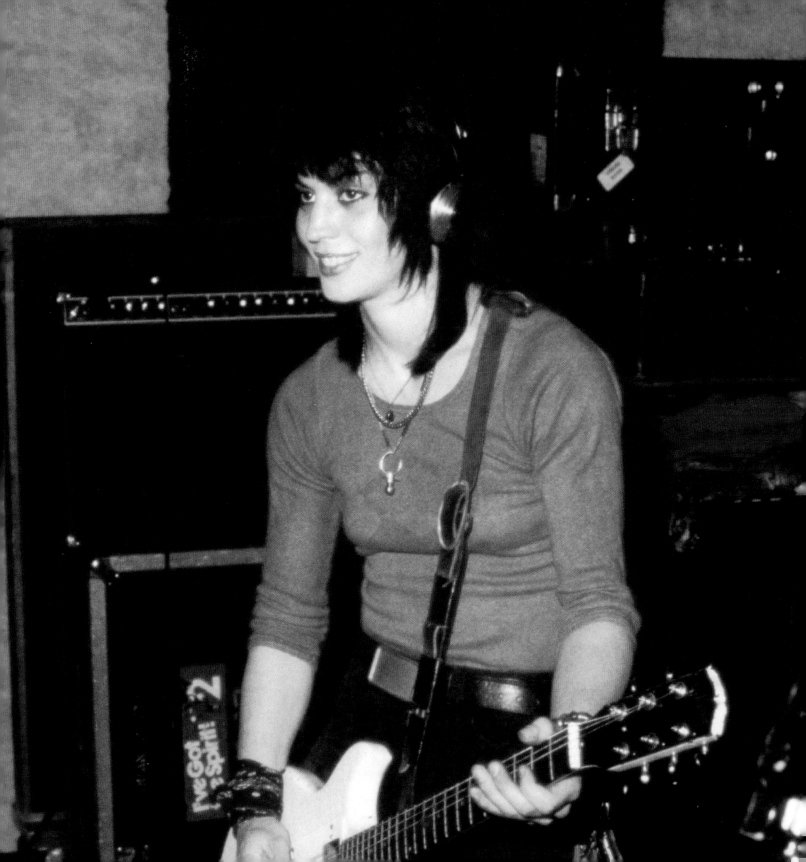

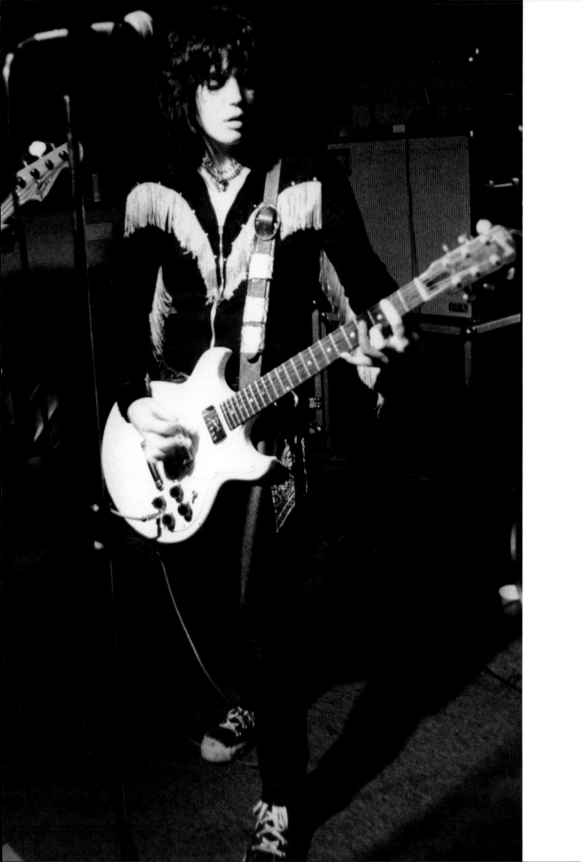

sound the same in the studio as when we are playing live. It can be different depending on the mikes and the building and stuff, but it's more of a feel. We set up live in the studio, we look at each other, we play off each other. Other bands have someone down the hallway, someone outside, someplace else where they don't even see each other. We react, we're right next to each other giving eye contact. We jump around just like we are on stage. We try to keep the tension of, "Oh, let's make this exactly perfect" out of it, and Kenny is always to trying to help us relax. He puts on headphones and stands out there with us. As producer, Kenny works with the band when we lay basic tracks. He'll sing a song to help us along, so we can get a basic track. Nobody gets lost.

I'm not a trendy person — I like to make music one way. I only feel comfortable playing straightforward rock and roll. I like producing other bands. I worked with the Germs in 1979. They were Runaways fans, especially Darby Crash and Pat Smear. Darby would show up outside the studio when we were recording our second album, *Queens of Noise*. I remember he'd say how much he liked the new songs and his hair being a strange color.

After The Runaways broke up, it was obvious I could use something to do, so Darby asked me if I'd produce their album. I just tried to make them sound the way they sounded on stage. I had a blast. It was just a matter of going in and twisting knobs. I watched them do basic tracks, then decided which I felt were the best. I always consulted with them on it. Then we'd do vocals. We didn't do any effects or anything heavy, it was straightforward.

I produced three songs for Bikini Kill at a place called Avast in Wallingford. It was great. They'd been on tour, so they were well rehearsed, and they knew what they wanted to do. The songs took one, maybe two takes tops. I went out and did some vocals on two songs. I played guitar on one song, we mixed it down and it was complete in 12 hours, from start to finish. They're a really great band.

I produced a band called Circus Lupus, which is a band on Dischord Records. They're out of D.C.; that's Fugazi's label. They are a great indie label that's been around for years. My god, probably since '80, '81, something like that? And

they sign all D.C.-area bands. But they're well known in the underground scene. Ian MacKaye, who runs Dischord, has such integrity. Like, they always did all-ages shows. And every gig was $5 bucks, and all their CDs are $10. And it stayed that way. I don't even think he uses contracts to sign bands; it's all on handshakes. He's like this anti-establishment guy that's been offered deals up the ass. It's like he's just completely outside the system but succeeding. He's my hero, my idol. I've always looked up to him. And he's a great artist and helps keep that scene alive. It gives a lot of people hope. Fugazi introduced me to Bikini Kill.

I've produced a couple of our bands on Blackheart Records; I did a little bit with Girl in A Coma and The Vacancies. I want to hear it like I hear 'em live. I'm not trying to make it necessarily grander or anything like that. You want it to sound good. You might make it a little bit, you know, thicker and stuff than it would sound live. But basically, you want to do what the band can represent. If a band has a record, I would think they would want to be able to reproduce that live.

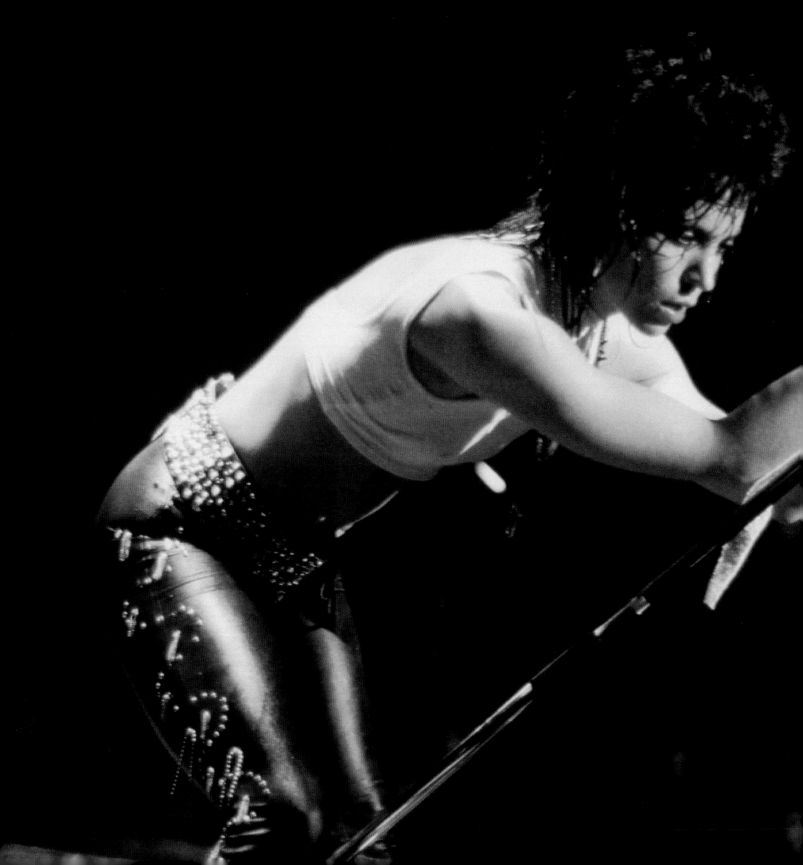

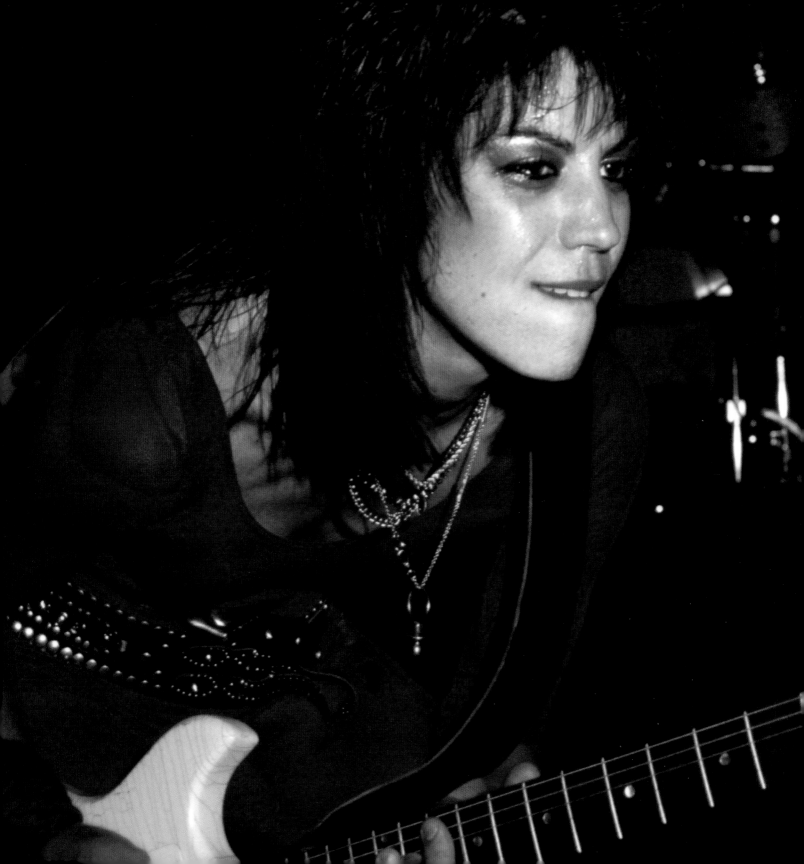

11

LET SOMEBODY
ELSE BREAK
THEM IN

Since I was in The Runaways, I've used a Gibson Les Paul guitar, and no matter what pickup, I still get the same sound. I started to use certain pickups and always got the same sound. Now I use Music Man amps, and no matter what studio I'm in, or gig I'm at, no matter where I play, the sound that comes out of my amp and into the mike, in the studio or live, is exactly the same sound all the time. Even when I change guitars—I can change models—it's the same sound. It's one sound, and I always get it.

Once in awhile, I do a solo, but it's really minimal. And the most basic, you know, a Chuck Berry lick or somethin' really simple, you know? What made me want to play the guitar was hearing songs like 'All Right Now' by Free. There's times in that song when the chords, they bend a little bit out of tune and come back.

I always buy my guitars secondhand. I've never bought a new guitar, ever, and I don't want to. Let somebody else break them in. Once I get a hold of it, I know I'm going to need to change things. I might have to change the bridge because, if it's a

really old guitar and it's got an old bridge on it, you might have to change it because it'll keep going out of tune. So I'll put a badass bridge on it. What I usually use is a Red Velvet Hammer pickup that was handmade—they don't make them anymore—by a guy and his son out in L.A. They're supposed to be louder and give you distortion but also be clear at the same time, which I personally find very effective. I put those pickups immediately into a Melody Maker, and I fell in love with the sound. Now I put it in all my guitars. All my Melody Makers and my Epiphone have these Red Velvet Hammers.

I really worked on learning my guitar because people tend to overlook rhythm guitar a lot. They tend to say rhythm guitar doesn't matter, but it's just as important as bass and drums. It keeps the tempo; it's the unstated thing. I don't say that just because that's what I'm playing, it's just that I notice it. I always called myself a bar chord basher, I play bar chords. I play in standard tuning. I play very much with the drums, which is like a bass player. I'm about the rhythm and about keeping the song structure. It's not about the lead guitar aspect of it, for me.

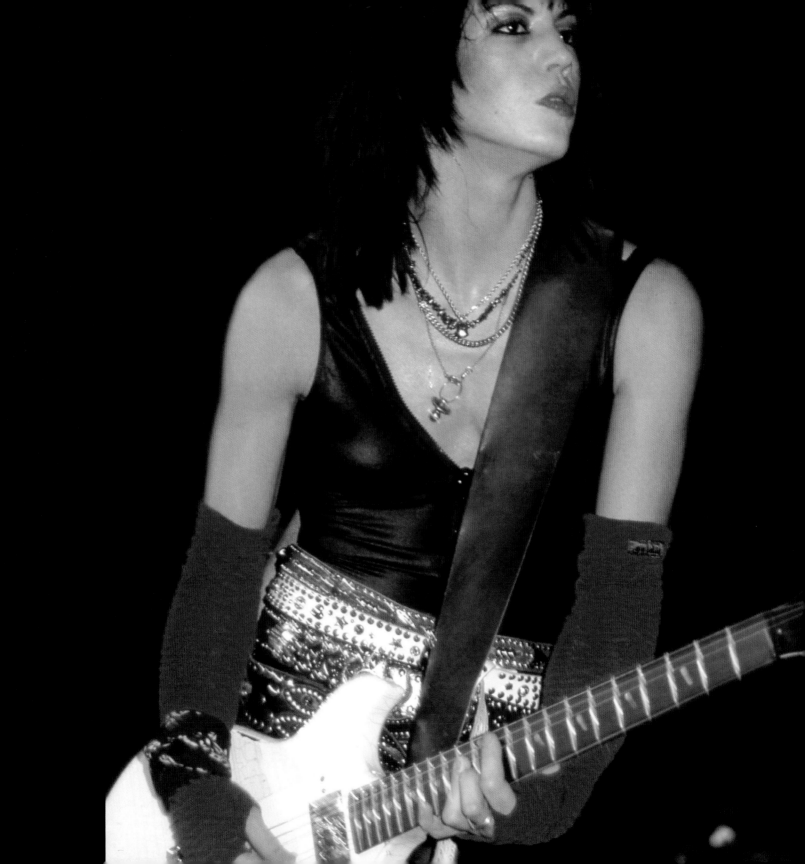

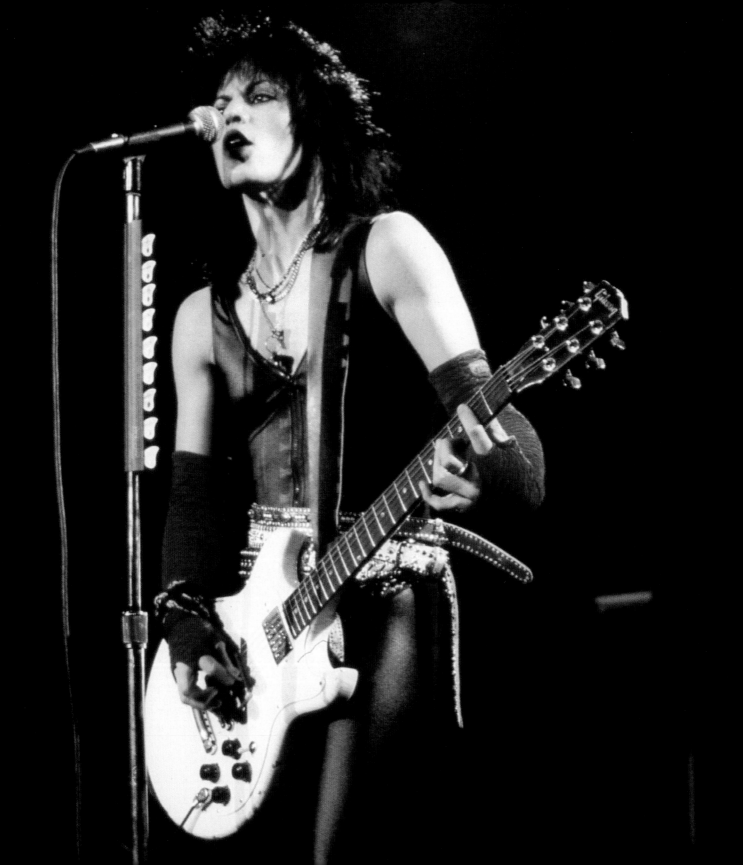

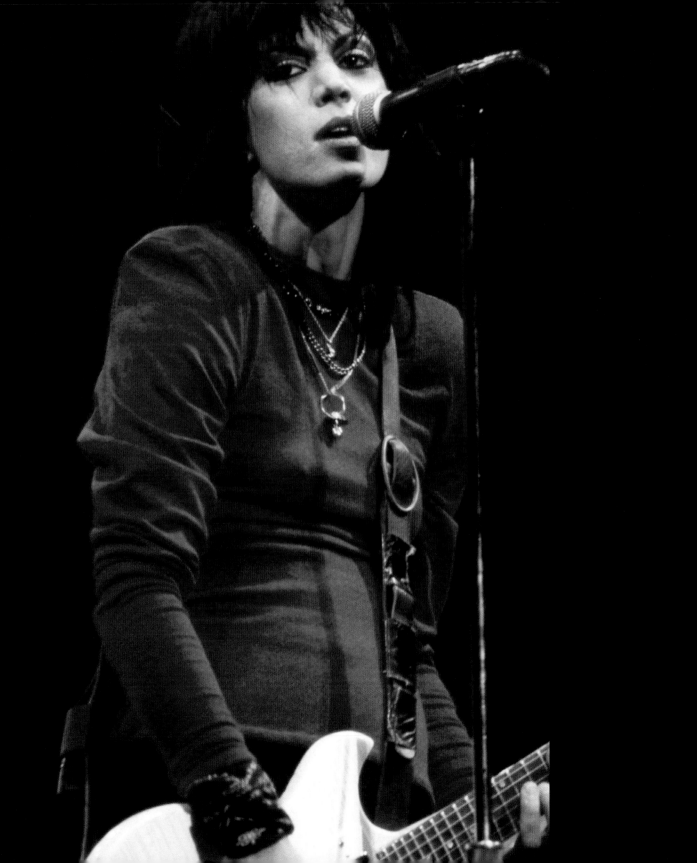

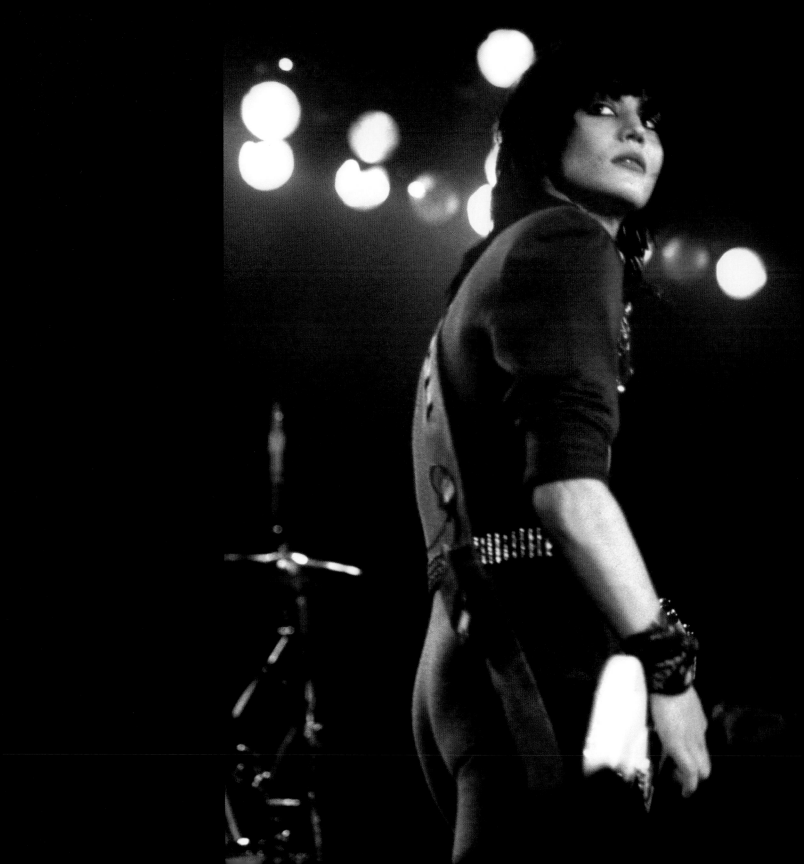

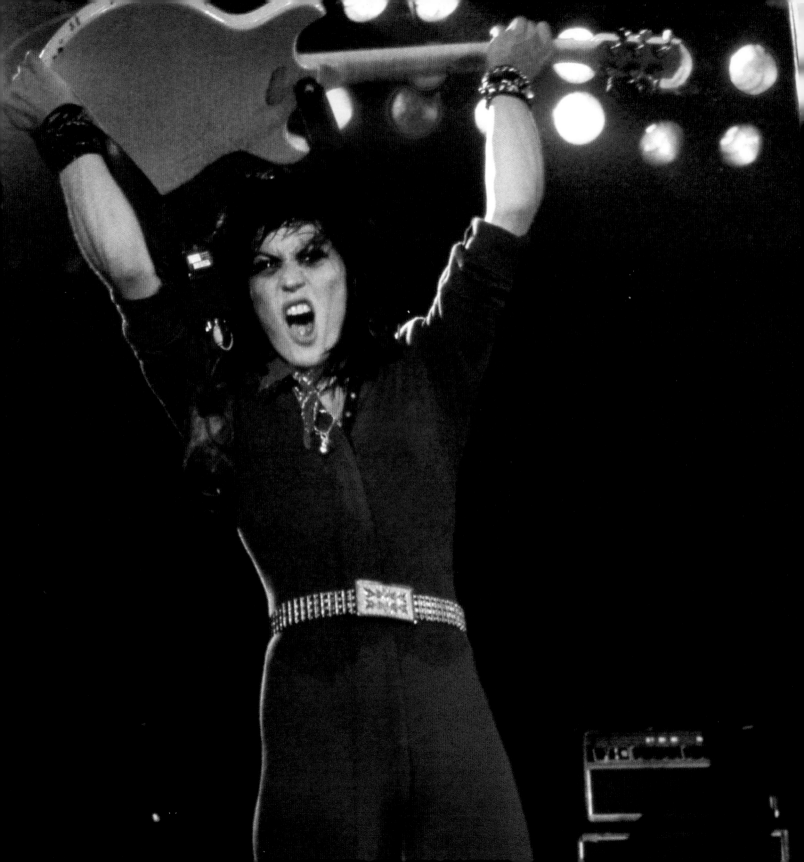

"*I LEARNED HOW TO SCREAM FROM MARC BOLAN OF T. REX. IF YOU GO LISTEN TO 'BANG A GONG,' YOU HEAR HIM SCREAM AND YOU GO, 'OKAY, THERE'S JOAN.' THAT'S ME ALL ROLLED UP INTO ONE SONG.*" – 1987

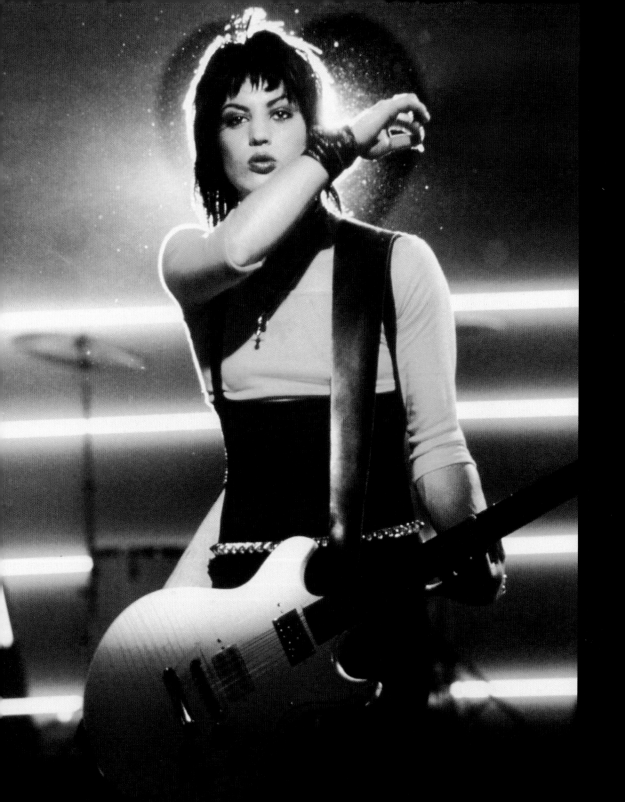

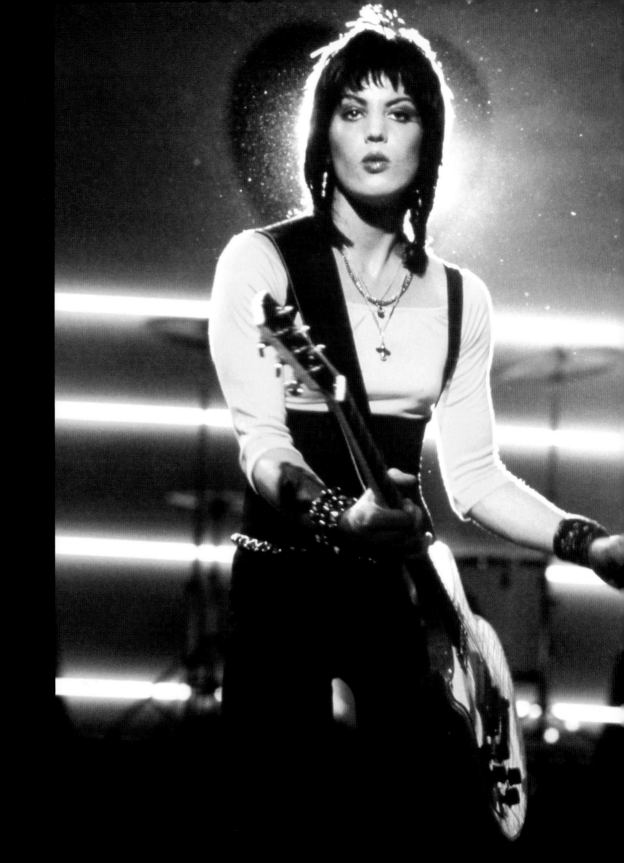

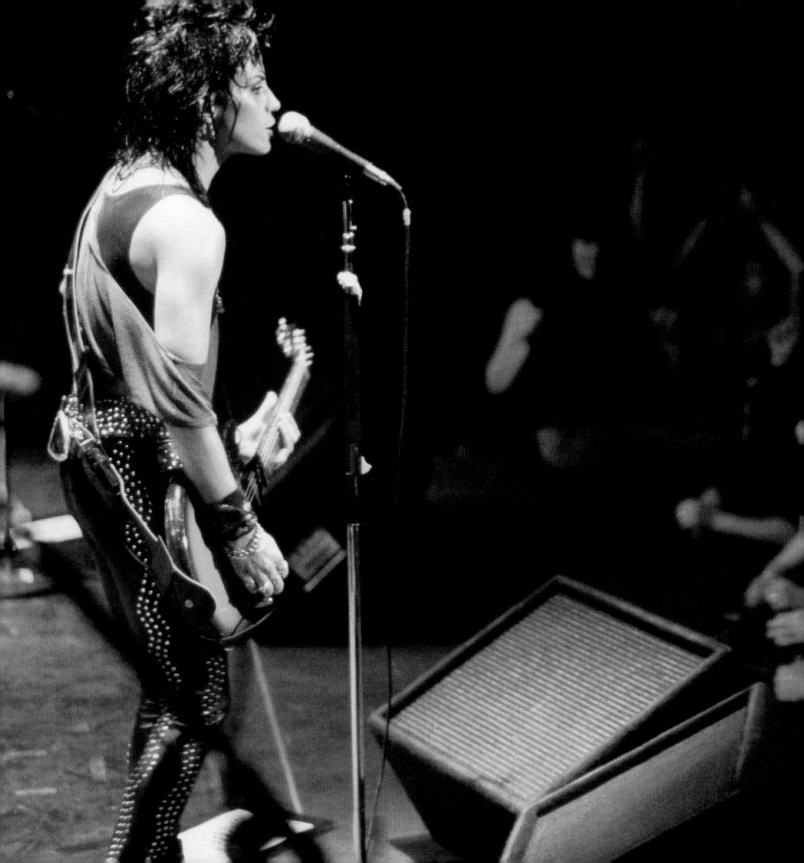

12

I LIVE FOR THIS

Some bands are only into touring as a means to support the release of an album. The part that really gets to me is to take what you've done in the studio and play it for people in person. It's intimate. You make eye contact. They can touch you. It takes a good eight months to a year to do the U.S. the way we do it, and then there's the rest of the world. We hit all 50 states, and I'm gonna do it again. We're the only band I know that played eight cities in every state—I don't know if you could name eight cities in Iowa, but we played them. It's an adventure going on the road; it's like camping. You get to see the world, and you learn to appreciate America—the plumbing, the phones, the TV, all the things you take for granted.

I like to be more thorough and try and get as many places as I can. We're playing a place up here that's never had a concert before. And to me, that's what rock and roll is about. You bring something to the people that they can enjoy. They just get a rush, and they like meeting you if they get a chance. A lot of these people don't have the money to travel to the big cities, so they really appreciate it when you go out and play for them. You give them memories—memories they can't have if you don't go.

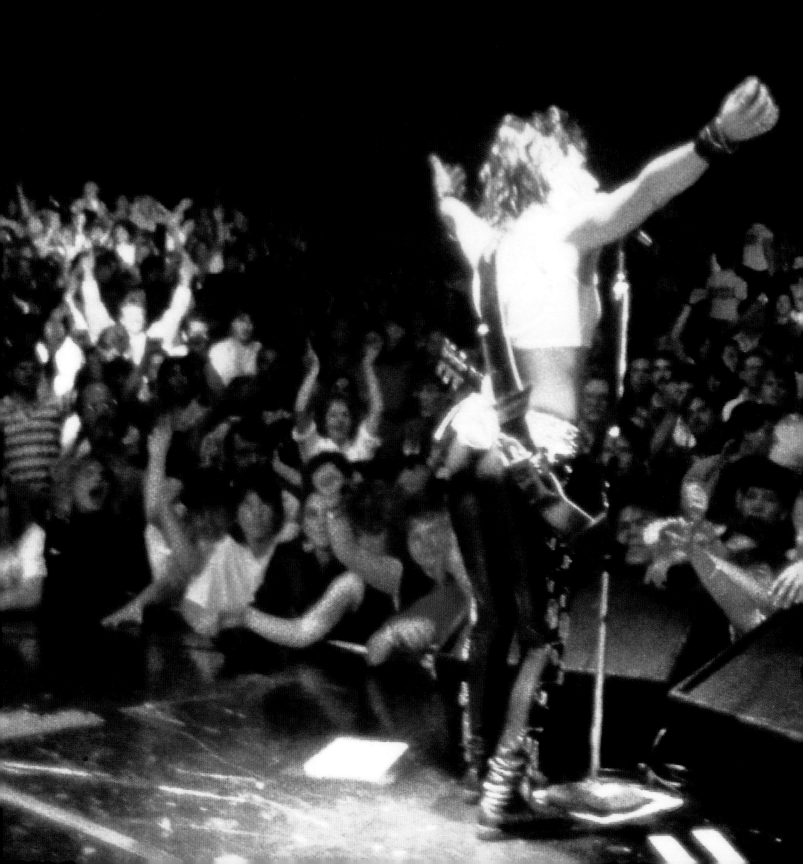

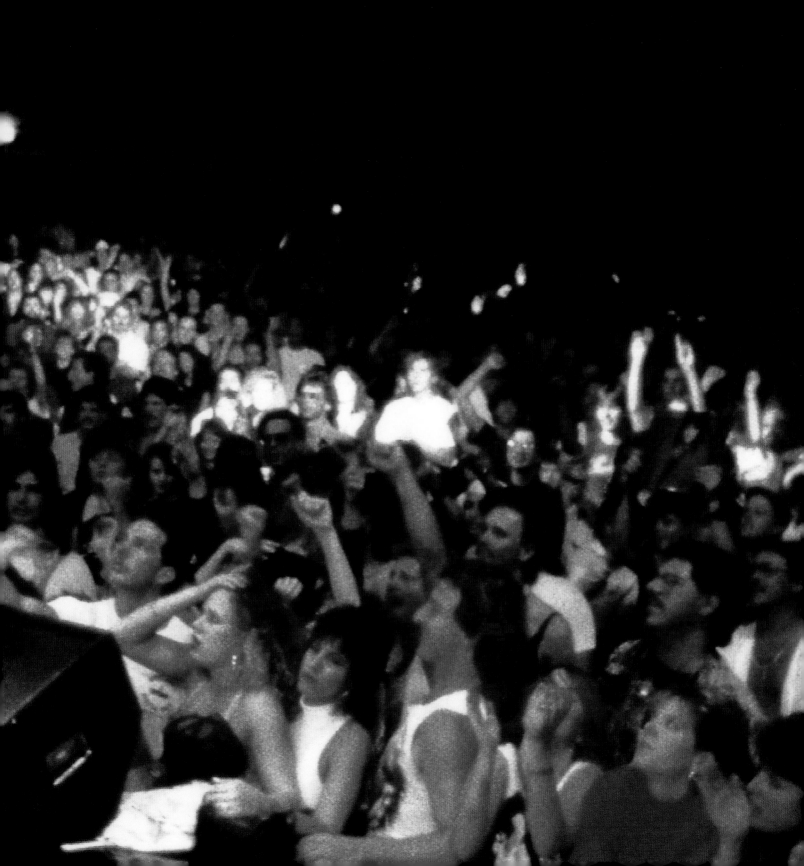

I'm happy on the road, making records, and playing clubs—that's good enough for me. I don't want people all over the place and hanging outside my door. I'm not in this to become a millionaire. I'm in this because I love the music, and I love to sweat while up there on stage playing rock and roll. It's really that simple. I would prefer to play in a theater, rather than a big arena where it's so cold you have to keep your coat on for the whole show. I mean, it's nice to hear 20,000 people screaming. It's a rush, but I like to get up close to the people. In a small place, everybody can see you, and you can see them. They're right in your face. It's really important to me to get out there and look people in the eye and hopefully sing songs they can relate to. We played to 100,000 in Philadelphia, and it was daytime, so you could see everybody, and it looked incredible. It was like, you know those pictures of the Pope when he went to Poland? Wherever you looked, it was just people. It was massive. It's a release—emotionally and physically.

I have been in situations where I felt really exhausted because we're very energetic. It's like a basketball game every time we play, back and forth, and runnin' around. And there's times when everything gets really loud—I'm sure other bands can relate—and they can't hear their monitors, and it's **so fuckin' hot**, and everybody's looking at you, and you look down and think, "Oh my God, I've got seven songs to go!" But somehow you find a way. You get out of the way and grab a breath. You close your eyes and the room spins, then you open your eyes really fast so you can get your bearings, especially with all the lights flashing. I was never worried about people rushing the stage, 'cause the band and I feel completely at home. The stage is our turf. When the kids get onstage, they don't know where the hell they are! I guess I've never been in a situation where thousands of kids have done it all at once. There's nothing that can compare to seeing those faces looking up at you. You start going more crazy on stage and they get more crazy—it's a relationship you never feel except on stage—like you'd been on a real heavy roller coaster ride, like an adrenaline rush, pure pleasure. I don't like it when the crowd sits down. In fact, one of the first things on my checklist is to find out about security to see if they let the kids stand and rush the stage. If it is a rule, we see if we can get it waived.

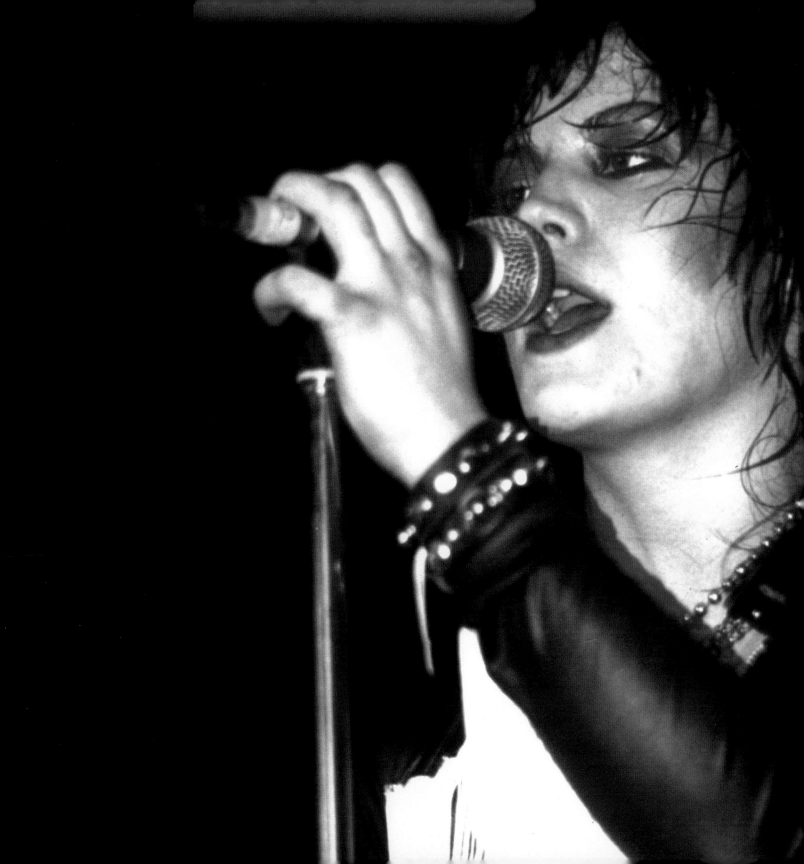

There's something about touring that's really magical—a special love you have with your audience that nobody else can get into. Plus, that's the Blackhearts' forte, playing live. I think that's probably where we shine best. I still want to take our music around the world to a lot of places we haven't yet. In 1982, when we went to the D.D.R., it was intense. We were the first Americans to go, the ambassadors. And the thing is, they were into rock and roll. There weren't any crash barriers. The only thing they couldn't do was clap their hands together at the same time, that I had problems getting them to do. They even knew the words to 'Crimson and Clover.' It was very special. We stood out in the parking lot after the show, trying to give every person something—a button, a pass, a handshake. Trying to make contact was very important to us.

It's a real joyful sensation. You're just full of happiness. You get chills. It really probably does sound corny, but it's like when everybody in the audience and I and the band seem to reach the same level. There's like an electricity in the room. Everybody's on the same wavelength. It's like an overwhelming feeling of love, almost. It's like a pure happiness feeling. I guess that's what music has done for me. If nothing else, it lets you know that you're not alone.

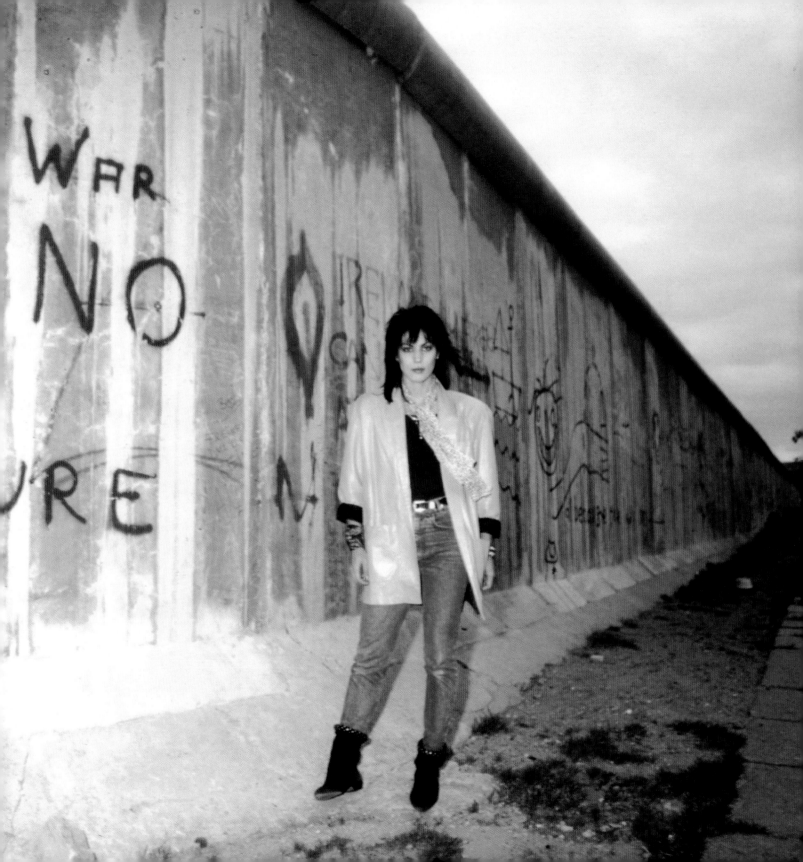

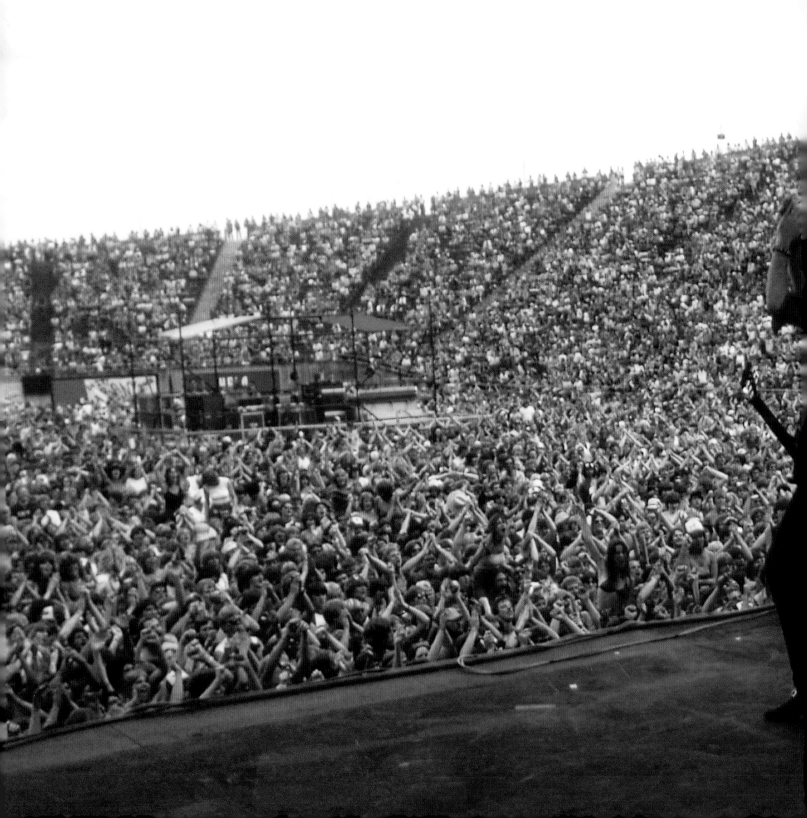

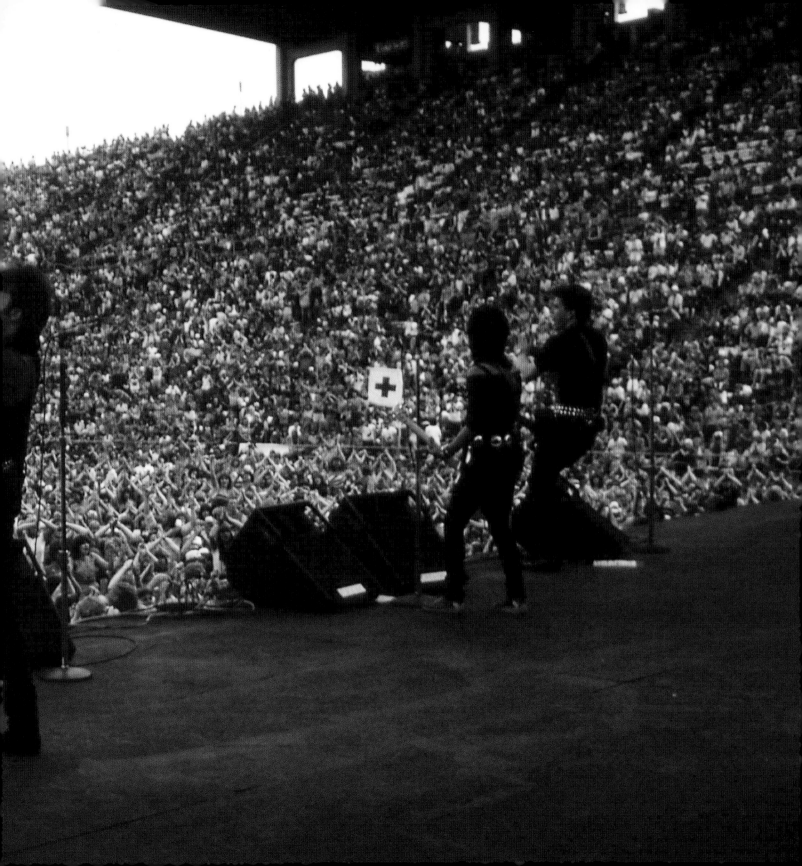

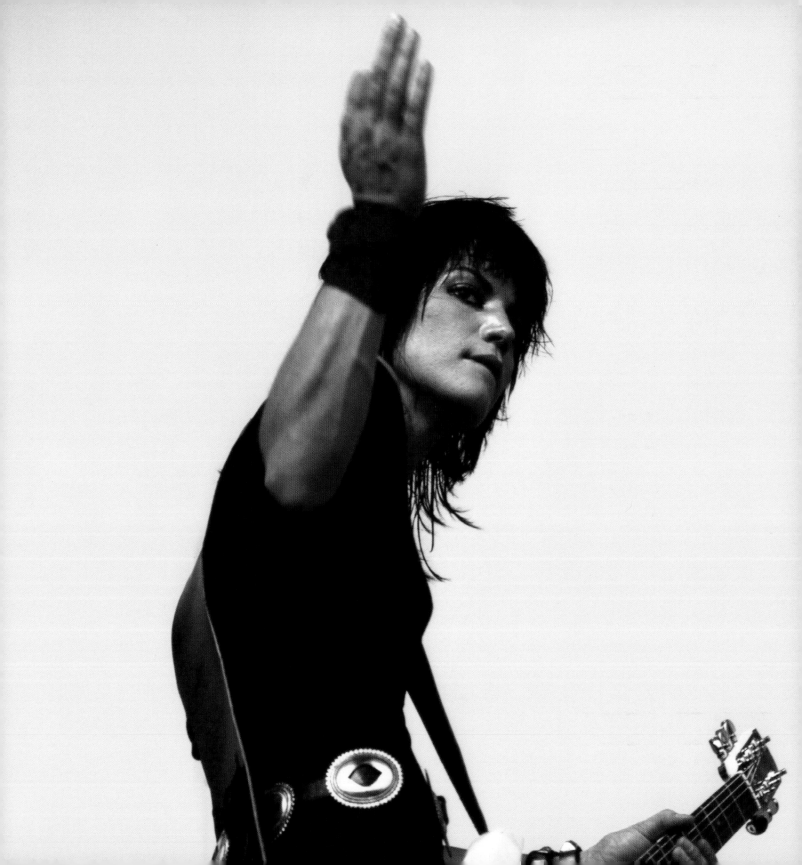

" *One of the best birthday memories I have is when I went to see The Who on their American tour. I think it was 1982. And I went to see the first show in D.C., and before the show I went backstage and said hello to the band. Roger Daltrey just walks in the room and says, 'Oh, I hear it's your birthday,' drops to his knees with his arms spread out, and belts out 'Happy Birthday.' You know, I was pretty blown away.* " —1987

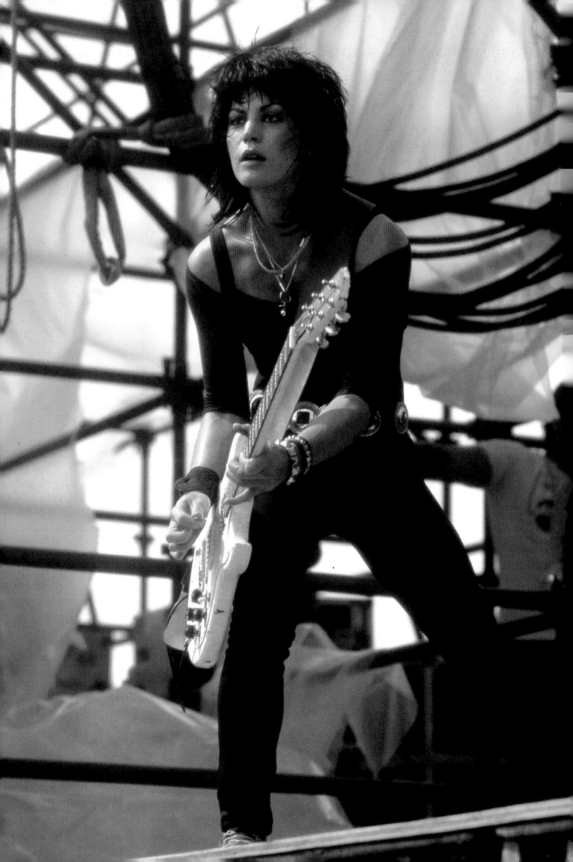

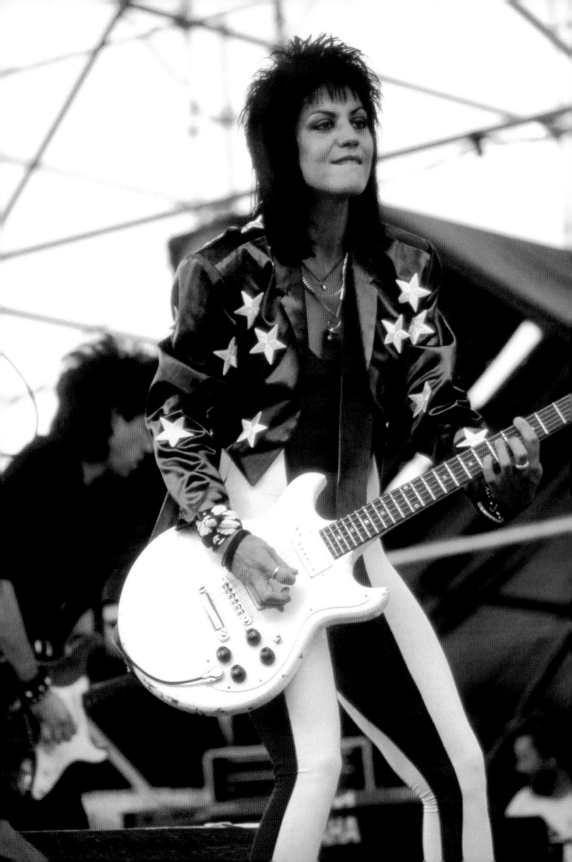

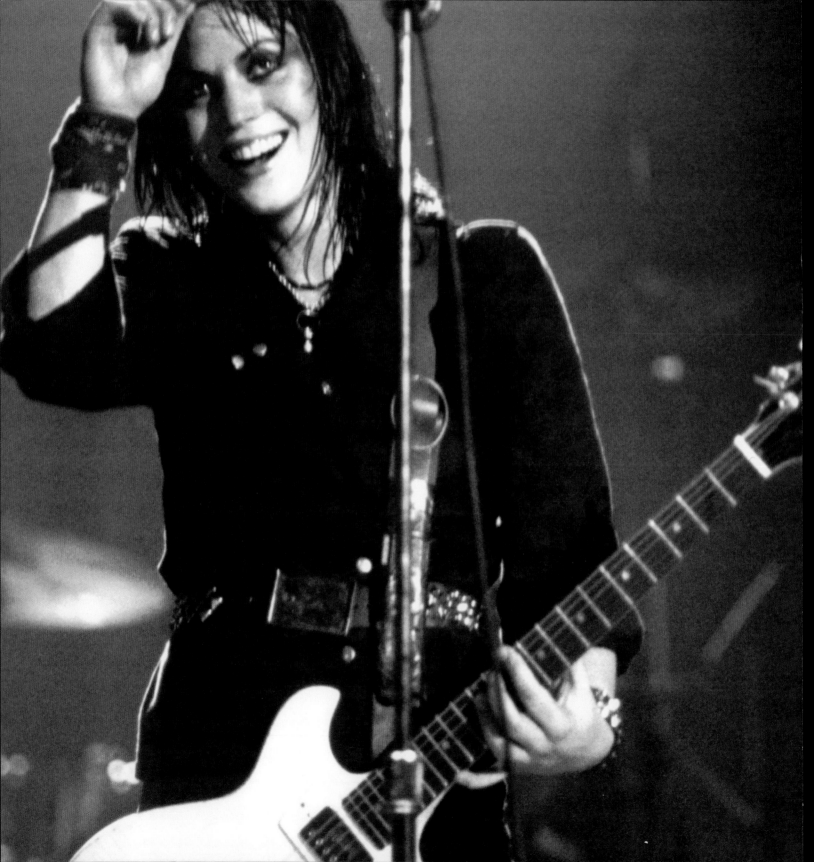

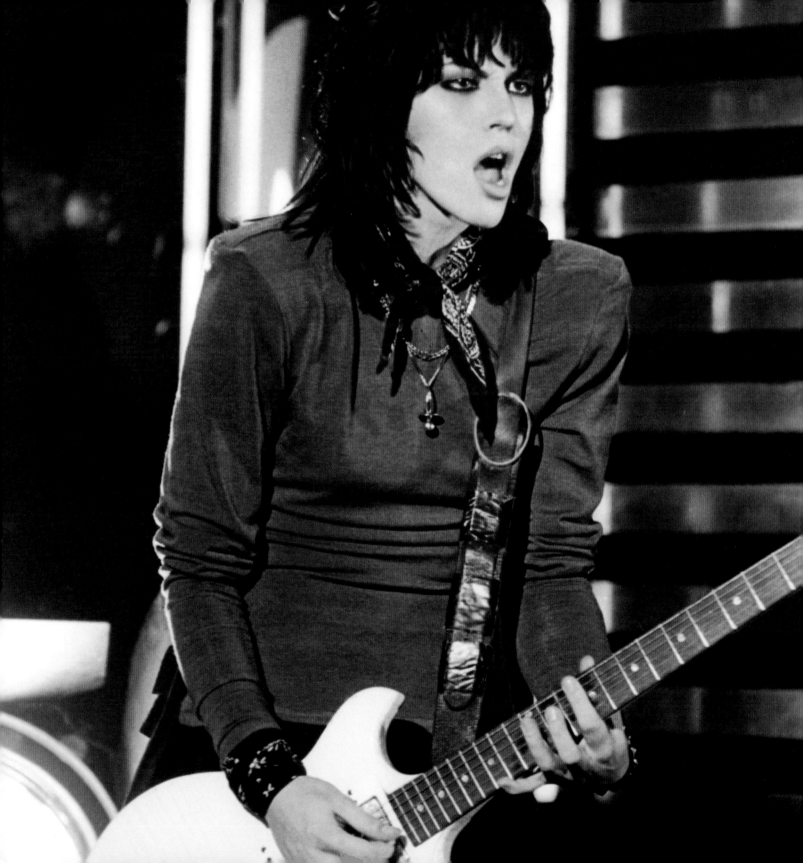

FUN PRODUCTIONS

PRESENTS

CHEAP TRICK

and

THE RUNAWAYS

FRI APR 18 PM

SANTA MONICA CIVIC

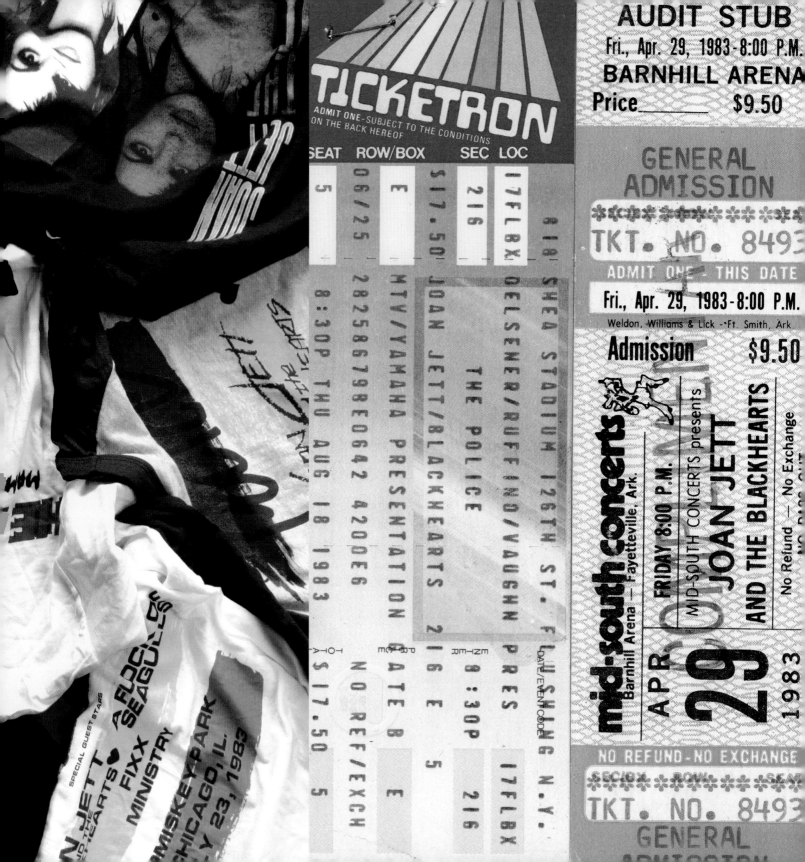

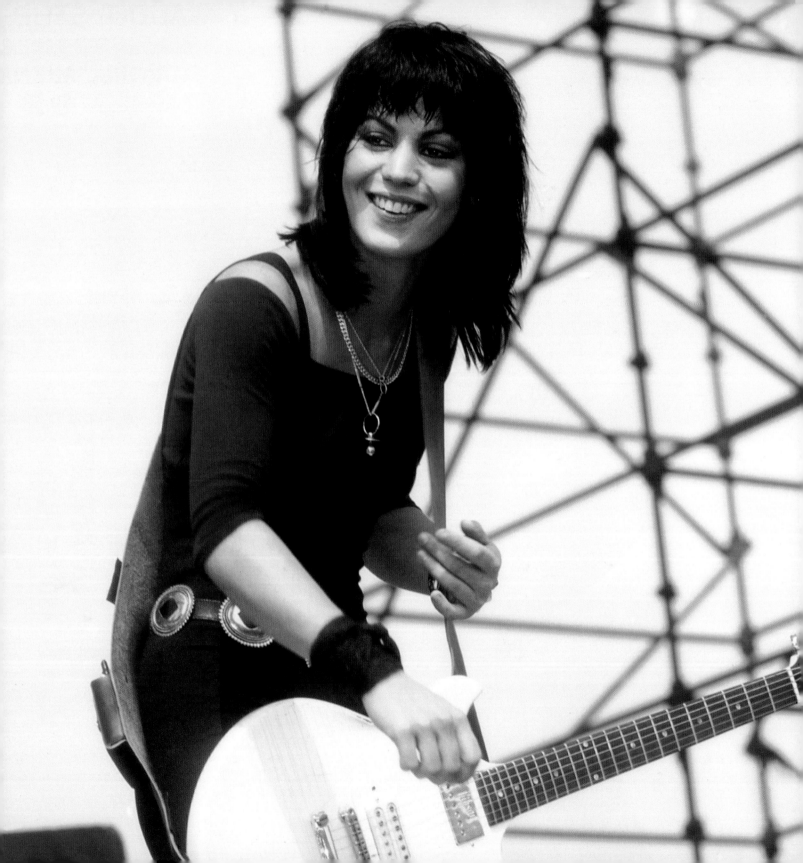

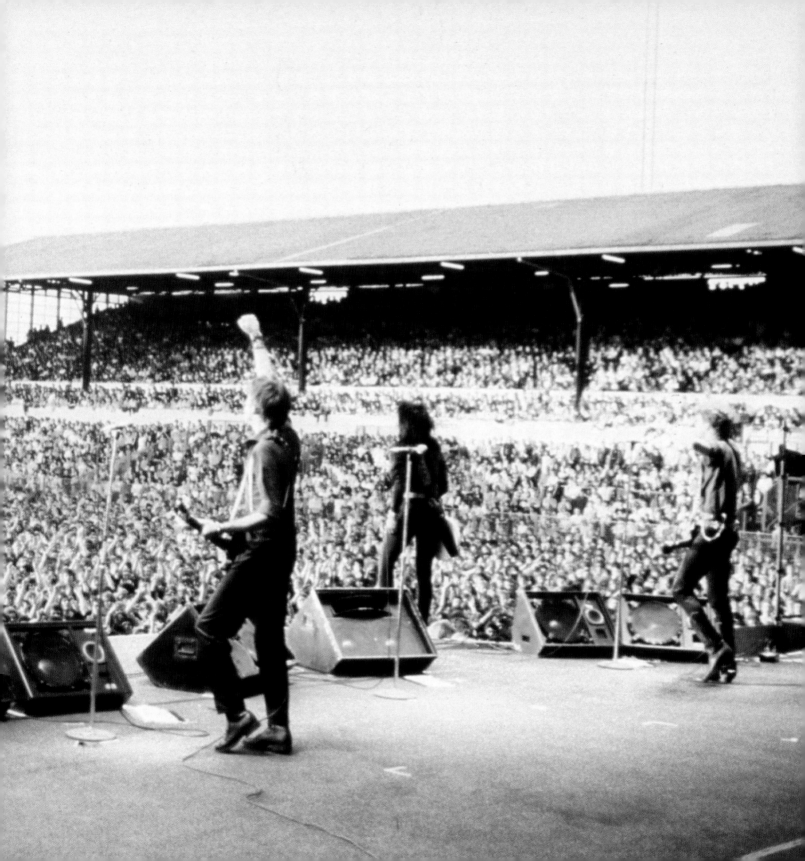

13

PRETTY DAMN HUMBLING

It's a very important relationship with fans. When we play live, the audience feeds off of us and we feed off them. If you're lucky, it keeps going like that, and by the end of the show, it's crazy. I receive a lot of letters that say mainly this, that the music has given them strength and that it's gotten them through very rough times. Sometimes they say they wouldn't be alive now if it weren't for my music. When I read that, I think how can I possibly stop what I'm doing? How can I get so frustrated with the business end of music to stop? There is that bond with your listeners. I don't ever want to lose it. A lot of letters, they're so inspirational. Some of them aren't even music-related, they say, "Thanks for being determined and sticking to it. It influenced me to go after that raise I was too scared to ask for, and I got it." They write that they saw the way I handled myself, and they try to apply it to their life and work. Sometimes girls write, "I loved the show. You've inspired me to pick up a

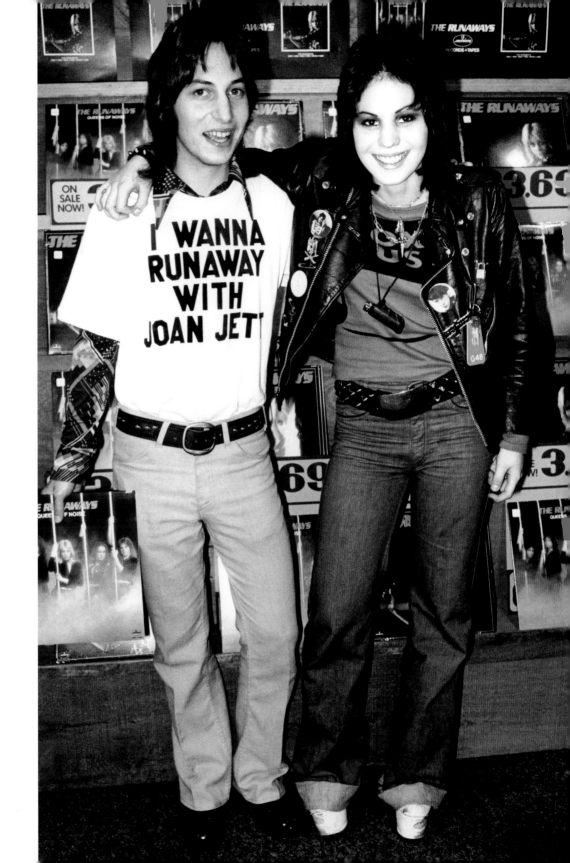

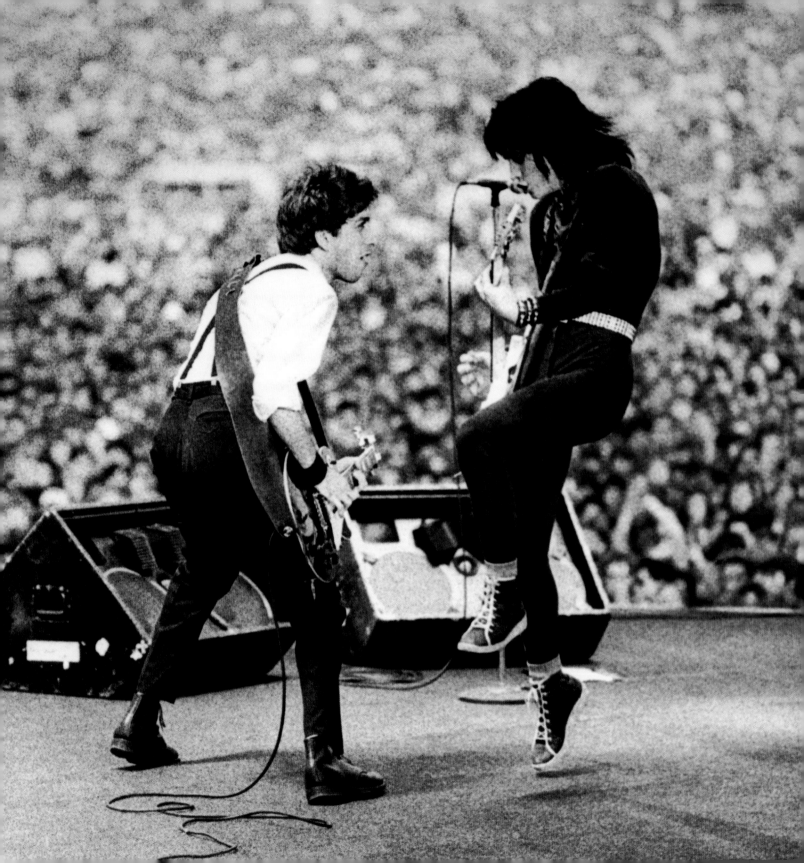

guitar" or, "You've inspired me to start a band" or, "We're in a band, and now we're doing good." It's when someone says that a song helped them get through a heavy time, or my music was there for them when they quit drugs, or inspired them not to commit suicide. It's really heavy. It makes me realize that music is healing. It's a really powerful thing, not to be taken lightly. It is an amazing feeling when someone tells you that you have inspired them. In a lot of instances, someone will say that The Runaways motivated them to pick up a guitar. It is pretty damn humbling to be put in that position. It's not something you take lightly. It's very touching to be a role model; it is an intense compliment. I have been very lucky to meet a lot of women in bands who have been motivated by myself or The Runaways or both. I tend to be a big fan of theirs. I don't know what that says.

14

SMACK 'EM

People do seem to expect me to haul off and smack 'em. Maybe I give that impression because I am very intense. I am determined, but people might mistake that for being masculine or bitchy. That's just me. You do have to have the strength to believe in yourself.

There are those who are really scared to death of me, who are actually physically trembling and shaking when they come to shake my hand, or those who think they can just do anything they want with me, and I have to straighten them out right away. I guess it's like anything else, they come in all categories.

People usually use the word aggressive to describe me. I somehow don't think that's the right word. Tough? I think the word tough is too much. I think people get tough and aggressive mixed up with mean. I don't think I'm mean. For the most part, I think I'm fairly easy to get along with. I'm approachable and people can come up and say hi. I'm not gonna bite their head off, you know.

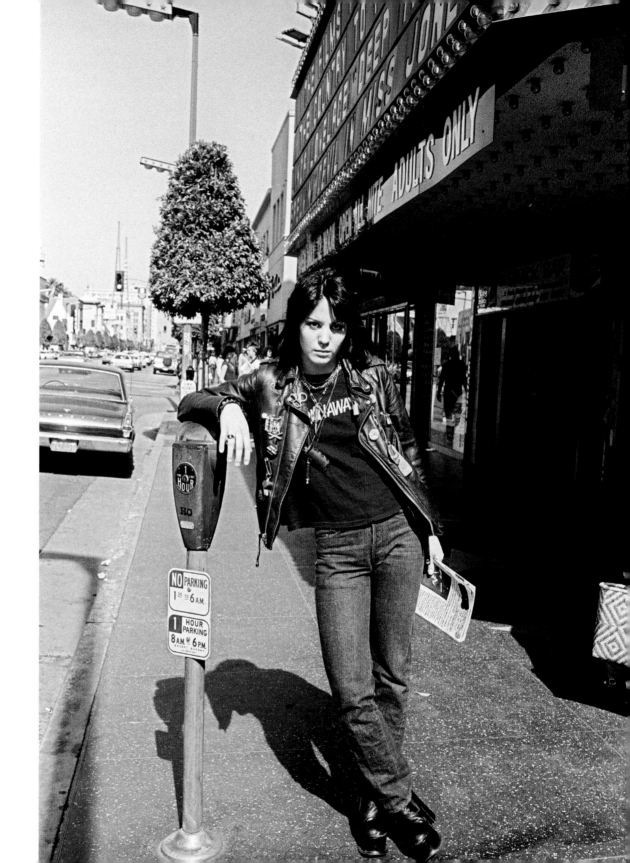

"THE TOUGH IMAGE WAS PUT UPON ME. I DON'T THINK I'LL EVER SHAKE IT…

...BUT PERSONALLY,
I DON'T REALLY CARE.
I JUST WANT TO PLAY
ROCK AND ROLL." —1981

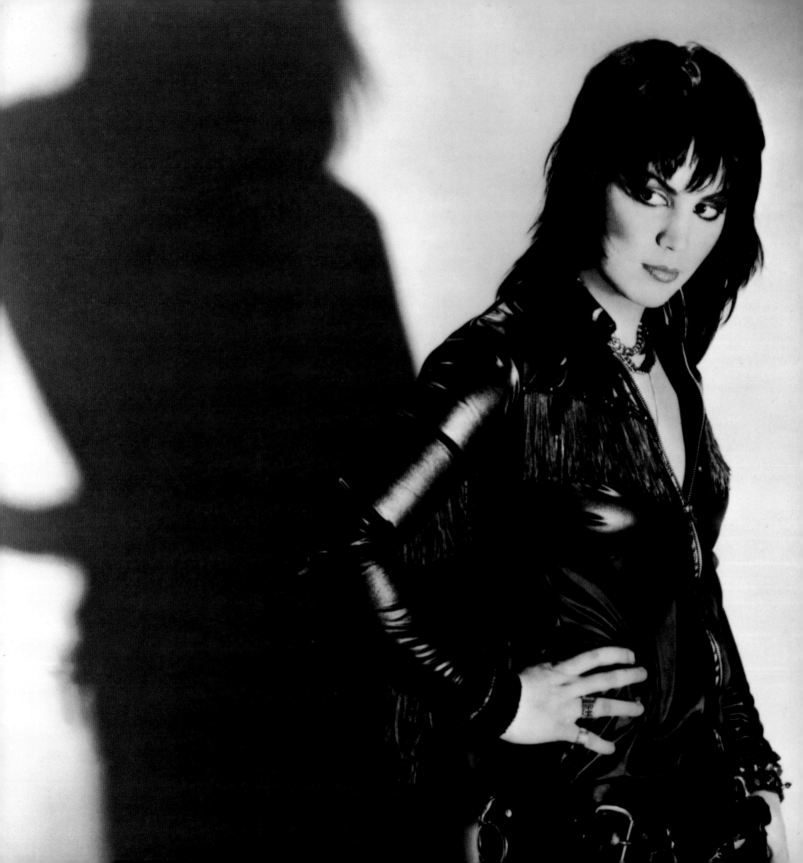

" *Photographers ask me what kind of image I'm trying to project, and I can't honestly think about it. I've got no idea, and it confuses me. I just try to be natural and do what I'm doing. I do what I want to do. It's me—what you see is what you get.*" –1983

Rolls Royce
Rent-u-Car
UPSTAIRS
SUITE 2

8549

The
PLEASURE
CHEST

FRI & SAT 11AM–3AM
DAILY 11AM–MID

NEW YORK
PHILADELPHIA
MIAMI
HOUSTON
CHICAGO
ATLANTA

LUBE
AVAILABLE HERE

YOUR
PERSONAL CHECK
IS WELCOME
HERE

master charge

VISA

BBB
BETTER BUSINESS BUREAU

DINERS CLUB
INTERNATIONAL

15

LEATHER JACKET, DARK HAIR, HEAVY MAKEUP

Before The Runaways, I lived in the Valley, so most of my clothes were homemade—I glittered and spray painted T-shirts. I didn't shop much in Hollywood. Maybe I got my boots there. At fetish shops, like The Pleasure Chest in West Hollywood, I'd get really basic stuff—T-shirts with weird things on them, belts. Really, I just wore jeans and sneakers and a leather jacket and a T-shirt, you know. But that leather jacket, the dark hair, heavy makeup, it was kind of armoring because people were kind of afraid of me.

I ran into Rick Nielsen from Cheap Trick recently, and he reminded me that The Runaways were the first people to wear that Cheap Trick shirt that became so famous. I think they made them when Cheap Trick made *Cheap Trick at Budokan* in Japan and The Runaways had just recorded a live album in Japan. So we were together, and they gave us the shirts. We were big Cheap Trick fans because we had played several shows with them, and I was happy to wear their shirts. But anytime I see that now, I always remember that we were the first people ever to wear those Cheap Trick shirts.

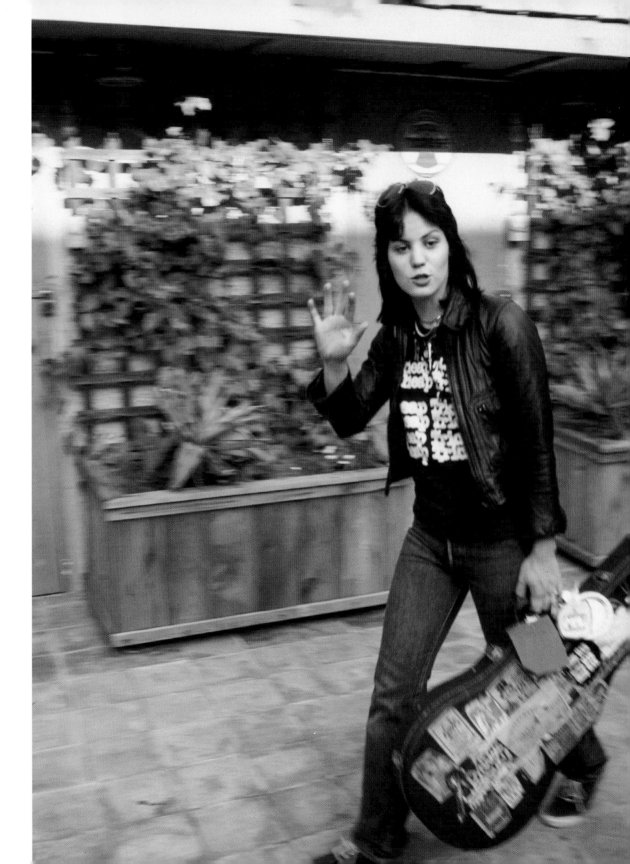

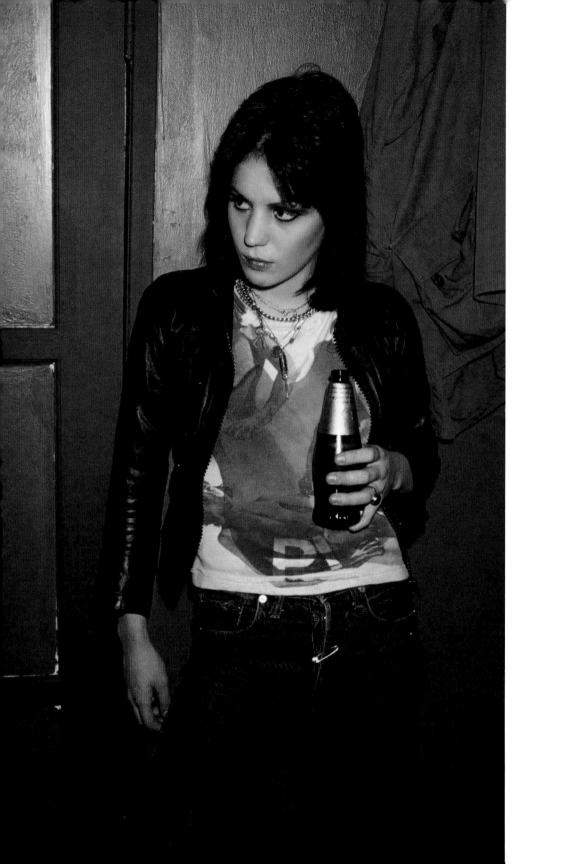

I don't know why. It probably really did evolve from just the look and stuff, and maybe my manner, in the way that I just know how I feel. And then I state it very toughly, maybe.

After I had a bit of success with 'I Love Rock 'n Roll,' I think people wanted to sort of elevate my look, sort of do the same thing, but maybe in a bit classier way. Actually, Kenny's wife, Meryl, had a lot to do with this. I've never been someone to wear dresses. In a way, it's just not my energy. I kind of wish I did like to wear dresses because it just gives you variety, you know? But it's just not me. So it's very easy for me to kind of create my own uniform. And I think that's what I've done over the years.

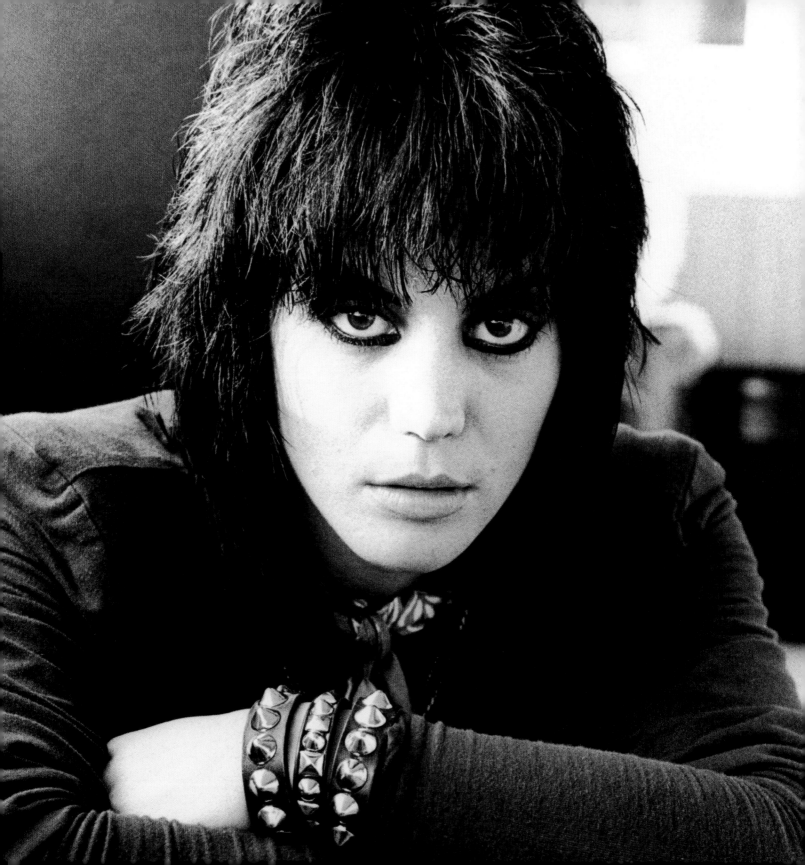

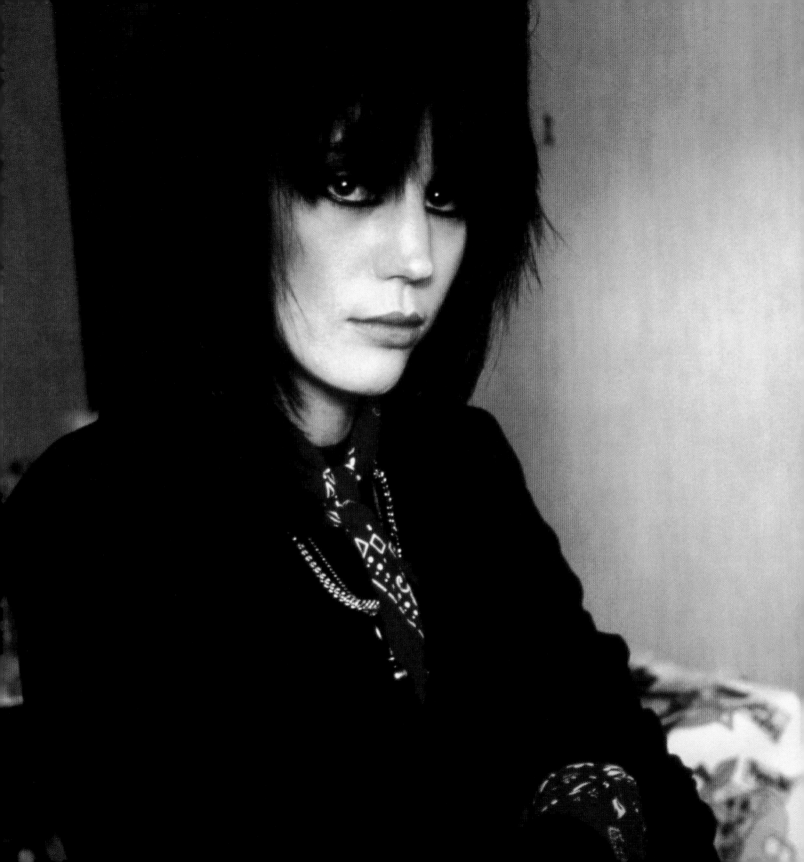

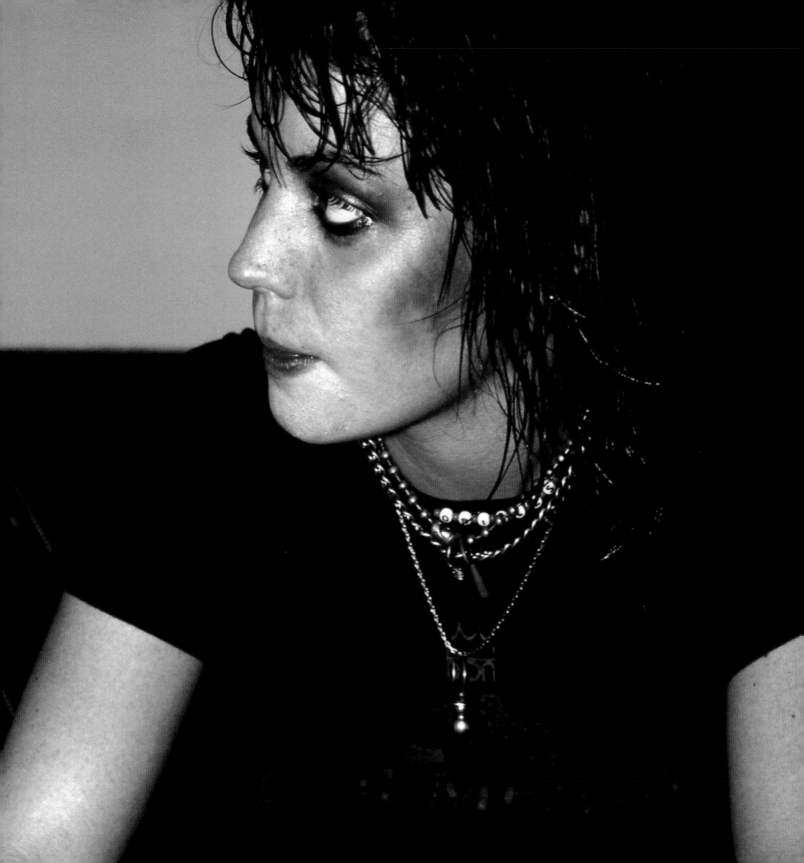

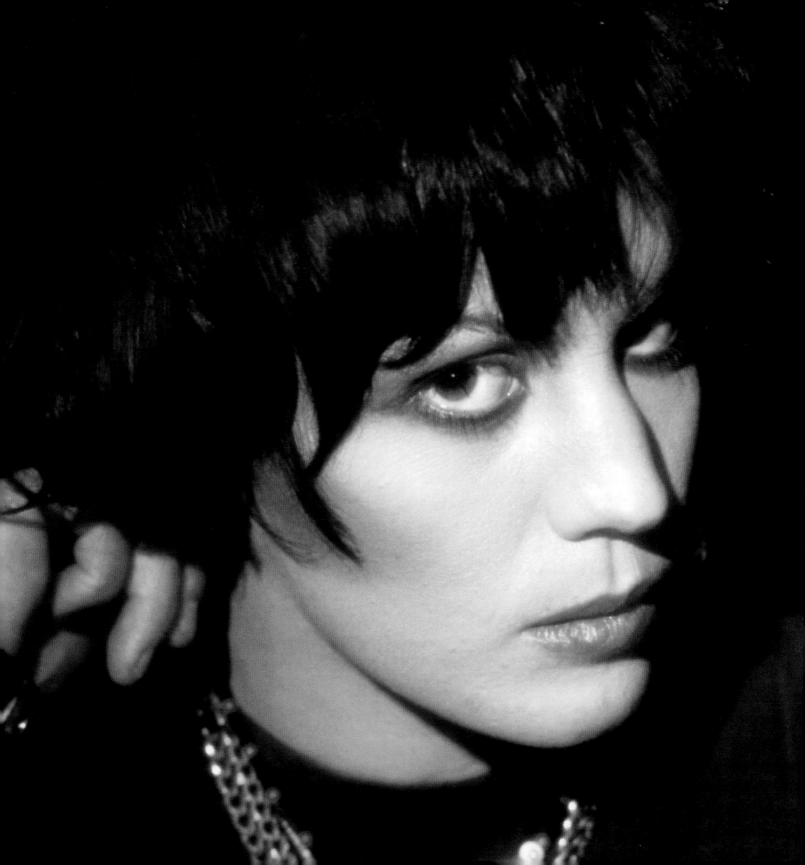

"I'VE BEEN DOING THIS SINCE I WAS 15. AND I'VE BEEN DRESSING THE SAME WAY, YOU KNOW?"

—1981

"I'M LIKE A DORK WITH ANIMALS,

BUT I REALLY DON'T CARE BECAUSE

I LIKE MY ANIMALS MORE THAN I

LIKE A LOT OF PEOPLE." —1981

16

VIDEOS

I LOVE ROCK 'N ROLL

1982

When we looked at this in color like we shot it, I'm thinking,
"Oh my god, that jumpsuit kinda looks horrible." The pads
were like football shoulders. And it just—it just didn't look—
just didn't look good.

But at the same time, there was a little monitor next to it, run-
ning in black and white. And I'm going, "That looks better."
You know? We're going, "I— I love rock— it's rock and roll."
Like why don't we do it something like it. They just flipped it
to black and white.

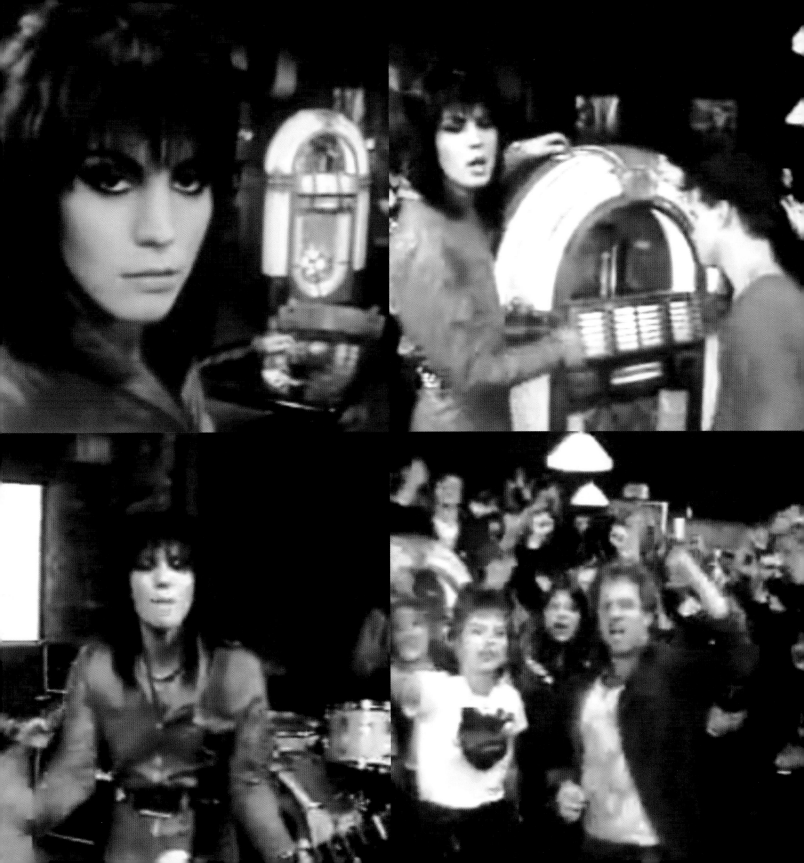

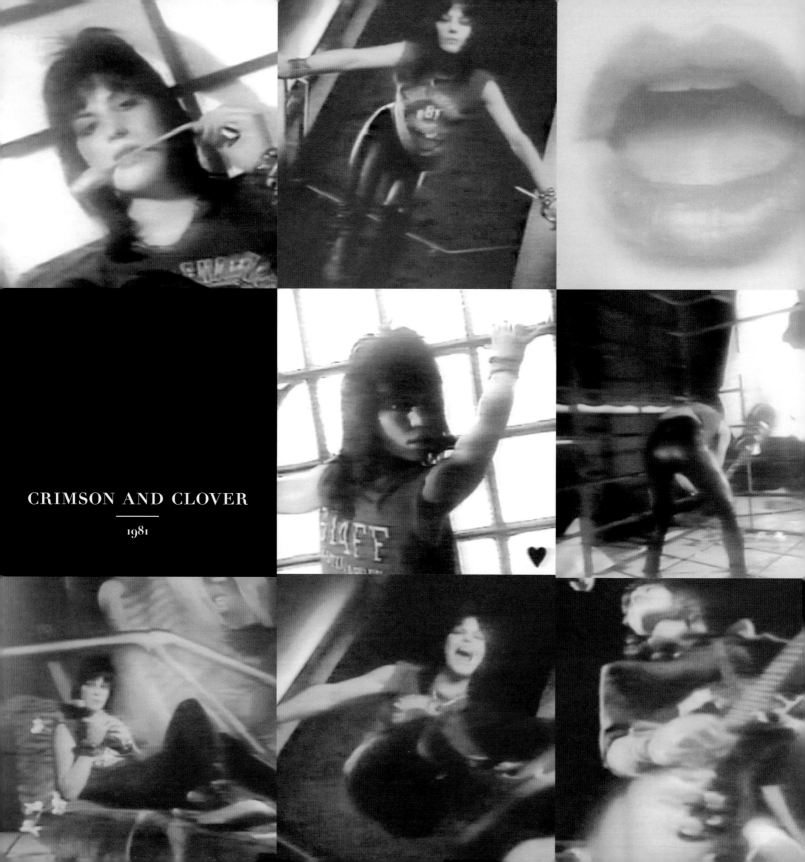

CRIMSON AND CLOVER

1981

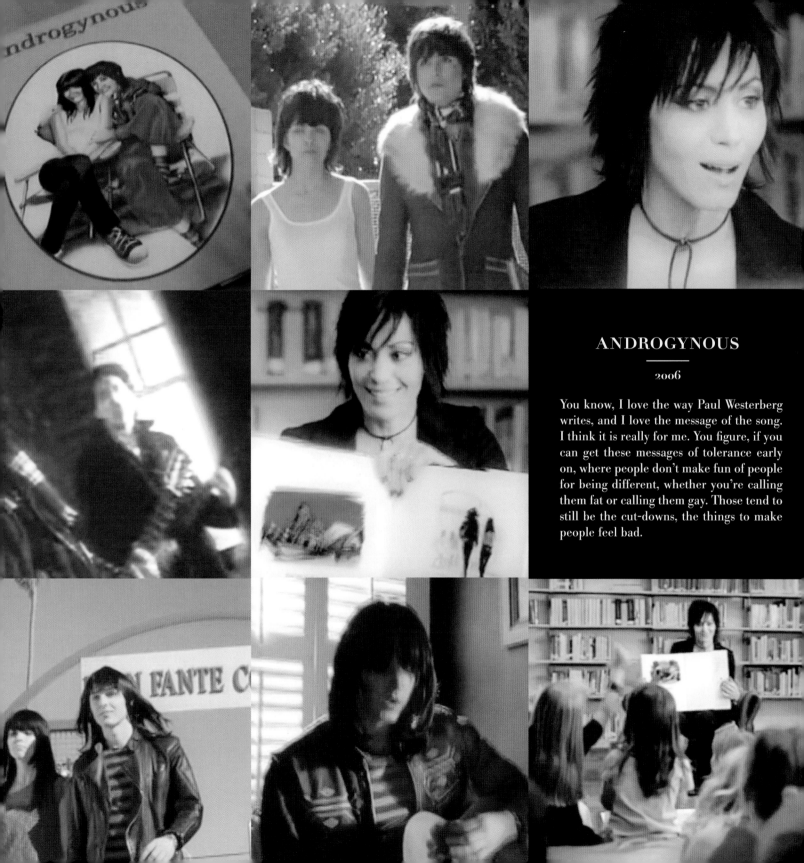

ANDROGYNOUS

2006

You know, I love the way Paul Westerberg writes, and I love the message of the song. I think it is really for me. You figure, if you can get these messages of tolerance early on, where people don't make fun of people for being different, whether you're calling them fat or calling them gay. Those tend to still be the cut-downs, the things to make people feel bad.

THE FRENCH SONG

1983

I love that video. Those were Bowie's extras because he had just shot 'Let's Dance' with the same video director, David Mallet. He's an incredible guy. He did three of the videos at once: 'Fake Friends,' 'The French Song,' and 'Everyday People.' But we spent all the money on 'The French Song,' and you can tell, if you watch the videos. I was singing in the verses, but I did an overdub where I was whispering the words.

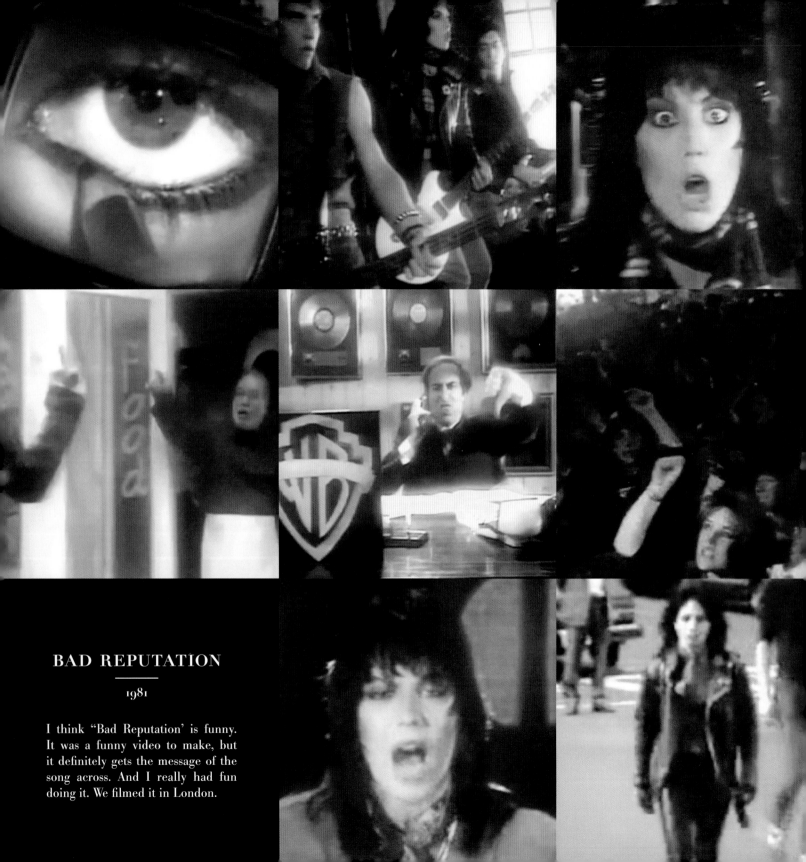

BAD REPUTATION

———

1981

I think "Bad Reputation' is funny.
It was a funny video to make, but
it definitely gets the message of the
song across. And I really had fun
doing it. We filmed it in London.

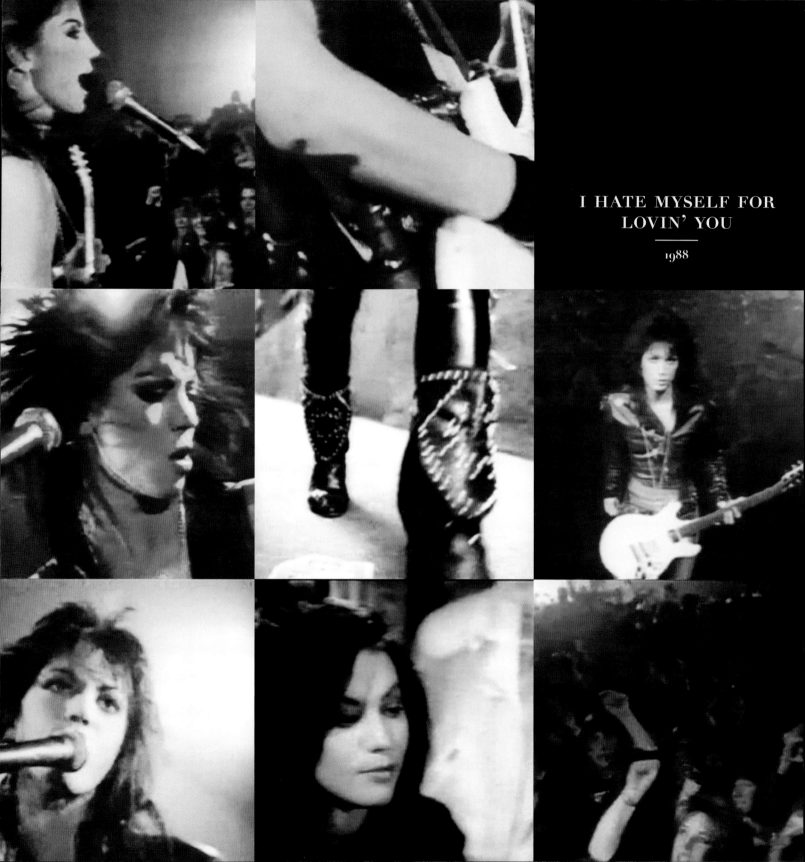

I HATE MYSELF FOR
LOVIN' YOU

1988

JOAN JETT
Orioles Fantasy Camp
1991

17

I LOVE SPORTS

I've always been a tomboy, and I've always loved sports. My earliest memory, I picked up a ball that was around the house, probably the dog's ball, I don't know. My dad started playing with me, and I had a brother to play with. We would play a lot around the neighborhood. We'd play everything: baseball, kickball, football.

Then I started getting into rooting for teams, and I loved the Green Bay Packers. They're my team. And I like them because when I was a little kid there was a famous *Sports Illustrated* cover from like '66 or something called The Mud Bowl. And both teams, Green Bay and I think that the other team was Cleveland, were playing in the mud. And they were so muddy you couldn't see who had the white uniforms and who had the dark uniforms, you couldn't even see the helmets. Their helmets were covered. You couldn't see who was on what team.

There was just one guy that had a helmet that had like a swipe clean of the mud. And you could see a G on it. The Green Bay G. And for some reason I don't know, maybe it was the mud, I just went, "That's my team." And I've been a Green Bay

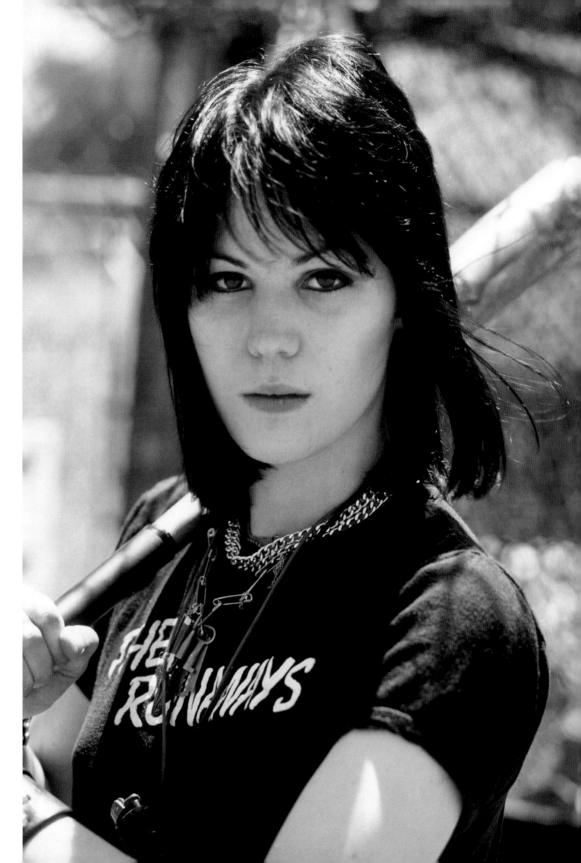

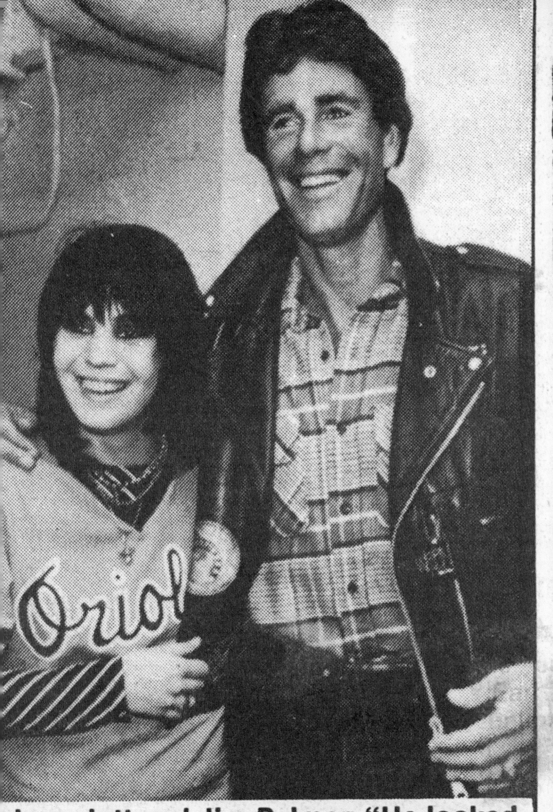

Joan Jett and Jim Palmer: "He looked pretty good when he came off the

**"I love the Orio
I love baseb**

and

Packer fan ever since then, even though I never lived in Green Bay, Wisconsin. And I have no connection to them beyond just loving that symbol.

We lived in Maryland for a while, and my dad would take us to baseball games. We'd go see the Baltimore Orioles. That was our team.

The first game my father took me to see was the Baltimore Orioles against the Oakland A's. And Jim Palmer of the Orioles threw a no hitter; that is incredible. I just always loved baseball. I stayed connected to the Orioles as a fan through the years. After I had success, I was lucky enough to be able to sing the national anthem for them several times. It coincided with when Cal Ripken started his streak of consecutive games. He did 16 years of consecutive games where he never missed a game. A kind of incredible feat that he started in like 1982 when I had 'I Love Rock 'n Roll.' I remember being on the field with the Baltimore Orioles, and Cal was a rookie, and the ball went between his legs when they were warming up. I think he was nervous because I was there. The other guys on the team were kind of making fun of him. It was really cool. And then many years later, when Cal broke Lou Gehrig's streak of

consecutive games played, I was called to sing the national anthem again. It's not something I do normally, sing the anthem. It's a tough song, and, you know, it's not my forte. It's not what I wanna do, but for the Orioles, I'll do it.

I'm a basketball fan too. I love watching basketball. I love going to the women's professional basketball games, so now I have season tickets for the New York Liberty. A lot of times I don't get a chance to go to the games 'cause in the summer that's when I'm on the road. I keep buying the seats anyway just because I wanna support 'em.

I think that sports and rock and roll are very similar. I think the band is like the team. Everybody has their part. You need your team. You need your band.

18

THE STUFF
WE SAW WAS
SO SURREAL

I like doing things for the troops, playing for them. We've done some trips in the past where you're goin' into hostile territory. And I'm talking about a lot farther than it's been publicized. And it's, you know, dangerous. And some of the stuff we saw was so surreal. Surreal. And you think, "Man, you should be scared shitless." They seemed to know, if your life is gonna end, it would be so fast that, there wasn't time to be scared.

As a thank you for doing things for the troops they asked, "Would you guys like to jump?" I said, "Yeah!" Kenny didn't want to do it, but he had to do it because I was doing it. He couldn't be out-toughed in front of the Army people by me. So, he had to go. I've got all of the footage. You can see the fuckin' fear in his eyes on the plane. It's amazing. They had cameras on top of their heads. A guy jumps out ahead of you, a guy jumps out with you, and a guy jumps out behind you. And they're filming all around. It was like we were four miles up. It was incredible. You don't feel like you're falling. You feel like you're flying. It was incredible.

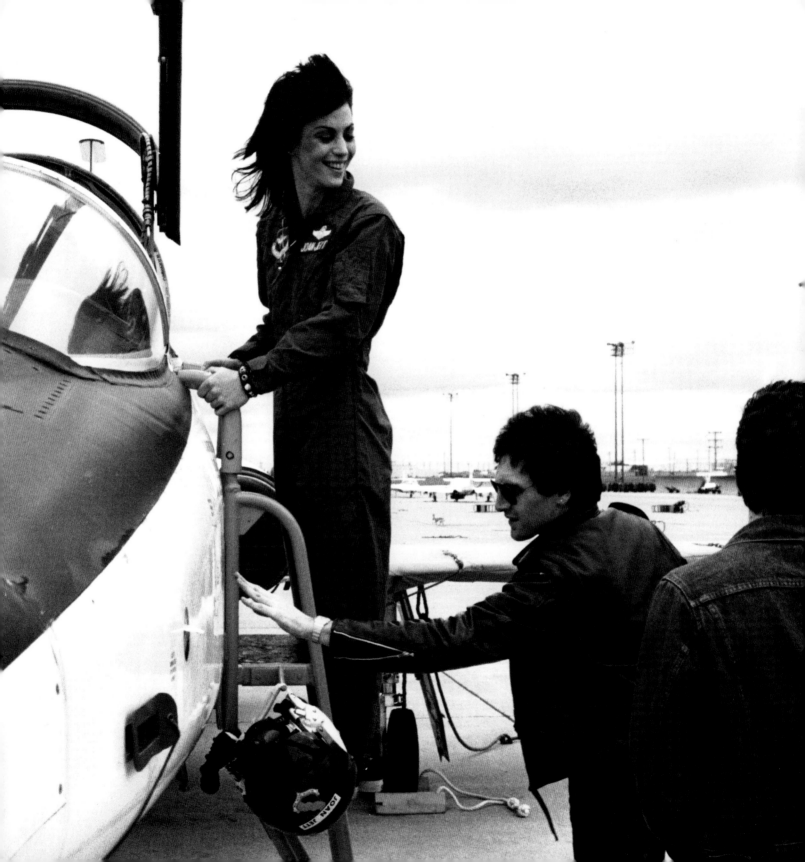

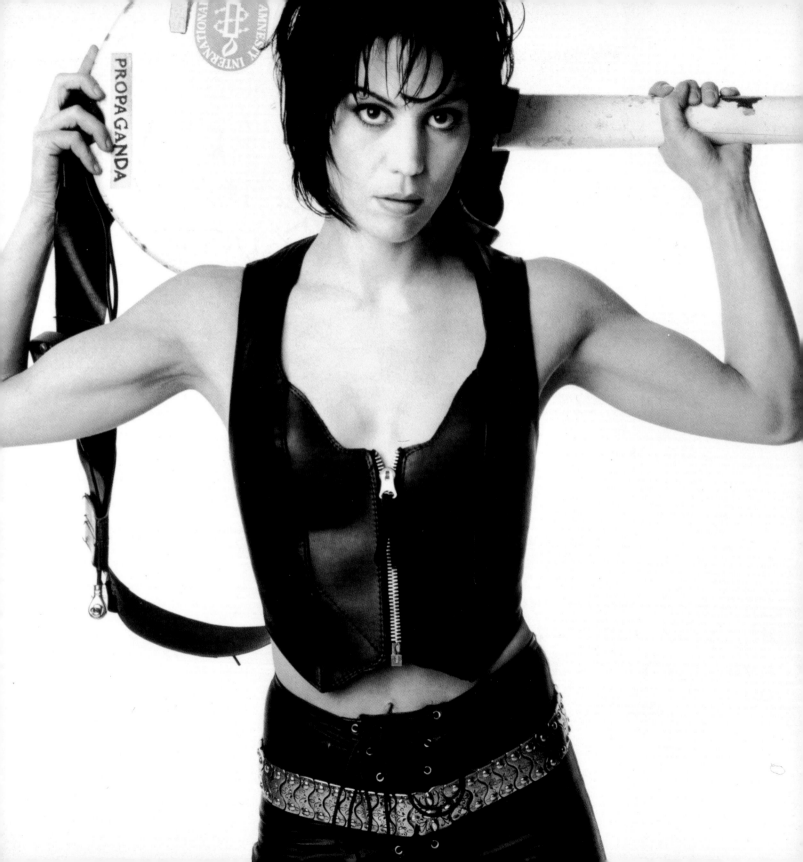

19

WOMEN
CAN DO IT

People get confused in their minds about what a woman is. I think deep, deep down girls sometimes feel like they have to hold themselves back, that they can't just get up on stage and do whatever comes out. I never even think about it. It's like when you're in the middle of sports. You're not thinking about what you're doing, you're doing it. To me, that means going up and howling like a banshee and sweating, which some girls might consider being unwomanly. It makes me feel good. It makes me feel sexy. I don't feel inhibited.

I think my strength is being an underdog. The fans love an underdog. If I opened doors for women in rock, then I'm happy. A lot of people in this industry turn on you when they think you become establishment, corporate rock. Other people will love you only when you do well. The fans stick with you. I'm always up against obstacles, but it doesn't scare me. You just have to have courage and stick to your guns. I admit I'm stubborn, but I'm proud of what I've done. I just want to remain a rock-and-roll purist and have my place in the book they write on rock history. I think I've made a place, and no one will ever take that away.

"ALL MY LIFE, I'VE BEEN TOLD GIRLS CAN'T DO THIS. IF GIRLS CAN PLAY CELLO IN A SYMPHONY, THEY CAN PLAY GUITAR."

—2006

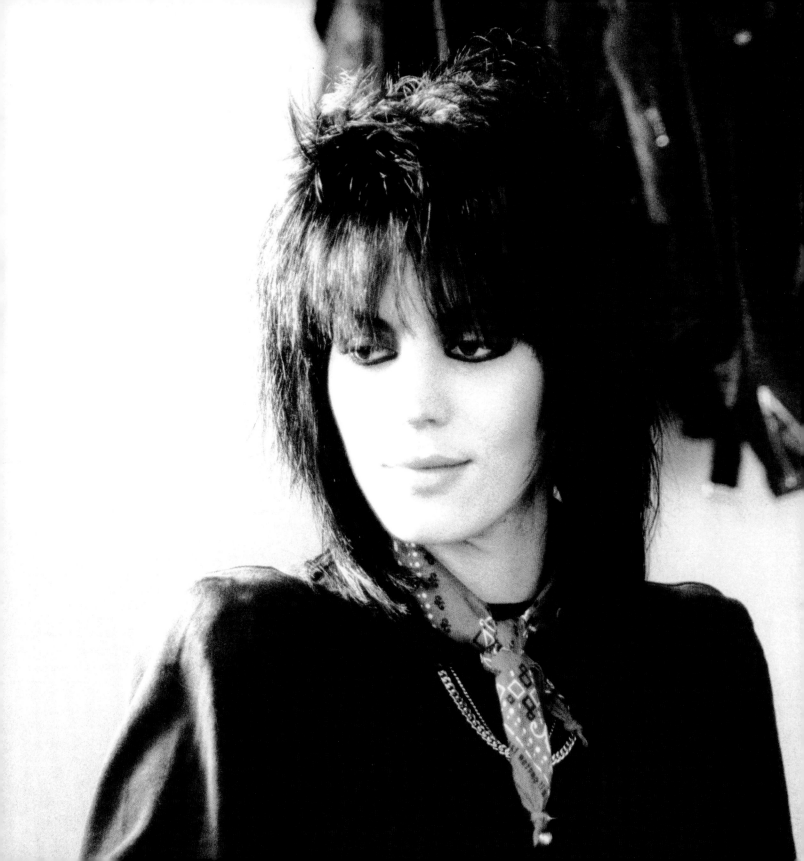

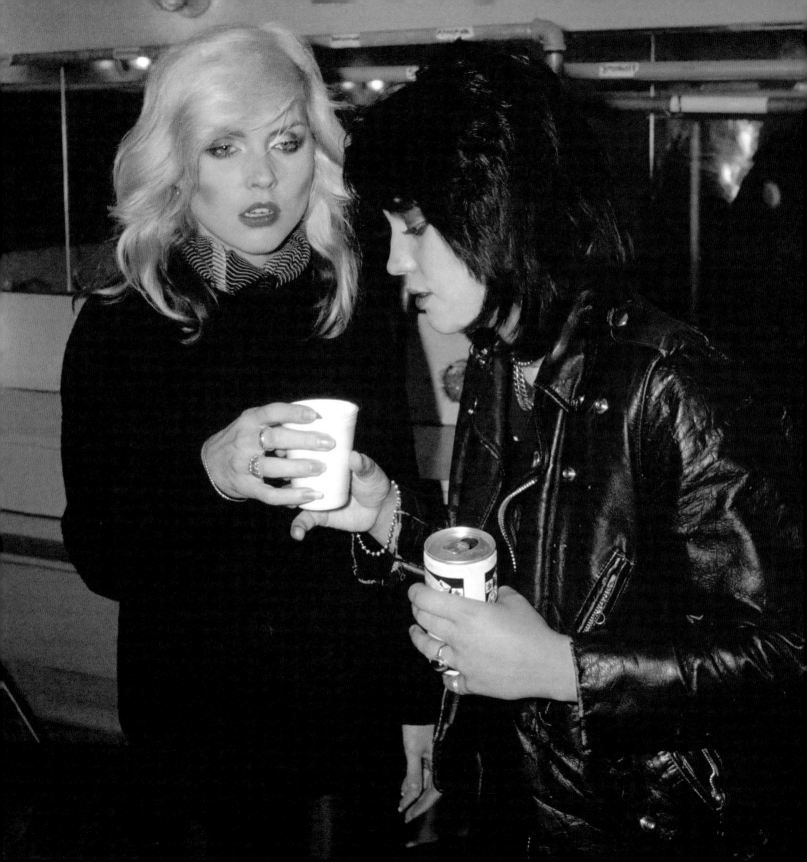

I'm kind of a loner in a lot of ways, but in other ways, I'm very much a rule follower. Rules of civility. Rules that help us all get along. Rules that say, when you're on the righthand side, you stop at a stop sign. There's a thing called right-of-way, please and thank you. My rebellion is not about authority, well maybe it is a little bit about authority, but it's more about society. I got along great with my parents. Great, really great. And I got along great with my teachers. I had no problems at school; I was a good student. So I wasn't rebelling against school. It was more about society and what they allow. You're given two messages. You're saying girls can be anything, and then you give girls shit when they do something outside the box, different than what you expect a girl to be. When a girl dresses different than you expect a girl to dress, if she doesn't just have a dress on with her long hair parted in the middle and big tits and high heels…you know, I'm not cutting it down at all. It's just, that's one uniform, and I have my uniform.

I think it's important to try to step into the unknown. I mean, I think everybody has totally rational fears about the unknown. And that's why we all stay in our habits, whether they're good

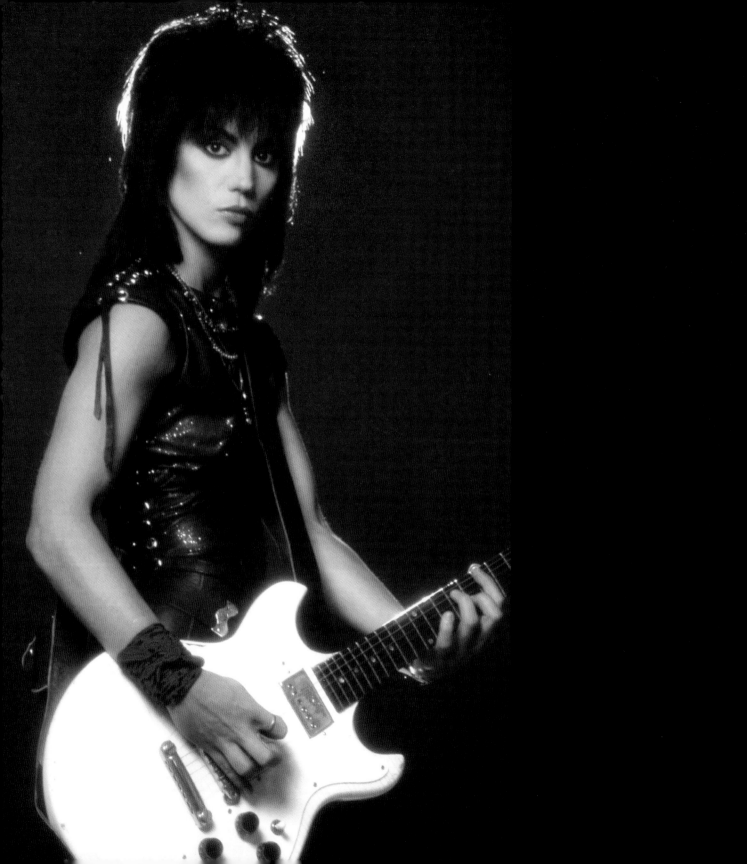

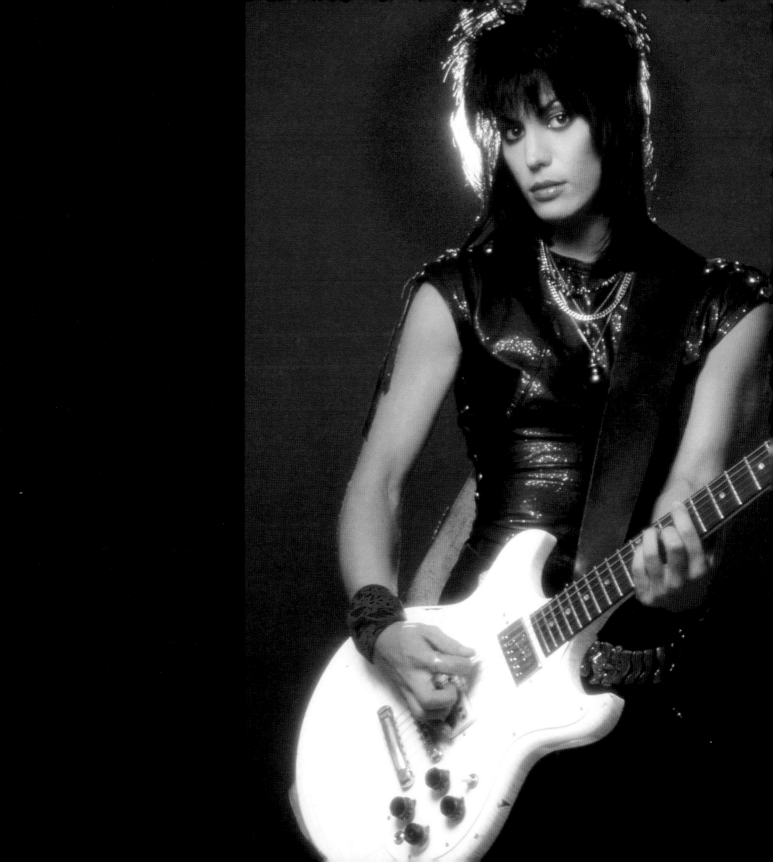

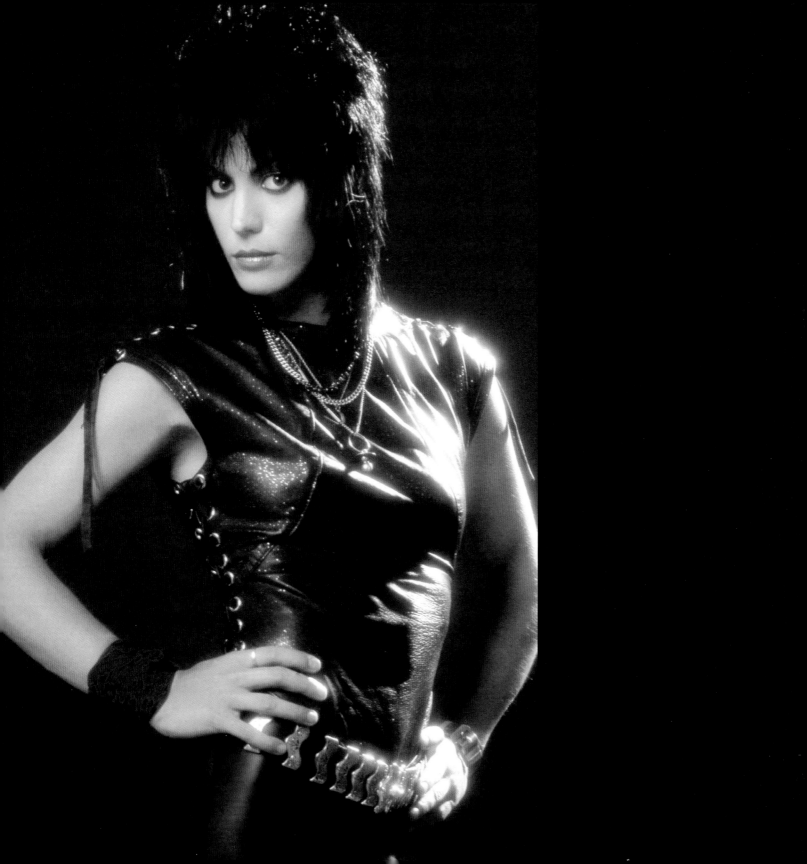

ones or bad, especially bad habits. Because even though we might know this is bad for us, it's the thing we know. And to do something else, even if it's good for you, it's not easy.

As I've grown up, I've started thinking about these things. And as I watch other performers and entertainers in general, just speaking about being afraid, saying, "I was very nervous before I went on out there." These are very accomplished people who've done a lot. And you think, well, they still get nervous; people still get scared. It's something you will never really get over. But, you know, the unknown is not scary. It's just unsure. I'm more confident, and I trust that the universe can take care of me if I just try to go with the flow. And the more I do jump into that unknown, I find it's been okay.

Is it brave? God, I don't know. I mean people may define it that way. I have put myself in situations that people would think you'd have to be kind of brave. I think for me it's just right. It's just like I was told, "Girls can do anything." It's fair. It's about the principle; it's all about the principle. I'm really sick and tired of seeing articles about "women rock." I don't want to be

involved in that kind of crap. When they start writing articles about "Italian rock" and "Jewish rock," then maybe I'll want to be in an article about "women rock." But until then, throw me in there with the Kinks, the Rolling Stones and The Who. I think it's improved a lot for women in rock, although they do assume you're not as good. It's funny to watch people wake up. Like at a sound check or something, our sound man will say, "OK, Joan, play some guitar for me," and I'll start ripping off some Chuck Berry-style something, and all the security people will look around like, "God, that came out of her guitar?"

Now women feel that they can do it; they don't feel so insecure anymore. As far as being easier … it varies. It's still tough, it's a lot of hard work, and there's going to be a certain amount of crap, and you have to be ready to deal with it. Women have found a voice in rock and roll. It used to be that girls were only allowed to be gentle singers and songwriters, but now it's okay to express anger and frustration as well. There's an acceptable outlet now for all that emotion.

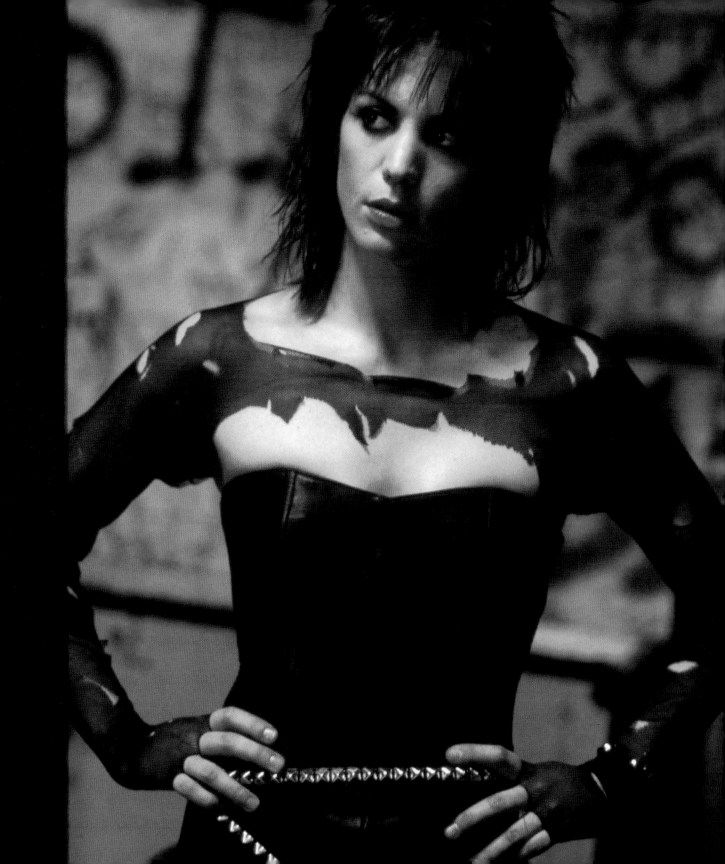

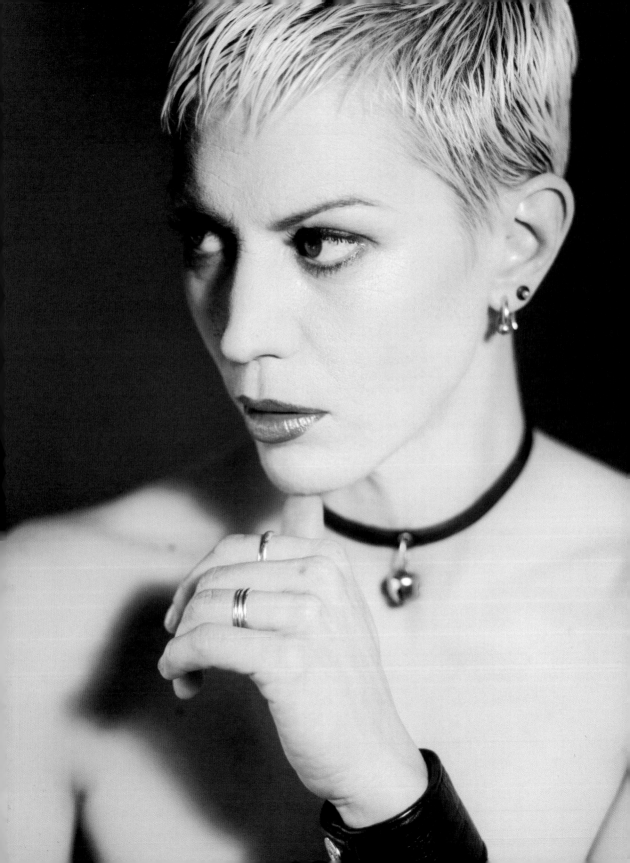

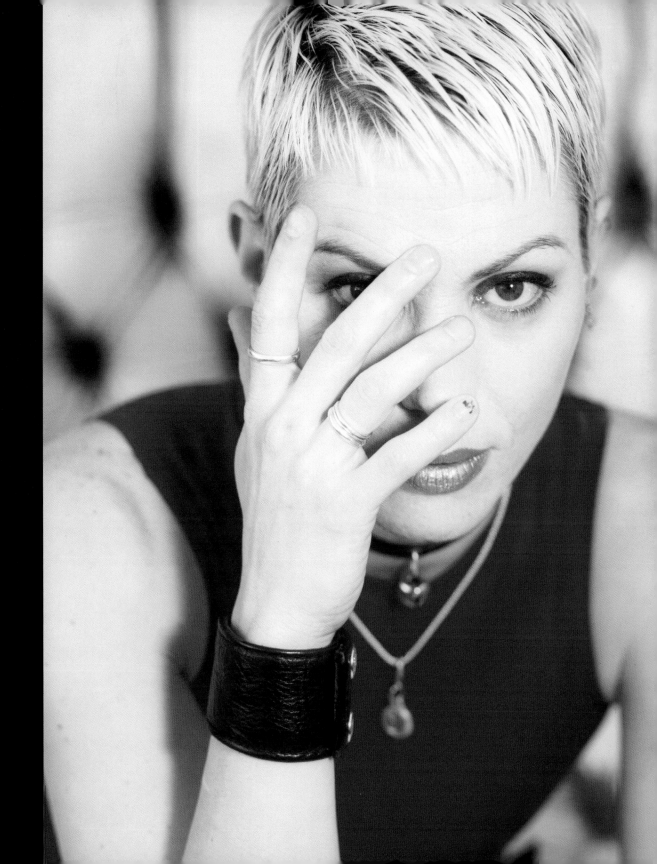

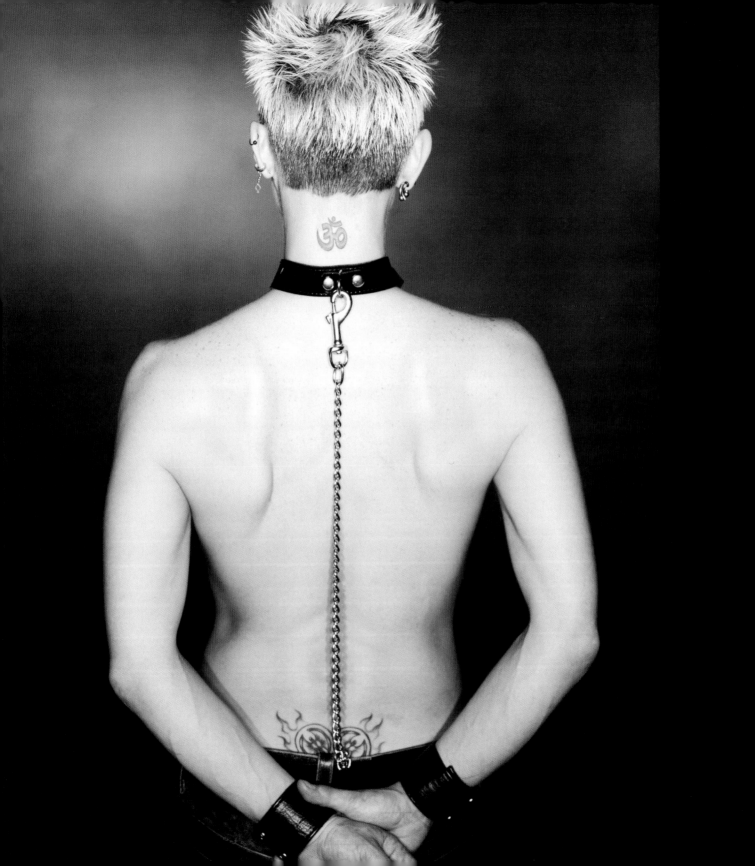

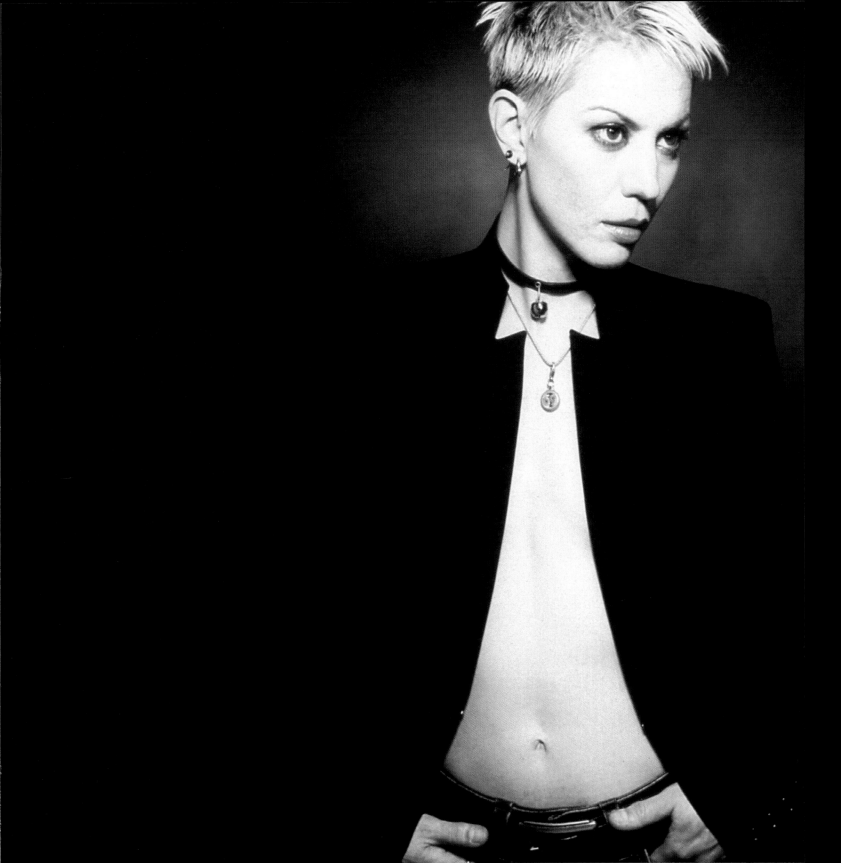

20

YOU CAN'T
WANT TO DO IT
FOR THE MONEY

If you are going to set out thinking you are going to be a rock star, you'll be disappointed real quick. You can't want to do it for money. You can sit and dream about getting on stage, getting in those lights, and making people happy—that was my dream, and I was lucky enough to make it come true. But it is a lot of hard work. It's physical, it's mental, and it is very taxing. If you are doing it to impress your friends, you'll do it for a year and give it up. If you want to be a musician or a singer, you have to really, really want to do it.

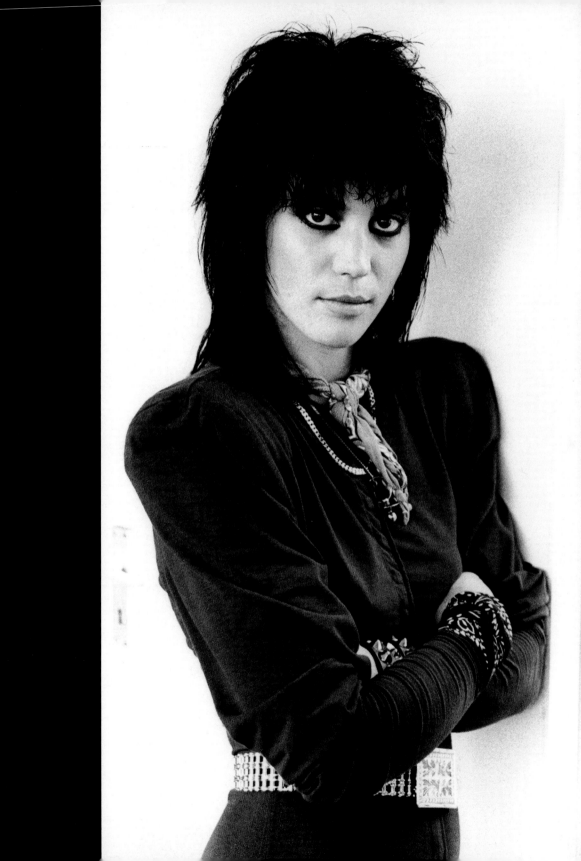

"THE MUSIC IS
WHERE THE HEROES
ARE. IT HAS TO COME
FROM THE MUSIC
ON THE RECORD,
THE SOUL AND
INSPIRATION...

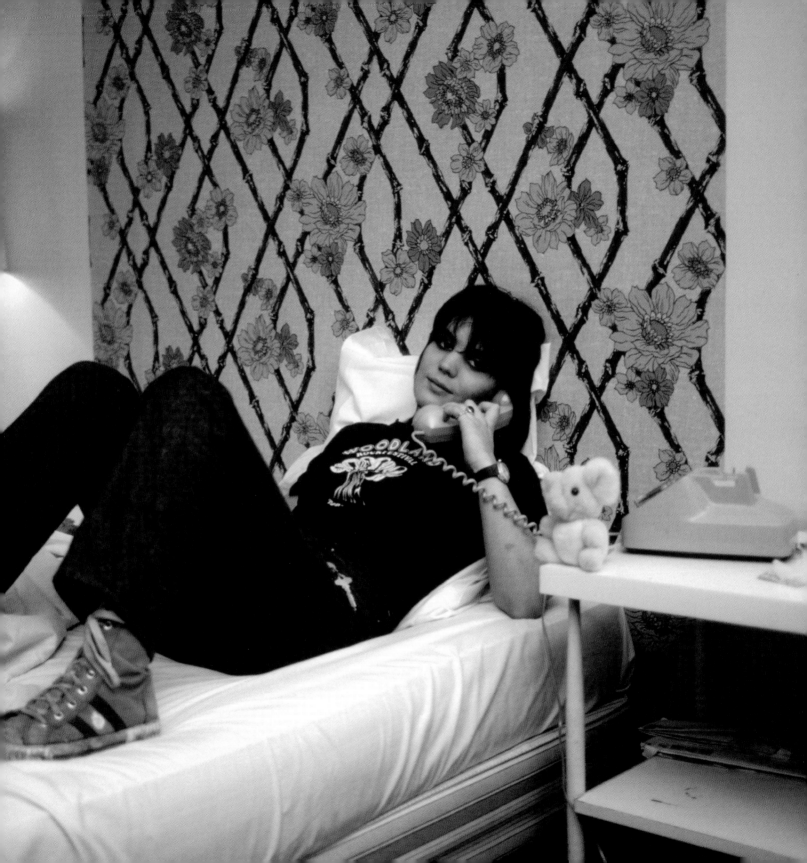

…IT DOESN'T MATTER IF THE PERSON WHO MADE THE RECORDS HAS SKELETONS IN THE CLOSET. IT'S THE PERSON ON THE RECORDS WHO REALLY MATTERS." —1992

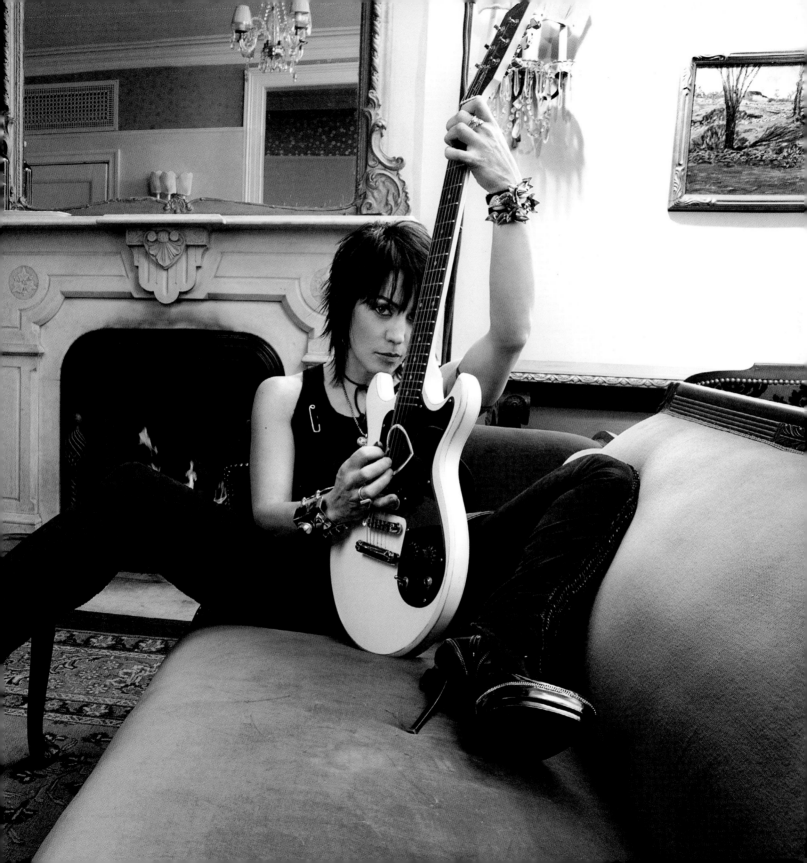

1975 The Runaways are formed by
Joan Jett and Sandy West.

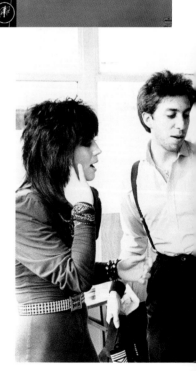

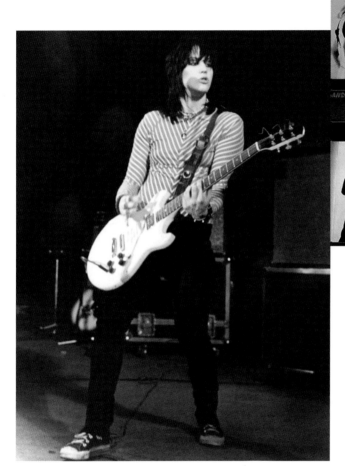

1971 Joan receives her
first guitar.

1979

The Runaways break up.

Joan meets and writes her first song with Kenny Laguna.

Bad Reputation LP recorded.

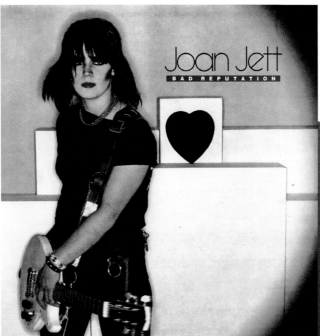

1981 | *I Love Rock 'n Roll* LP released.

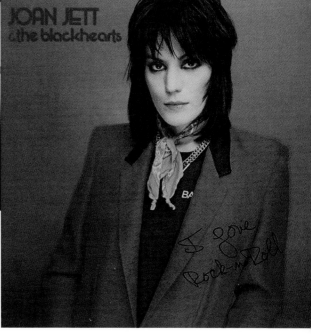

1982 | 'I Love Rock 'n Roll' is the number one single eight weeks in a row on the Billboard charts.

1980

Blackhearts form and tour Holland.

"TWENTY-THREE RECORD LABELS TURNED IT DOWN.

I HAVE ALL THE LETTERS.

THEY SAID, 'THIS IS INTERESTING, BUT WE DON'T HEAR A HIT.'"

1982

'Crimson and Clover'
single released.

> *"I'VE SLEPT ON A LOT*
> *OF FLOORS AND*
> *EATEN THE ROLLS*
> *OFF OF A LOT OF*
> *OTHER PEOPLE'S*
> *ROOM SERVICE*
> *TRAYS TO GET*
> *WHERE I AM."*

1983 *Album* LP released.

Singles 'Fake Friends' and
'Everyday People' released.

1984

*Glorious Results
of a Misspent Youth*
LP released.

1985 *Good Music* LP
released.

1990

The Hit List
LP released.

1987

Light of Day film and
'Light of Day' single
released.

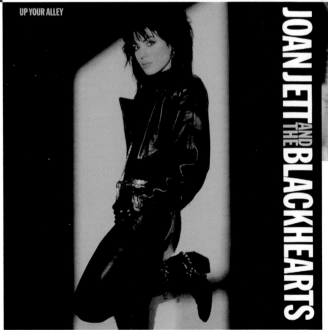

1988

Up Your Alley LP
released.

1991

Notorious LP
released.

"WOW, COOL, JOAN JETT!
SHE LOOKS LIKE SHE HAS
A REALLY GOOD ATTITUDE!"

—BEAVIS AND BUTT-HEAD

1995 | *Evil Stig* LP
released.

1993 | *Flashback* LP
released.

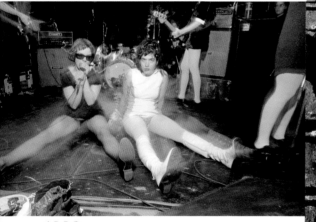

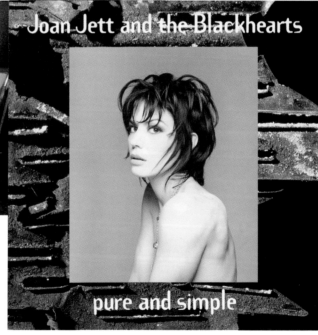

1992

Joan produces Circus Lupus
for Dischord Records and
Bikini Kill for Kill Rock Stars.

1994 | *Pure and Simple*
LP released.

1997

Fit To Be Tied
'Greatest Hits' LP released.

2010 | *The Runaways*
film released.

2004

Naked LP released
(Japan only).

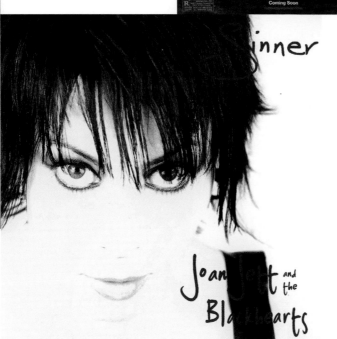

2010 | *Greatest Hits*
LP released.

2006 | *Sinner* LP
released.

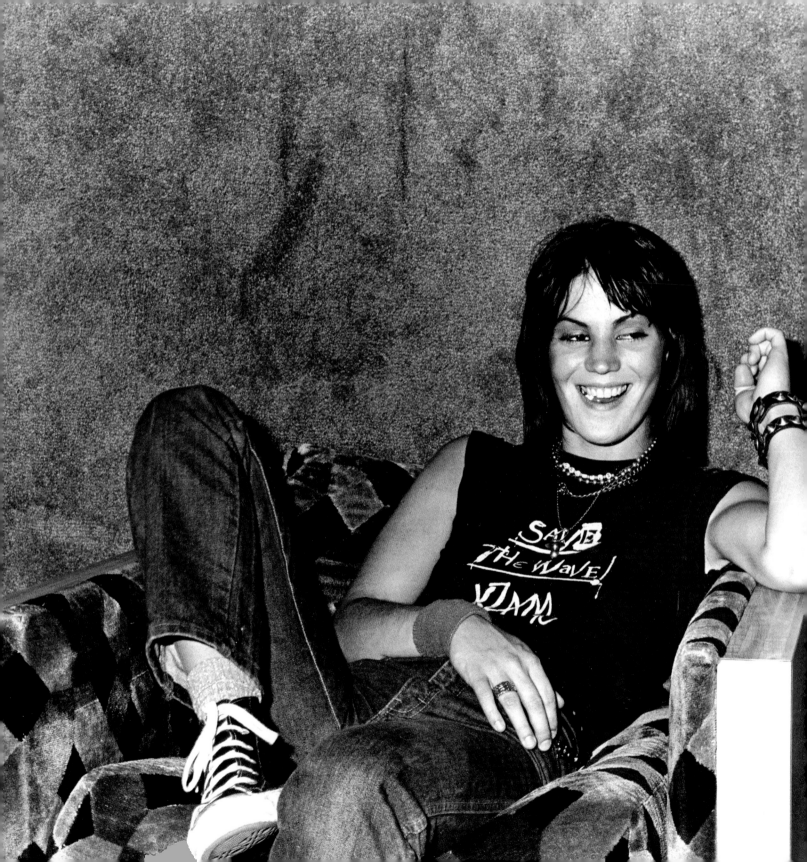

I LOVE
JOAN JETT

I first heard Joan Jett in 1976, one Saturday during my weekly visit to the music store. It wasn't a store in the mall. It was a three-feet-wide stall of bootlegged foreign music cassettes right on Kurosh e Kabir Avenue, a few blocks from my family home in Tehran, Iran. Every cassette's cover was in black and white—having been xeroxed—giving the store an arty, X-ray look. I was so excited to find The Runaways wedged between Nana Mouskouri and Glen Campbell. I had read about The Runaways in the English music magazines we could get at the foreign bookstore. The Runaways sounded exciting and kind of scary, and the prettiest one was named Joan Jett. She excited me in a way I was not accustomed to, and I still feel the same way today.

Joan is a rare one indeed. The story that unfolds in *Joan Jett* is one of integrity, tenacity, and such originality that it is impossible to not be inspired. The text in this book comes from many different resources. To start, I reviewed three decades of printed and taped interviews with Joan, which was a dizzying treat. I then conducted eight hours of taped conversations with Joan and combined the two. What I found particularly interesting is that quotes from 1982 blend seamlessly with quotes from 2010. She knew who she was at 17 and feels the same in most ways today.

There is a lot to be learned form the wisdom of Joan Jett. I find myself at times wondering, W.W.J.J.D?

Todd
Oldham
NYC 2010

JOAN JETT WISHES TO THANK

TODO OLDHAM
TONY LONGORIA
KELLY RAKOWSKI
MATT CASSITY
KATHLEEN HANNA
KENNY LAGUNA
MERYL LAGUNA
CARIANNE BRINKMAN
CHRIS SCHWARTZ
MAXIMILLIAN VERRELLI
ALENA AMANTE
GABE GODIN
KING CURTIS HAWKINS
DUNCAN HUTCHINSON
JULIE RADER
KAROL KAMIN
ELLIOT SALTZMAN
HUBERT GORKA
BILLY CRATER
ED SARGENT
DEREK BRINKMAN
BRAD WEINBRAND
ZACHARIAH NAGY
OREN WARSHAVSKY

TED STACHTIARIS
BRANDON SOUTHERN
DOTTIE LLOYD
ANNE LARKIN
JIMMY LARKIN
CHARLIE LLOYD
JAMES LARKIN
NEAL & JOYCE BOGART
TONY MARTEL
KIM FOWLEY
CHERIE CURRIE
SANDY WEST
BRAD ELTERMAN
BOB GRUEN
JENNY LENS
DOUGIE NEEDLES
THOMMY PRICE
ENZO
RICKY BIRD
GARY RYAN
LEE CRYSTAL
KRISTEN FOSTER
KEN PHILLIPS

BOOK DEPT. WISHES TO THANK

JOAN JETT
KENNY LAGUNA
CARIANNE BRINKMAN
MERYL LAGUNA
KATHLEEN HANNA
KYLE DOLLINGER
BROCK SHORNO
JENN NIELSEN
ALENA AMANTE
MAXIMILLIAN VERRELLI
BRAD WEINBRAND
STEVE CRIST
PAUL NORTON
REID EMBREY
SARA DEGONIA
GLORIA FOWLER
TONY LONGORIA
YOSHI FUNATANI
KELLI HARTLINE
HILLARY MOORE
JOSH GEURTSEN
LINDA OLDHAM
DORICE ALEXANDER
MICHELE ROMERO

& SPECIAL THANKS TO

BRAD ELTERMAN
BOB GRUEN

Printed in USA.
ISBN: 9781934429600
Library of Congress Number:
2010921331

AMMO Books, LLC
P.O. Box 412402
Los Angeles, CA USA 90041

www.ammobooks.com

Design by : Book Dept.
Book Dept. is Todd Oldham,
Kelly Rakowski & Matt Cassity

PHOTOGRAPHY CREDITS *in order of appearance*

FRONT COVER
Bob Gruen

Deiter Zill
Robert Ellis
Joan on Santa Monica Blvd—Brad Elterman
Deiter Zill
Neal Trousdale
Joan at the Tropicana Motel—Brad Elterman
Bleddyn Butcher
Bleddyn Butcher
Kathleen Hanna & Joan—Kenny Laguna
CHAPTER 1
Joan's family photos
CHAPTER 2
Brad Elterman
CHAPTER 3
Joan & Rodney Bingenheimer—Jenny Lens
Joan & Rodney Bingenheimer—Brad Elterman
CHAPTER 4
Michael Ochs
Bob Gruen
Joan & Lita Ford—Michael Ochs
Kim Fowley & Joan—Jenny Lens
Kim Fowley & Joan—Brad Elterman
Joan & Jackie Fox—Brad Elterman
Michael Ochs
Michael Ochs
Michael Ochs
Brad Elterman
Brad Elterman
The Runaways with friends & family, left to right:
Cherie Currie, Marie Currie, Jackie Fox's mom,
Jackie Fox, Lita Ford, unknown, unknown,
unknown, Sandy West, unknown, unknown,
unknown, unknown, Dorothy Larkin, Joan Jett,
Kim Fowley, unknown—Brad Elterman
The Runaways & Kim Fowley—Brad Elterman
Cynthia Ross, Stiv Bators & Joan—Theresa Kereakes
Joan & Rodney Bingenheimer with fans—Brad Elterman
Joan & Sandy West—Brad Elterman
Michael Ochs
Johnny Rotten & Joan—Jenny Lens
Michael Ochs/Michael Ochs
Brad Elterman
CHAPTER 5
Kenny & Meryl Laguna with Joan—Unknown
Kenny Laguna & Joan—Unknown
CHAPTER 6
Kenny Laguna & Joan—Unknown
Joan & Carianne (Laguna) Brinkman—
Kenny Laguna
Robert Ellis

Rejection letter/Grammy nomination—
Todd Oldham
CHAPTER 7
Unknown
Neal Trousdale
Joan Jett & The Blackhearts, left to right—
Robert Ellis/Randee St. Nicholas/Robert
Ellis/Unknown/Randee St. Nicholas/Robert
Ellis/Mick Rock/Mick Rock
CHAPTER 8
Mick Rock
Unknown
Unknown
Mick Rock
Geoffrey Thomas
CHAPTER 9
Ron Akiyama
Ron Akiyama
CHAPTER 10
Ron Akiyama
Olin Bundrick Jenkins
*Darby Crash, Pat Smear, Joan, Lita Ford,
Rodney Bingenheimer*—Jenny Lens
Unknown
CHAPTER 11
Ron Akiyama
Ron Akiyama
Ron Akiyama/Ron Akiyama
Ron Akiyama/Ron Akiyama
Ron Akiyama
Robert Ellis/Robert Ellis
CHAPTER 12
Unknown
Unknown
Dianna Noyd
Joan at Berlin Wall—Deiter Zill
Ron Akiyama
Ron Akiyama
Ron Akiyama/Ron Akiyama
Ron Akiyama/'Bad Reputation' video still
Touring ephemera—Todd Oldham
Ron Akiyama/Unknown
CHAPTER 13
Brad Elterman
Robert Ellis
CHAPTER 14
Joan on Hollywood Blvd—Brad Elterman
Todd Kaplan
Todd Kaplan
Unknown
CHAPTER 15
Brad Elterman

Brad Elterman
Brad Elterman
Robert Ellis/Unknown
Unknown/Unknown
Brad Elterman
Ron Akiyama
CHAPTER 16
Brad Elterman
CHAPTER 17
Unknown
CHAPTER 18
Unknown
Robert Ellis
Debbie Harry & Joan—Brad Elterman
Geoffrey Thomas/Geoffrey Thomas
Geoffrey Thomas
Taft Barish
Randee St.Nicholas/Randee St.Nicholas
Randee St.Nicholas/Randee St.Nicholas
CHAPTER 20
Robert Ellis
Brad Elterman
Dusan Reljin
TIMELINE
John McCartney
Robert Ellis
Pat Graham
I LOVE JOAN JETT
William Pickering

Deiter Zill

Brad Elterman: ©Brad Elterman
Bob Gruen: ©Bob Gruen/
 www.bobgruen.com
Theresa Kereakes: ©Theresa Kereakes/
 punkturns30
Jenny Lens: ©Jenny Lens Punk Archive/
 Cache Agency
Michael Ochs: ©Michael Ochs/Michael
 Ochs Archives/Getty Images
Dusan Reljin: ©Dusan Reljin
Pat Graham: ©Pat Graham

Despite extensive research we have
been unable to locate the holders of
the rights to some of the images within
this book. We extend our apologies and
ask that they contact us.

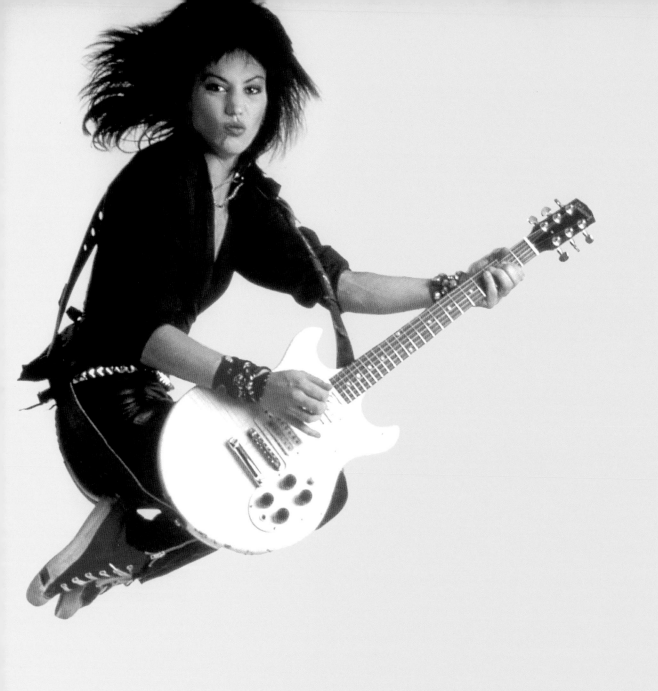